MW00808841

BUGSU

Photographs by **JOHN HALLMÉN**

Text by **LARS-ÅKE JANZON**

Translation by **JOY HILL**

Skyhorse Publishing

The feeling of connecting with someone is never as pronounced as when we look into their eyes. Humans, being the social creatures that we are, cannot help but to project emotions and a conscious mind onto not only our own species, but all the wildlife that are similar to us. Insects, on the other hand, are often too small to evoke such a response. Rather, we see them as something we cannot actually identify with. Maybe that's why we get such an altering experience when we pick up a magnifying glass and discover that what seemed like only a tangle of legs and antennae is suddenly staring right back at us.

When we further acquaint ourselves with insects, spiders, and the other small creatures that we refer to as "bugs," it changes our perception of nature. An ordinary grove copse transforms into something more when we discover and acknowledge its hidden inhabitants. Bugs are everywhere, but in order to find them, you must sometimes look very hard.

As a young boy, I loved turning rocks. *What can be found beneath this one?* A shiny beetle, a sullen centipede, teeming hordes of ants, or, better yet, something I've never seen before! Thirty years later nothing has changed—I still feel great anticipation and satisfaction when peeking under a rock.

Only under high magnification can we see and fully appreciate the varying shapes and designs of these bugs up close. The visual characterizations of the different species tell interesting tales of their behavior, living conditions, and adjustments to the surrounding environments.

I would like to give a big thank-you to Lars-Åke Janzon, whose texts added greater depth and an additional dimension of the biology of these creatures. The closer we get to nature, the more questions we seem to have. Lars-Åke's knowledge, experience, and ability when it comes to answering seemingly every question imaginable are unique. Thanks to him we now realize how much more there is to explore and that there are still a few stones left unturned.

John Hallmén, May 2012

These silhouette images reveal the natural size of specific bugs. All the species found in this book, whether photographed in nature or in a studio, can also be found in Sweden. Most of them are also quite common throughout the world. Here you see a tick, body length: 3 mm; and an American cockroach, body length: 35 mm.

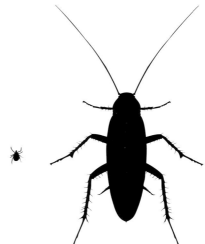

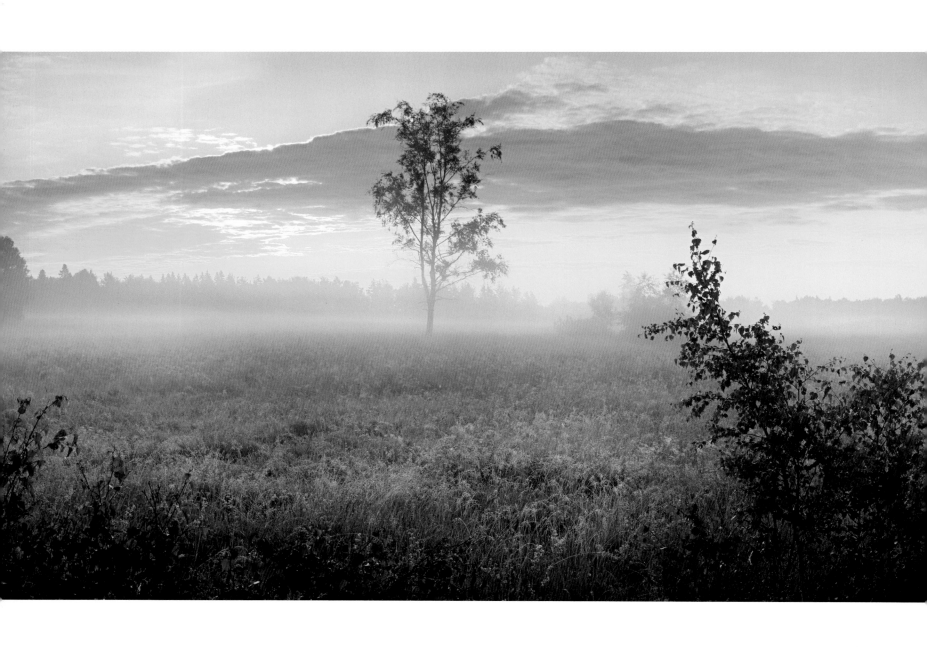

Dawn at the firing range of Utö (a small island, east of Stockholm) in early July. The local beetles are all sitting quietly among the plants and dewdrops. Soon this place will be buzzing with life.

INSECTS ARE COLD BLOODED, and it is the outside temperature that determines whether they are active or not. Insects are usually able to withstand frosty nights, as they can survive being sub-cooled (i.e., having their body temperature going below the freezing point without them freezing to death). When the sun rises, the heat brought will thaw the insects slowly and turn the frost into water droplets that will later evaporate.

Scientists have long debated whether insects have the ability to sleep or not. Some argue that insects have a simpler nervous system that cannot contain anything resembling our own sleep stage. Another argument would be that insects don't have any eyelids, and therefore cannot sleep. But today, we now know some insects do sleep, or at least have a behavioral state that resembles sleep. Insects require inactive periods of time hiding and sitting still. It might not matter what we call this inactive state, but we can confirm that they indeed have long, sedentary moments.

Emerald damselfly *Lestes sponsa*
Body length: 30 mm | Södermanland Country (Nackareservatet Nature Reserve, located on the border between Stockholm and Nacka), 8 exposures

This is one of Sweden's most common damselflies during the late summer. They live next to stagnant water that has rich vegetation. When the damselfly rests, it keeps its body turned downward, with its wings opened only halfway.

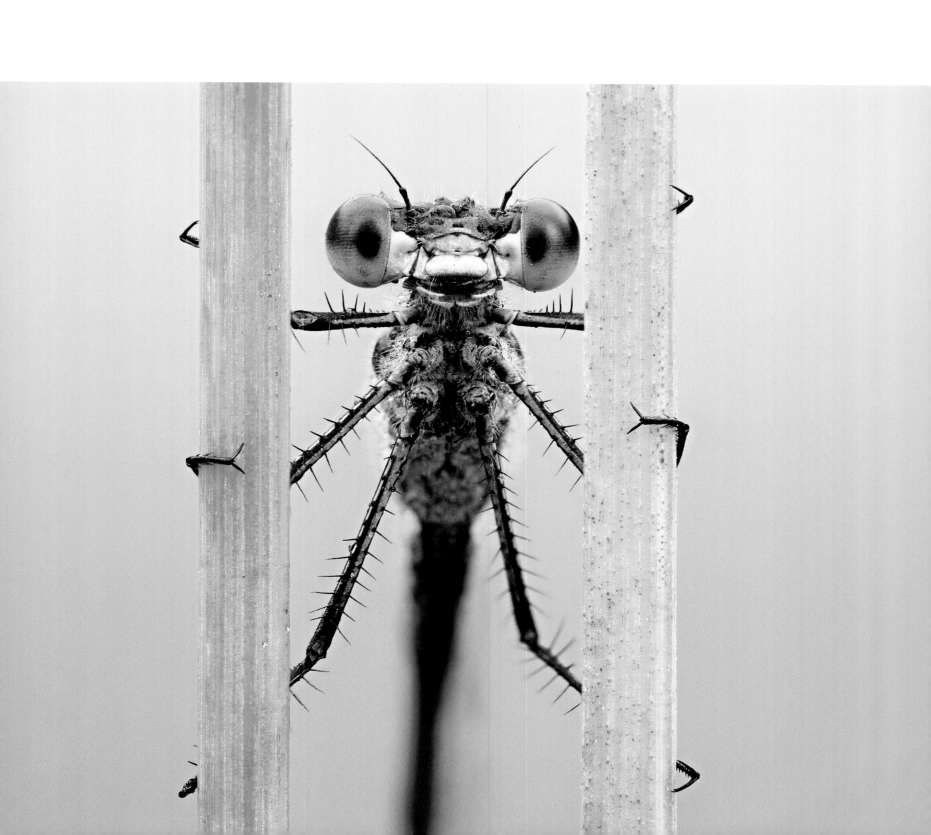

Crane fly *Tipulidae*
Body length: 11 mm | Öland, Sweden, 5 exposures

After a damp, cold night the crane fly slowly gets dry. During this time, it is completely defenseless and in danger of becoming easy prey for an insectivore like a passing bird or dragonfly. When dry and awake, the crane fly has a defense mechanism that can be best described as a type of self-mutilation. In a pinch it can "lose" a leg to get away. A lost leg will partly grow back again, but will never function as well as its original leg.

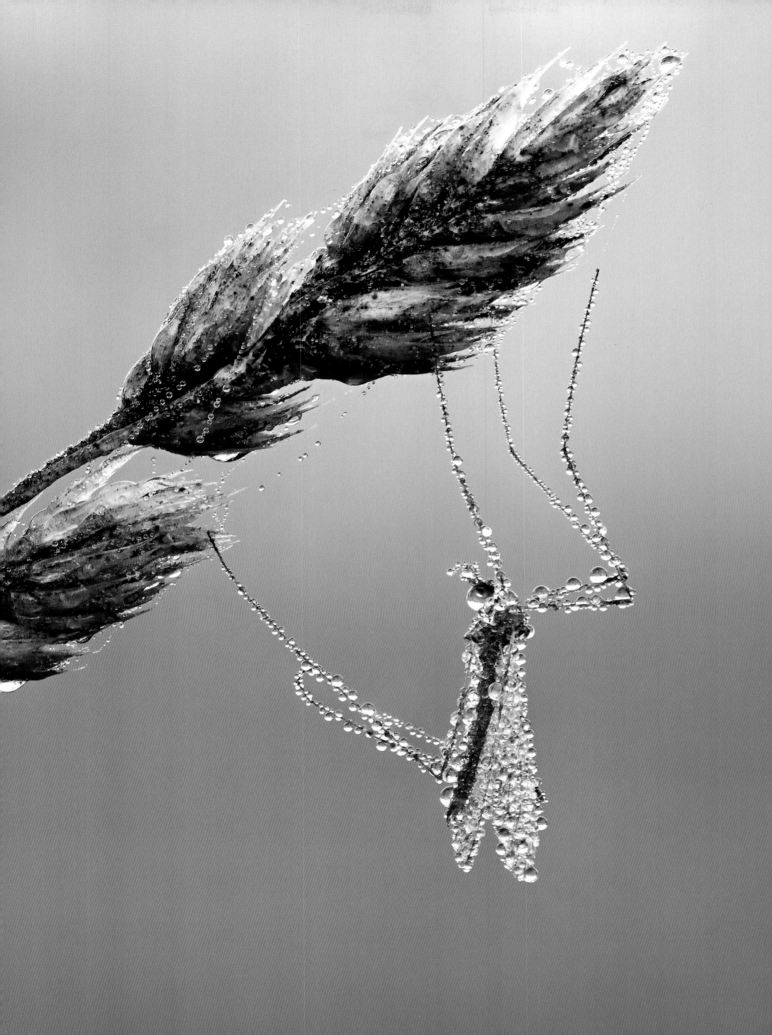

 Anthomyiidae fly *Anthomyiidae*
Body length: 7 mm | Södermanland (Nackareservatet Nature Reserve), 6 exposures

Anthomyiidae flies are a grayish/brown/black color, small to medium in size, and a close relative to the common housefly. They resemble the housefly but usually have a slimmer physique. You will often find these flies in flowers with accessible nectar, hence their Swedish name, *blomsterfluga* (flower fly).

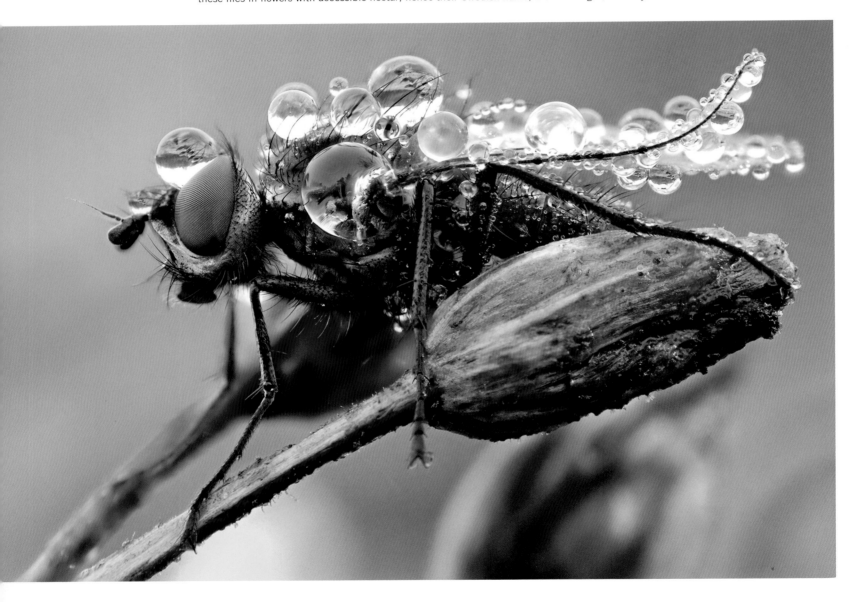

Bird-cherry ermine (moth) *Yponomeuta evonymella*
Body length: 10 mm | Södermanland (Nackareservatet Nature Reserve), 88 exposures

The bird-cherry ermine caterpillars are found only on bird-cherry trees, living off their leaves. When the caterpillars are fully grown, they spin a cocoon, and hundreds of cocoons can be found hanging together. In June, many bird-cherries are bare and completely spun by the caterpillars. The trees survive, even if they've been eaten bare several years in a row. The ermine attacks usually cease after a few years, when the natural enemy of the caterpillars—the parasitoid wasp—becomes numerous enough to keep the population down.

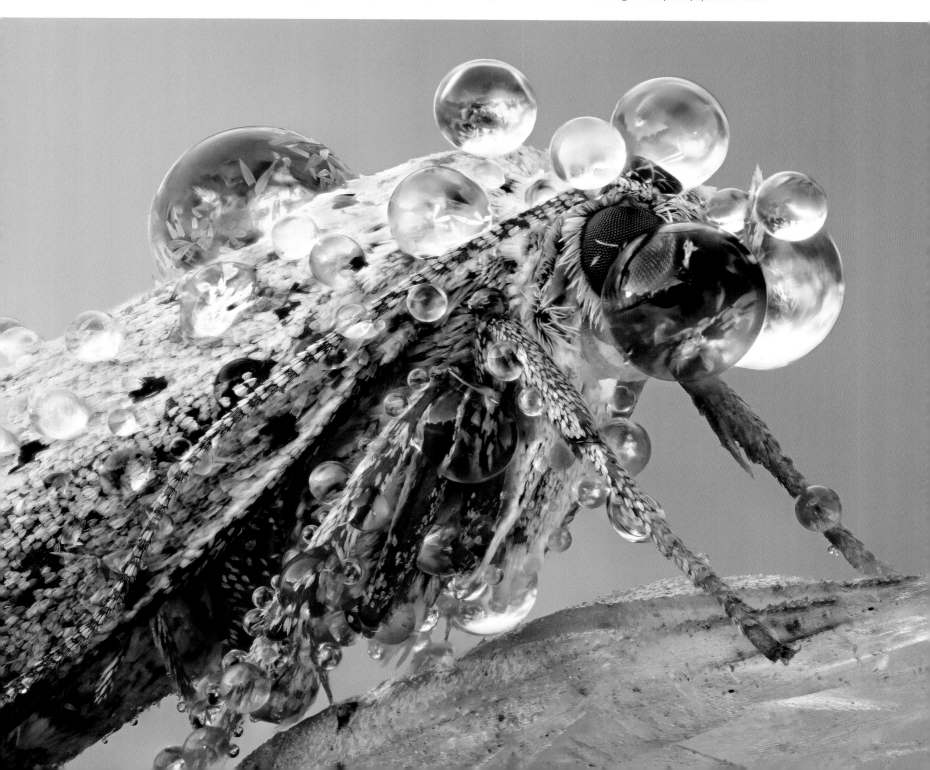

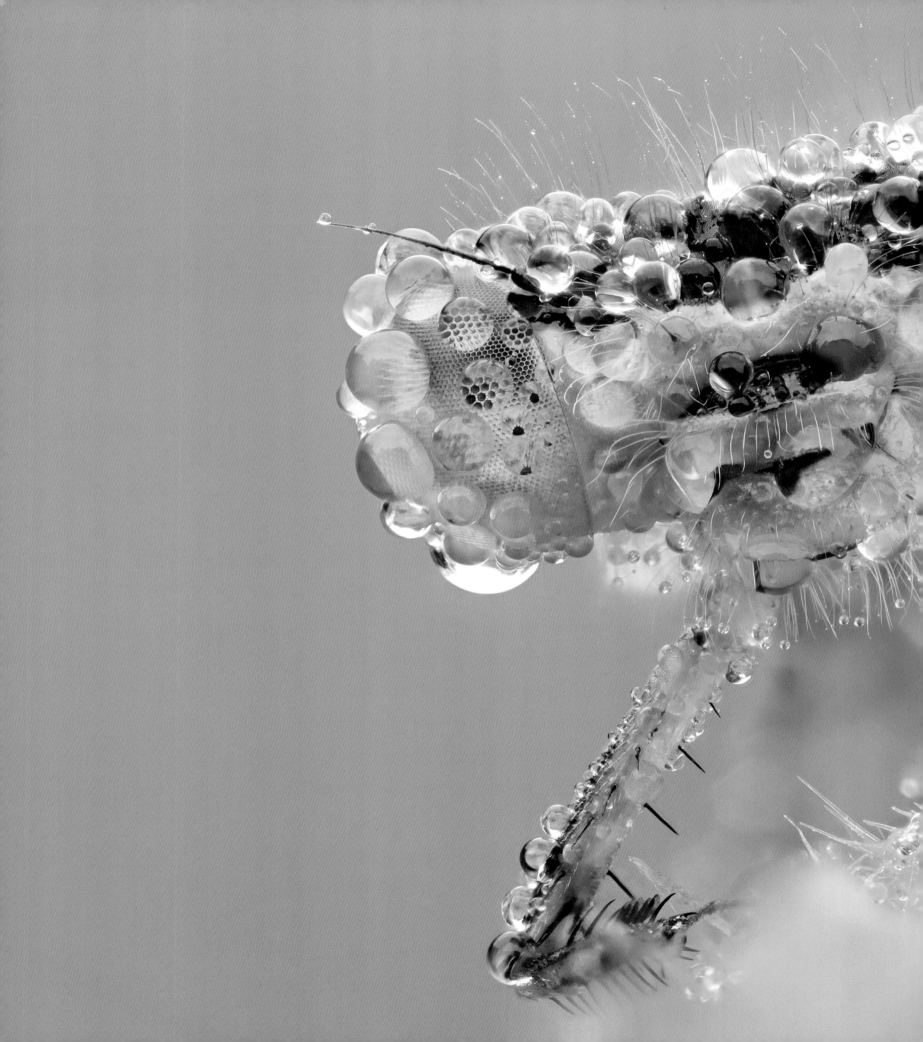

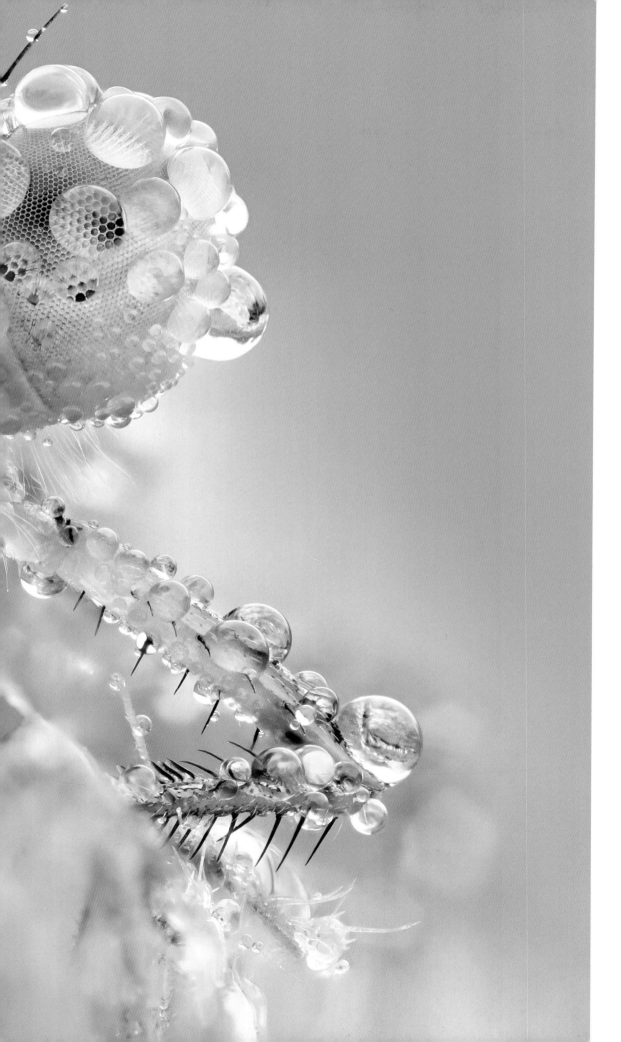

Damselfly *Zygoptera*

Body length: 30 mm | Södermanland (Nackareservatet Nature Reserve), 52 exposures

This damselfly is completely covered with water droplets. Larger dragonflies have multifaceted eyes that touch (or almost touch), while the eyes of the smaller damselflies are completely separated from each other. Before a damselfly settles down for the night, it finds a blade of grass that is wide enough to hide its body but still narrow enough for its eyes to stand out on either side, giving it an unobstructed view of all directions.

 Syrphid fly *Sphaerophoria scripta*
Body length: 7 mm | Södermanland (Nackareservatet Nature Reserve), 30 exposures

The black-and-yellow striped abdomen of this hoverfly is long; much longer than the wings when they are folded back. The syrphid fly can be found in meadows, rocky areas, and gardens that have plenty of flowers. It usually flies at a low altitude in habitats that contain mixed grasses and herbaceous vegetation.

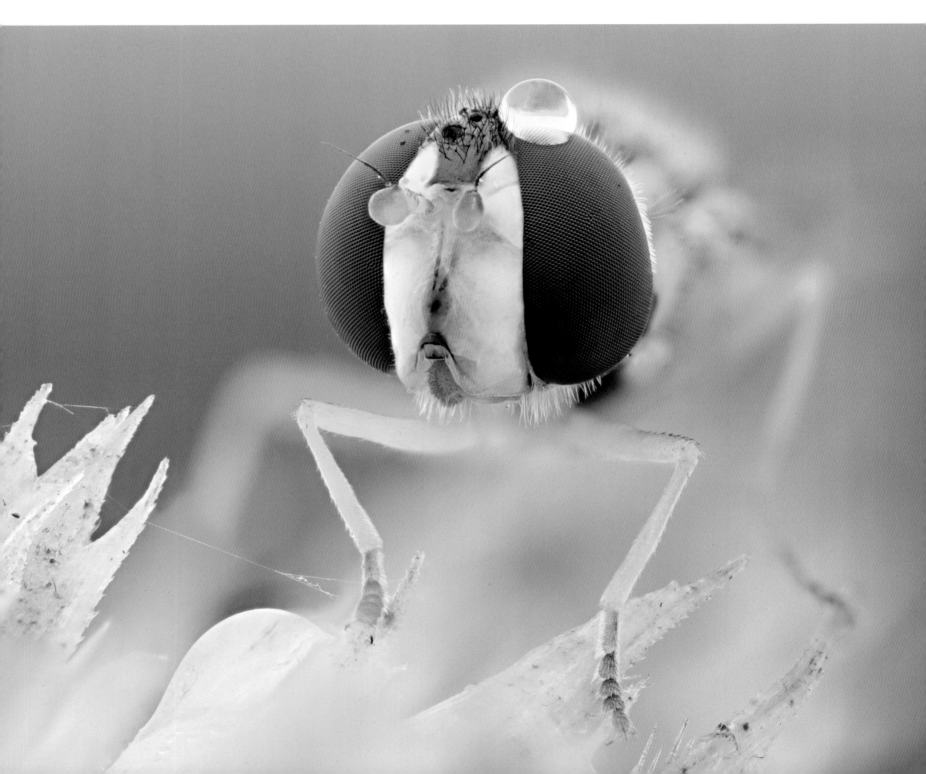

Robberfly *Tolmerus atricapillus*
Body length: 18 mm | Öland, 81 exposures

In adult insects, the multifaceted eyes can cover large areas of the head. This tends to be the characteristic with species that need perfect vision, such as those that fly fast and prey on other bugs. The curved surface of the eye makes it possible for insects to look in several directions at once, making it easier for them to find prey but to also avoid becoming prey themselves.

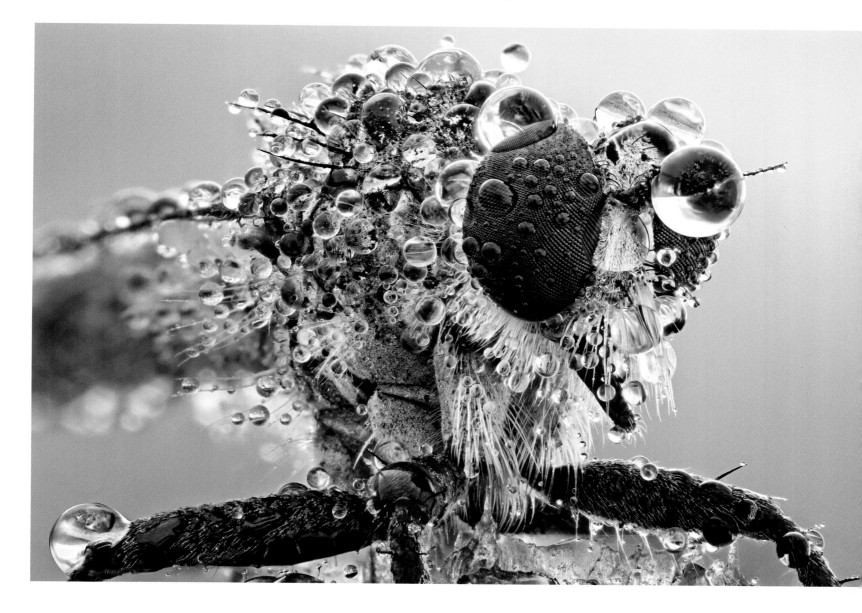

WITHIN THE WORLD OF INSECTS, one can find two different types of eyes: the multifaceted (compound) eyes and the single eyes. Compound eyes consist of a collection of closely adjacent individual eye units, which seen from the front appear hexagonal in shape. Each unit measures the light from a specific direction and is equivalent to a dot in a printed image. Any single unit does not perceive an image of its own, but it is the information collected by all units combined that gives the completed image. Few insects are blind in the sense that they have no eyes, but a life in darkness—a cave for example—has for some species resulted in a total reduction of eyes.

The final image perceived by the insect is probably exactly the same as the one we see with our own two eyes. However, because their eyes are so small, they cannot see as well as we do. The number of eye units varies from species to species, from some having none or a few, as seen in dark-dwelling insects, to nearly 30,000, as seen in some species of dragonfly. The main purpose of the compound eye is to react to movement, but it is not made to comprehend shapes. Insects do perceive color with an astounding accuracy, especially the flower-seeking ones. To be able to perceive colors, the eye must have receptors that are sensitive to light of different wavelengths. The visual spectrum for us humans allows us to see all the colors from violet to red. On either side of our visual spectrum there are additional wavelengths that cannot be experienced by the human eye, but that the insects are able to see. This spectrum includes ultraviolet light. Many flowers that depend on insects visiting for pollination have an ultraviolet pattern that is invisible to us but helps the insect find its way to nectar nearby. Some insects, such as bees, can see the polarization of light. Sunlight is polarized when it's reflected against the sky and differs depending on the angle of the sun. Bees can therefore determine the position of the sun even on a cloudy day, if only a small patch of blue sky is visible.

Slender fly (no English name) *Neurigona quadrifasciata*
Body length: 7 mm | Studio, 130 exposures

The *Neurigona quadrifasciata* looks like a mosquito, but is in fact a slender fly with long, thin legs. Being predators, they need to see well, which explains why their eyes are large and wide apart. They prey on small invertebrates, often smaller flies. When mating, the male approaches the female from behind, stretches out his forelegs, and courts the female by waving his black feet right in front of her eyes.

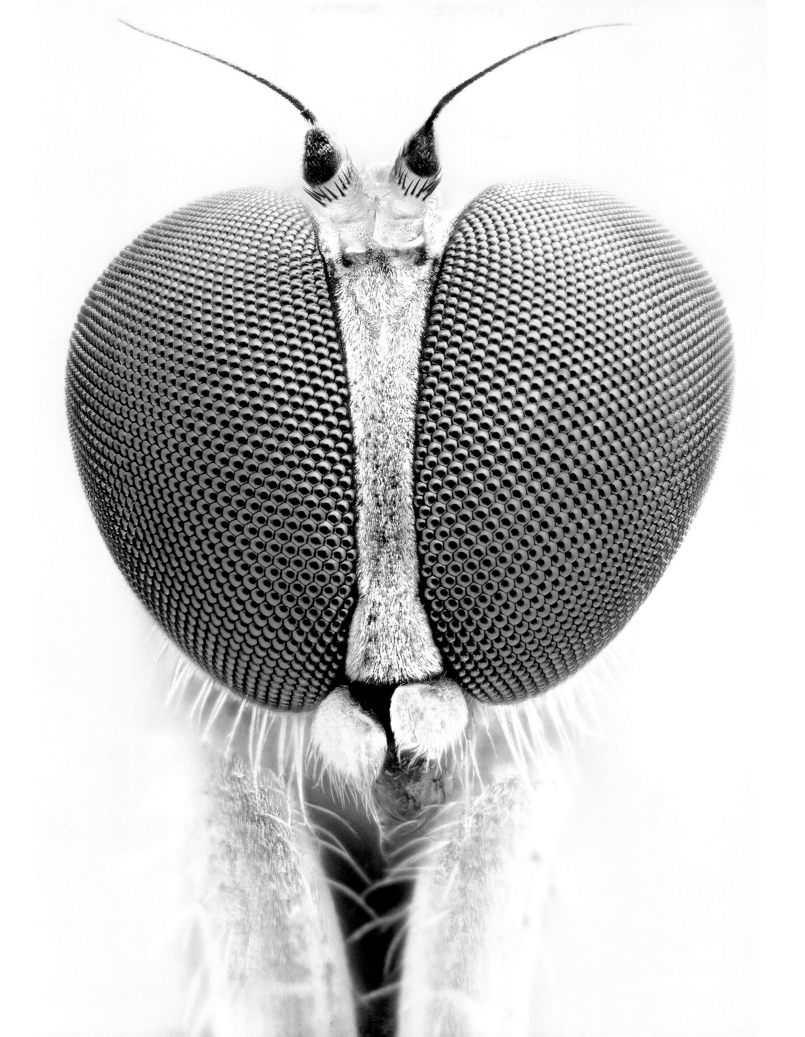

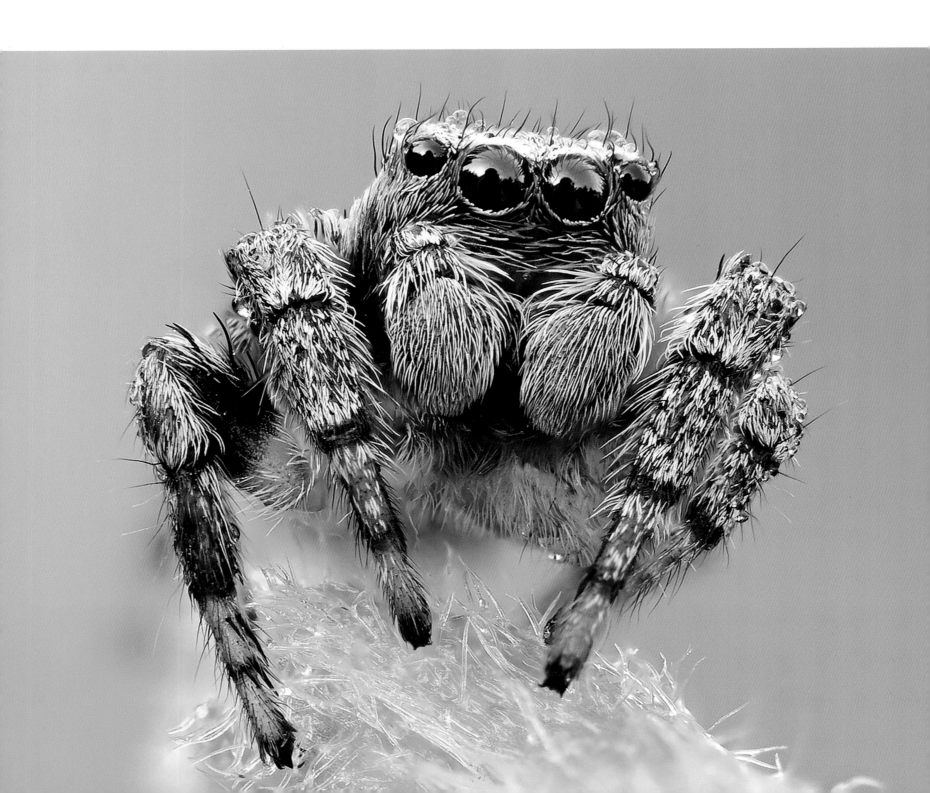

Aside from the compound eyes, insects also have several "simple eyes." The simple eyes consist of a lens and a quantity of light-sensitive cells. There are often three of them situated on top of the insect's head, but they do not give a clear vision of an image. The purpose of the simple eyes is not entirely clear, but because of the wide angle they are most likely used as a sort of light meter that tells the insect if it is flying up or down. When the insect is flying downward the simple eyes register the darker surroundings, and when flying upward they make everything brighter.

 Jumping spider *Salticidae*
Body length: 5 mm | Södermanland (Nackareservatet Nature Reserve), 13 exposures

The eyes of the spiders are not like the compound eyes of most insects. Rather, they are made up of smaller units that usually have a lens and retina, and operate just like our eyes. Most spiders have eight eyes, but you can also find spiders with four or six. All eyes are not used to see the same thing, as some react to movement while others are used as a compass or to enhance color and observe the surroundings so that the spiders themselves don't become the prey. Spiders that actively hunt usually have two larger eyes that are located on the central part of their head. The forward-looking pair of eyes picks up all the details in the surrounding environment. Spiders that catch their prey with webs have smaller or fewer eyes.

Marsh ground beetle *Elaphrus riparius*
Body length: 7 mm | Studio, 120 exposures

The marsh ground beetle is an excellent hunter that preys on short-wing and beach-digging beetles. Its eyes are much wider than its neck shield, giving it a wide field of view. The marsh ground beetle is an active, sun-loving species that cannot tolerate shade. It's active on sandy beaches near stagnant or slow-flowing water and can often be found running along the water's edge.

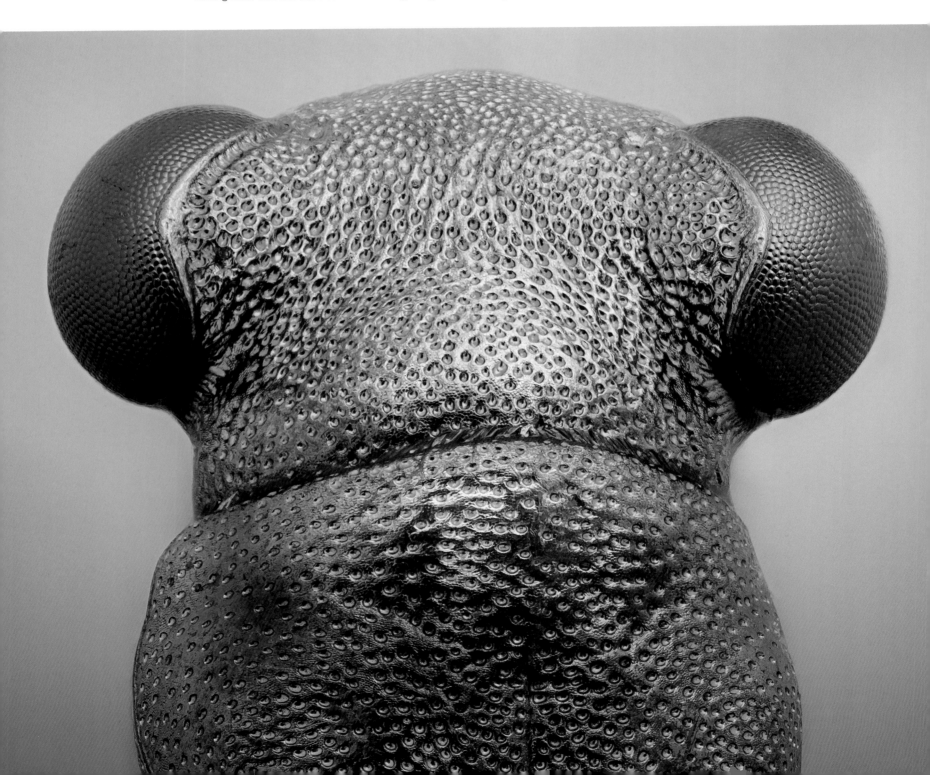

Common-snout hoverfly *Rhingia campestris*
Body length: 8 mm | Studio, 172 exposures

The common-snout hoverfly's extended beak places it in the family of hoverflies/flower flies. Adult males live on nectar while the females feed on protein-rich pollen. The common-snout hoverfly is a medium-sized species with a long, drawn-out bill. The bill safely cases its extremely long tongue, which allows the fly to reach deep into flowers for normally hard-to-reach nectar.

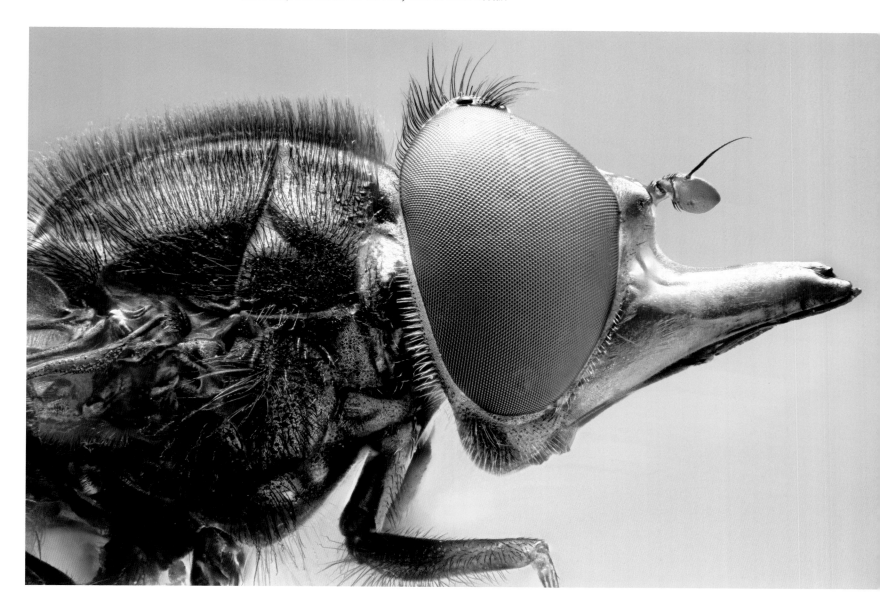

Yellow meadow ant *Lasius flavus*
Body length: 4 mm | Studio, 150 exposures

The yellow meadow ant is a species that doesn't have to see particularly well. Rather than relying on their sight, they "see" by smelling, as they almost exclusively live underground. Its antennae have odor receptors, which allow it to navigate and find its way underground.

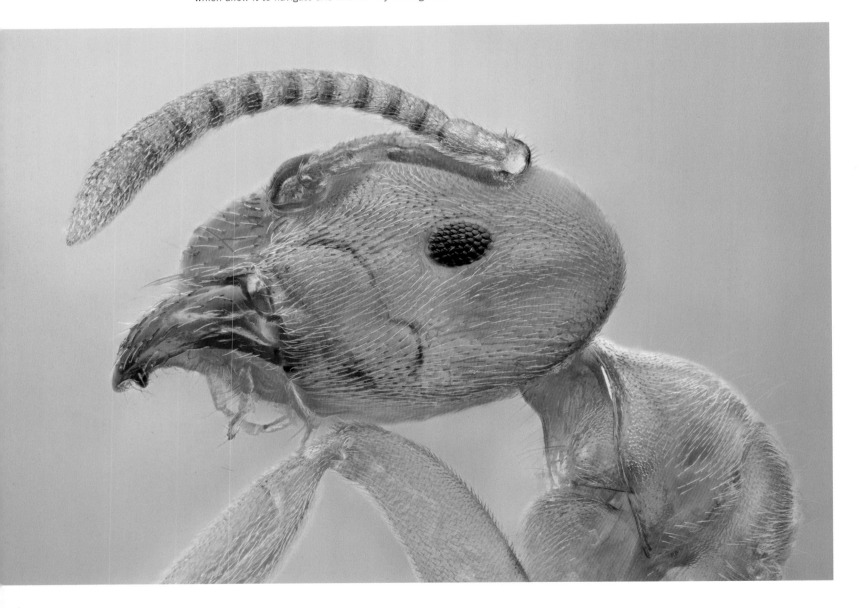

 Carpenter ant *Camponotus* sp., ♀ eye
Body length: 10 mm | Studio, 80 exposures

The carpenter ant prefers to live in damaged trees, stumps, and logs found on the ground. Even if one can find the occasional ant during the day, they are most active during the night, hence the reason why their eyes have relatively few facets. The males have small heads with large, protruding compound eyes that are mostly used to locate females during mating season. Females have larger heads than males but smaller, less-protruding compound eyes. The ants are in constant communication with each other and do so by using pheromones (fragrances) that control the cohesion within the community, which makes up for their lack of stellar eyesight.

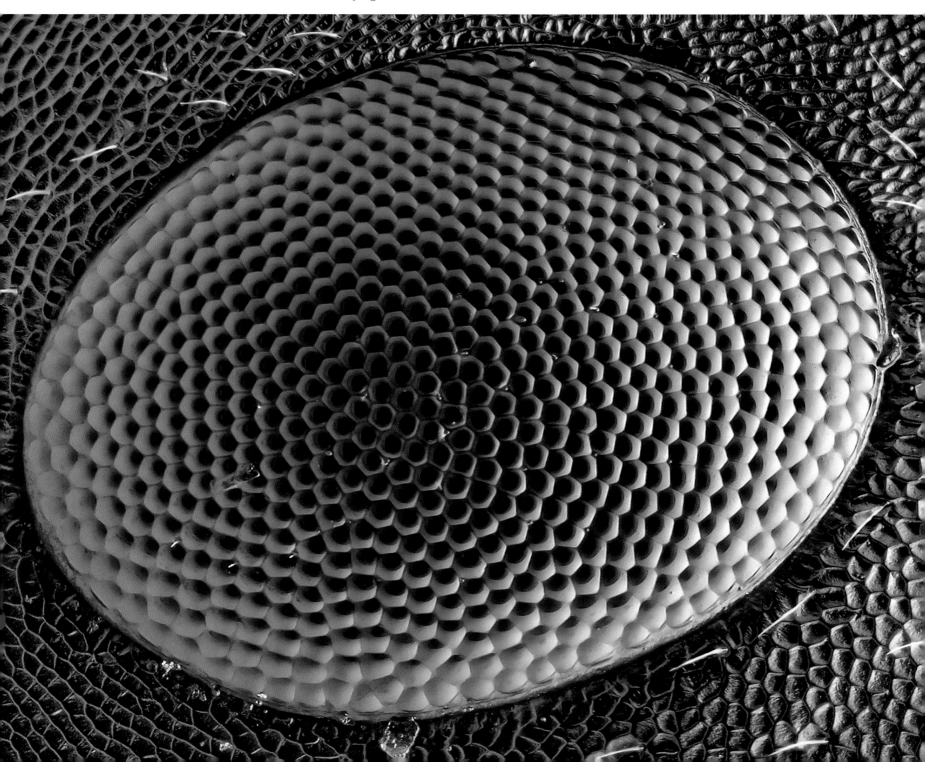

Whirligig beetle *Gyrinus substriatus*
Body length: 8 mm | Studio, 299 exposures

The compound eyes of the whirligig beetle are
divided into two parts. The beetle resides on the
surface of the water, and the upper part of the eye
is used to see above while the lower part is used to
see below the water's surface.

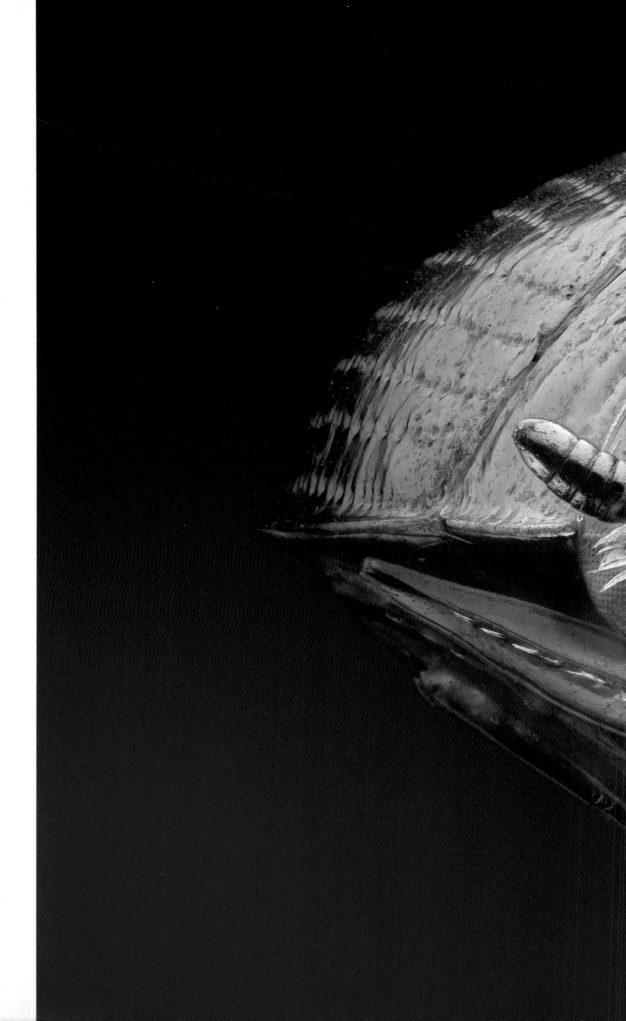

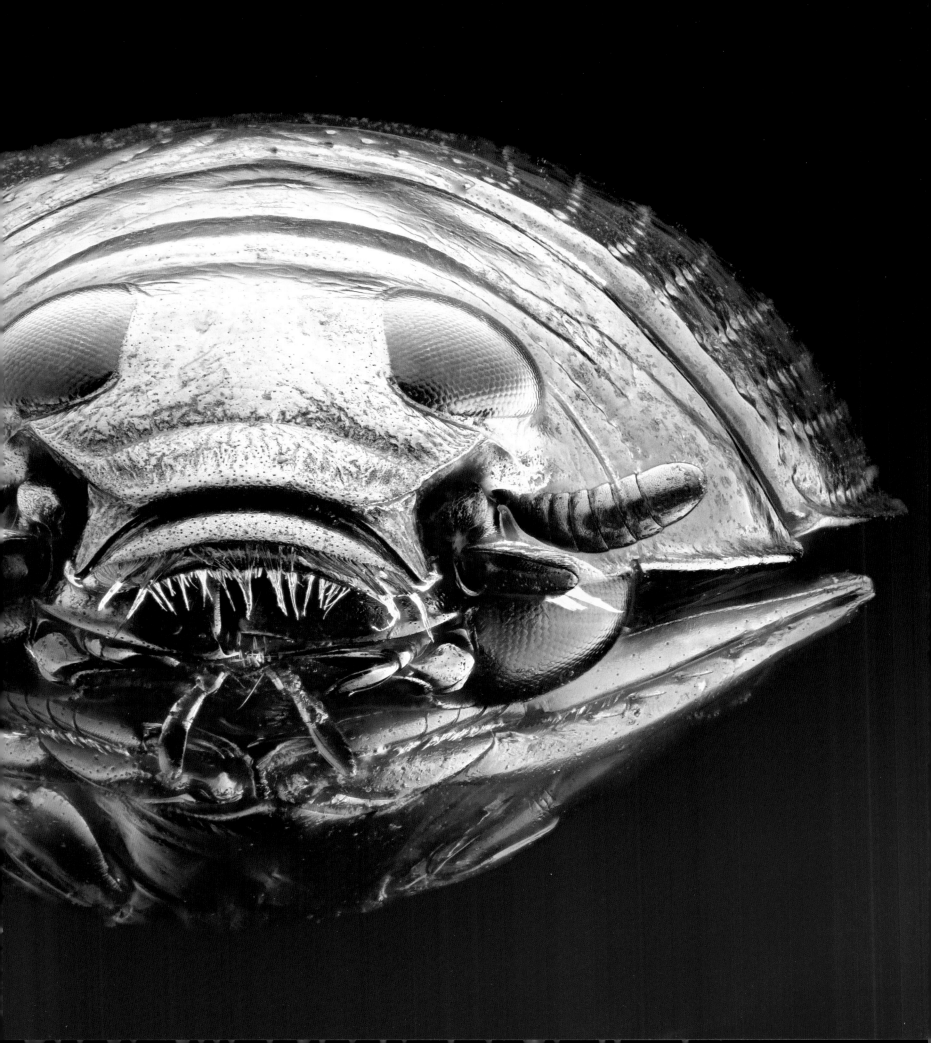

Variable damselfly *Coenagrion* cf. *pulchellum*
Body length: 30 mm | Södermanland (Nackareservatet Nature Reserve), 26 exposures

This species of damselfly consists of predators that usually sit and wait for their prey, but can also grab insects that slowly fly around. Their round eyes are situated widely apart and are completely different from one another. It is still not known why some species have a darker upper section on the compound eyes, but it's assumed that the darker color protects against the sun or strong light. Many of the species of damselflies are difficult to determine, but it is possible that this is an image of a variable damselfly.

(cf. stands for "confer," which means that the species has not been definitively identified)

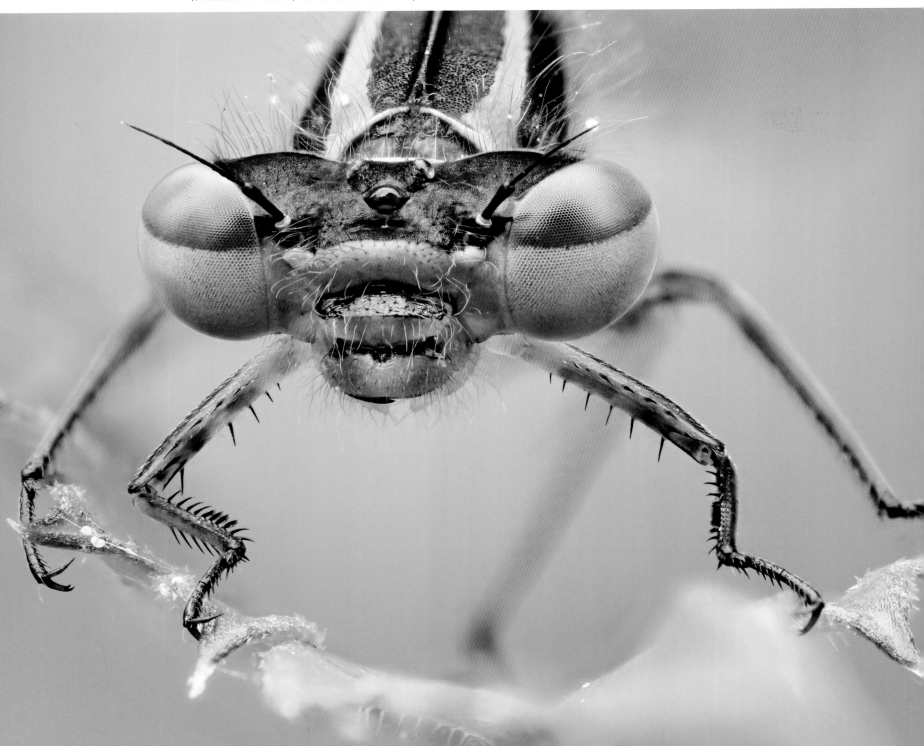

Band-eyed brown horsefly *Tabanus bromius*
Body length: 14 mm | Uppland (Väddö shooting range), 1 exposure

This species of horsefly is large with rugged, stabbing mouthparts and colorful, bulging eyes. The lenses of their compound eyes are not always the same size, as the males have large facets in the upper part of the eye, where the two eyes meet, while they are separated on the females. It is unclear why the surface of their eyes shimmer in all the colors of the rainbow, but one hypothesis is that the shifting surface filters the light to improve contrast. It is believed that the colors could also have a sexual meaning. It is only the females that suck blood, while the males live mainly off of nectar. The band-eyed brown horsefly is fast and can reach speeds of up to 60 km/h.

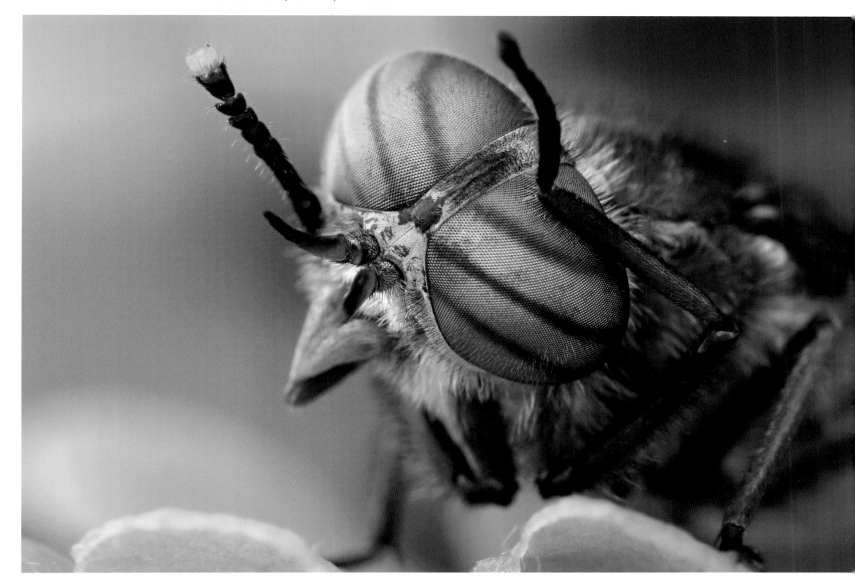

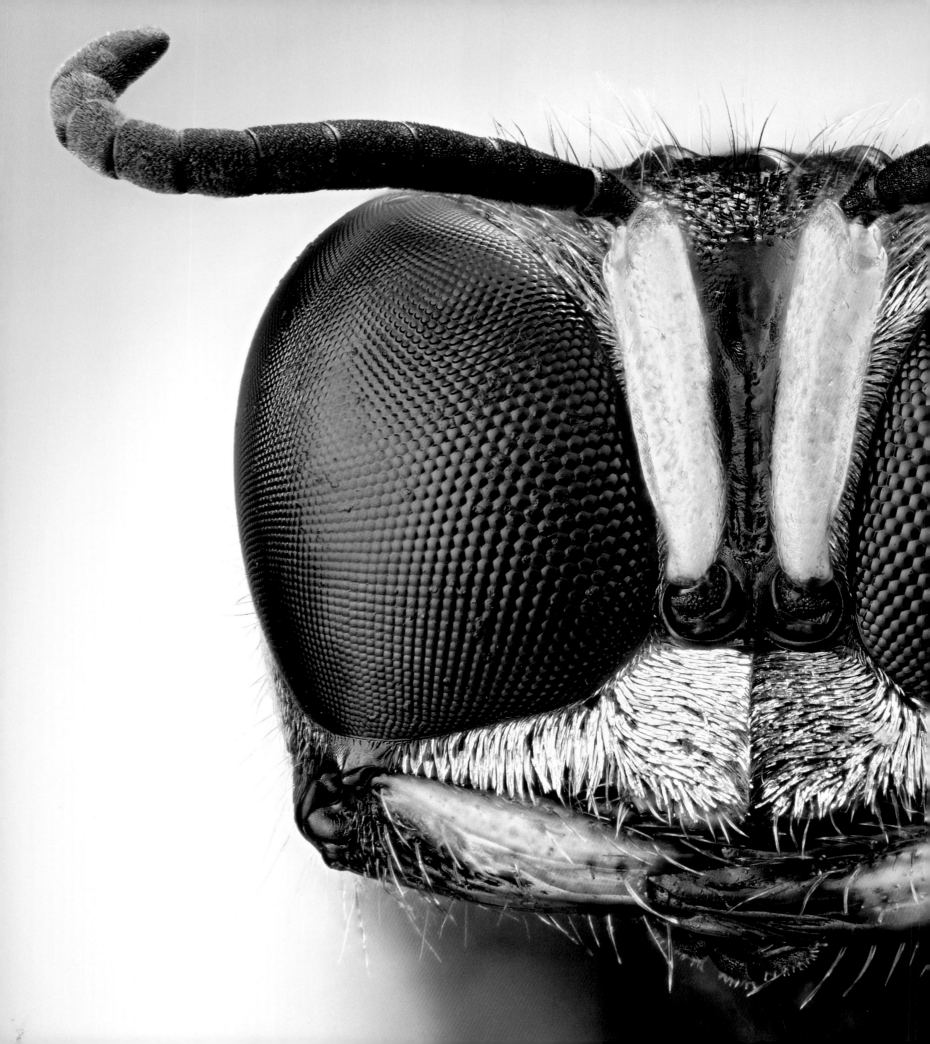

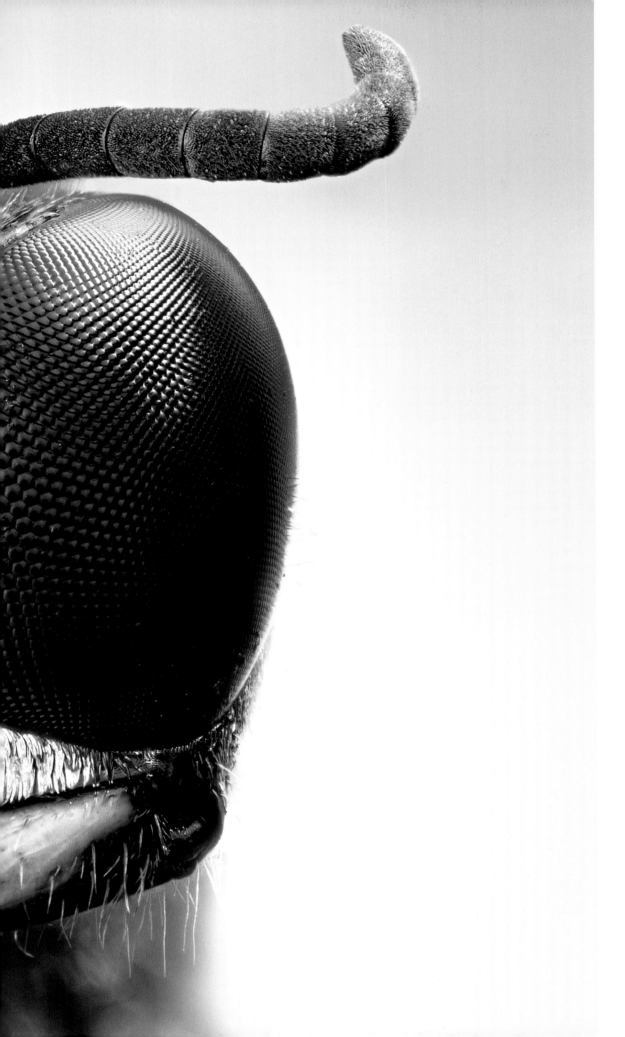

Square-headed digger wasp *Ectemnius* sp.
Body length: 10 mm | Studio, 76 exposures

The square-headed digger wasp needs to have great eyesight, as it hunts flies to feed the nest's larvae. The caught flies are injected with a paralyzing poison and then carried to existing cavities in trees (usually excavated by beetle larvae). The flies then serve as live food for the wasp larvae. Adult males and females feed off of nectar and pollen. Because of the silvery hairs on its mouth shield, it's also known as the silver-mouthed wasp.

31

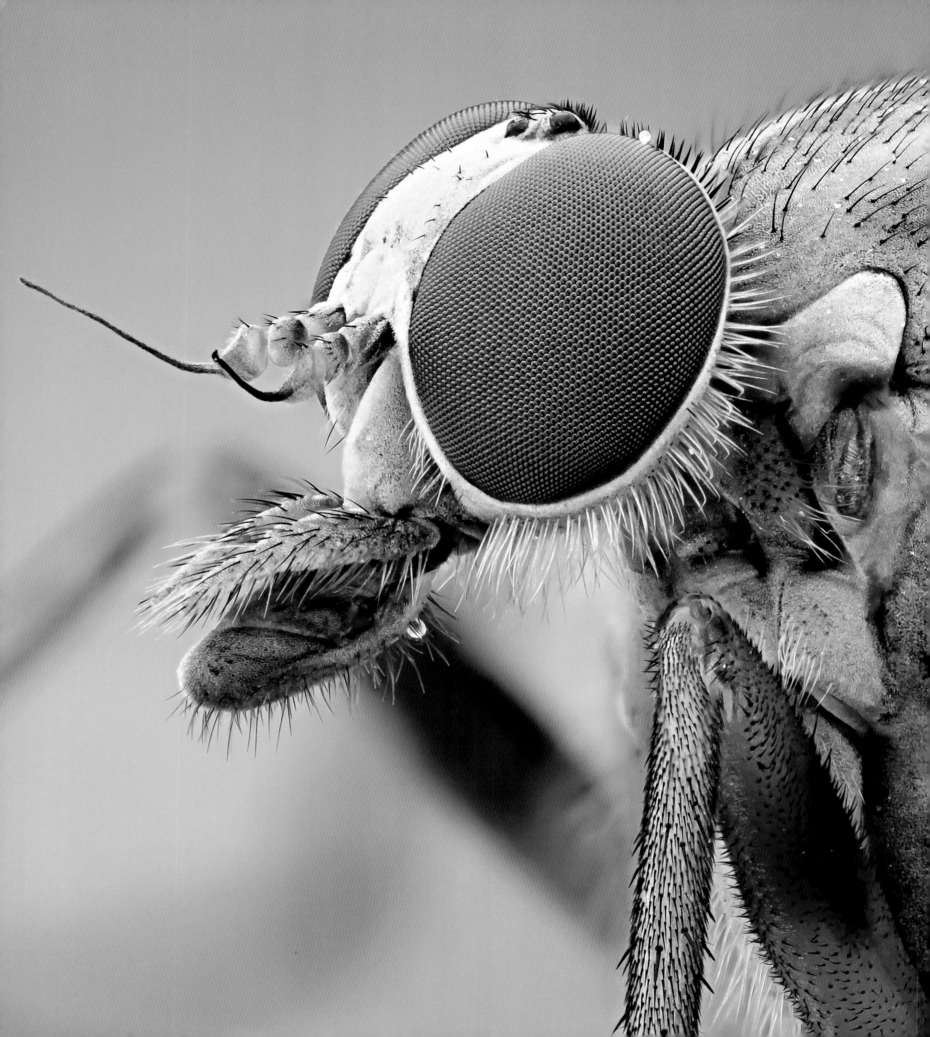

◄ **Downlooker snipefly** *Rhagio scolopaceus*
Body length: 13 mm | Södermanland (Nackareservatet Nature Reserve), 38 exposures

The eyes of the male downlooker snipefly are usually situated together and its mouthparts are quite fleshy. Downlooker snipeflies are a species of predatory flies that hunt smaller invertebrates. They can often be found sitting in damp environments, preferably on protruding leaves.

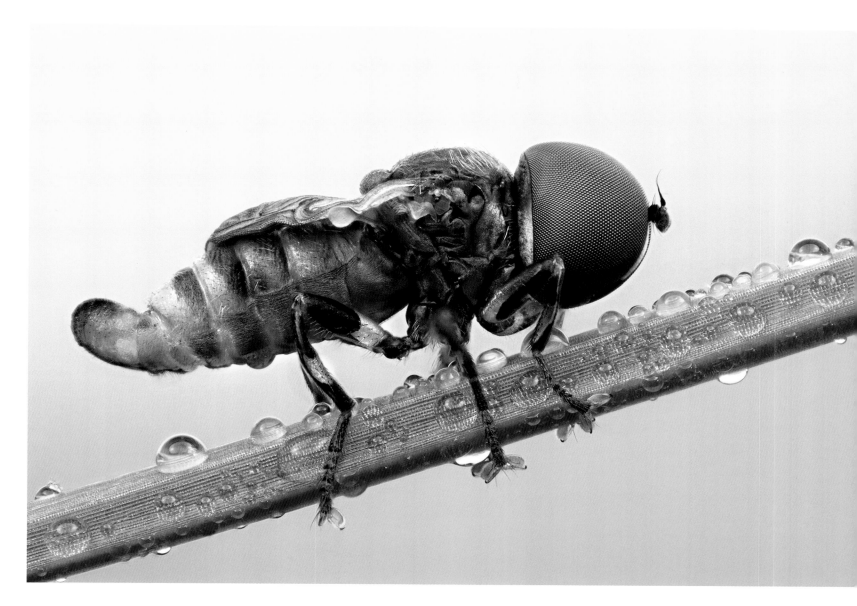

 Big-headed fly *Pipunculidae*
Body length: 4 mm | Södermanland (Nackareservatet Nature Reserve), 9 exposures

Almost the entire head of the big-headed fly consists of its eyes. Their large eyes likely play an important part in locating a suitable host in which the female can lay her eggs. The fly in the picture above is newly hatched and has yet to unfurl its wings. Soon it will be pumping out liquid in them so that they become long and narrow. The flies hover among flowers in search of accessible nectar and also around bushes, where they hope to find honeydew (i.e., sugary aphid excrement).

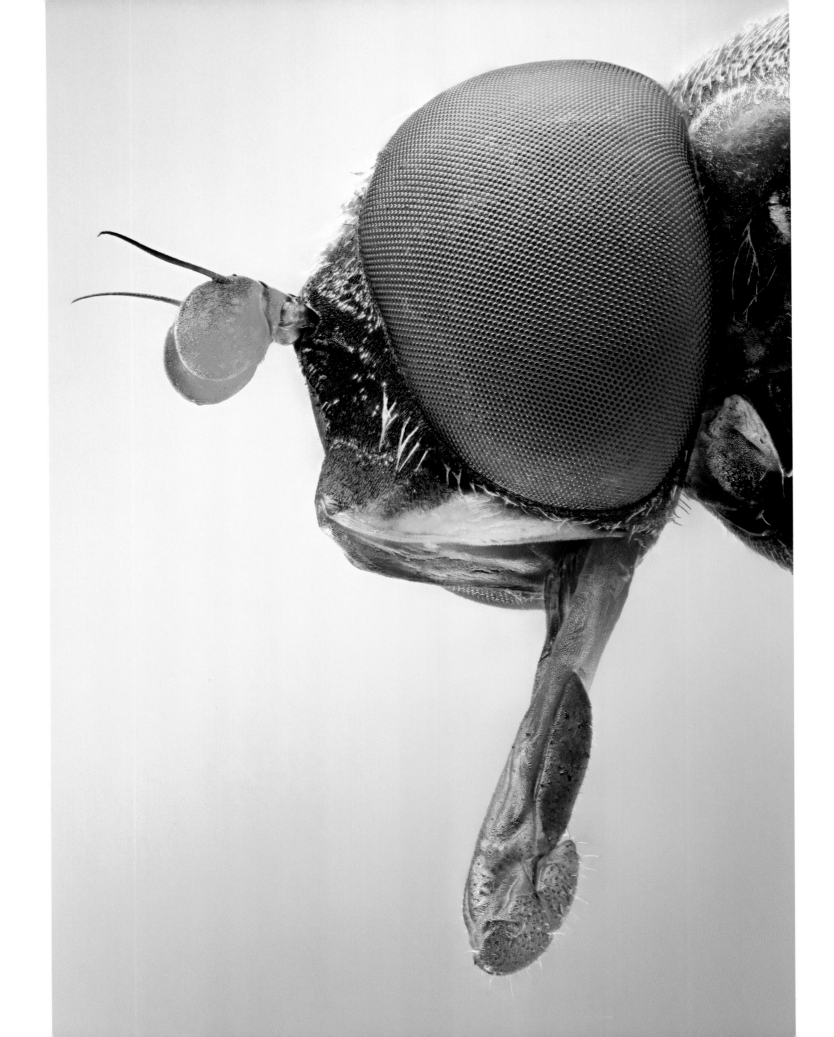

THE ORIGINAL INSECT was an omnivore and had a mouth that bit and chewed. Today we can find similar mouthparts on other insects, like cockroaches. During the course of evolution, a variety of mouth types have emerged. Often the designs of different mouthparts are characteristic of a genus, family, or order. Having the knowledge and familiarity of this is of great help when trying to classify and identify these types of insects. We usually associate the mouth with how the insect eats, but these differences can also have other functions. In particular, the upper and lower jaws can serve many purposes. They can be used as a defensive weapon, in competitive situations, or as a tool for digging. Their jaws are also highly resistant to mechanical as well as chemical influences.

The mouthparts are designed differently depending on how the food is ingested—in solid, liquid, or, in several cases, both forms. The biting mouth has similarly developed in herbivores and carnivores. It can be seen in the order of *Orthoptera*, where the predatory bush crickets and the plant-eating locusts have similar mouthparts.

Stinging and sucking mouthparts have developed in insects that feed on liquid and sometimes hard-to-access nutrition. To be able to reach the sustenance needed to survive, these insects must almost drill themselves into the tissue of either a plant or animal. The most advanced types of these mouthparts are extremely complicated, and can be found in insects such as mosquitoes.

Certain species don't eat during their adult stage and, as a result, all of their mouthparts have regressed.

 Thick-legged hoverfly *Syritta pipiens*
Body length: 8 mm | Studio, 189 exposures

The thick-legged hoverfly's mouth is designed to lick and suck up food. The tongue can be found on the tip of its more or less pourable, tube-like mouthparts. Using this, the fly can pick up pollen grains and other nutrients.

Apple fruit weevil *Neocoenorrhinus aequatus*, ♀
Body length: 4 mm | Studio, 121 exposures

The apple fruit weevil uses its highly specialized mouth-parts to notch leaves with precision. They cut, or rather bite, through the leaf from the edges until they reach the midrib. Afterward they can roll the lower part of the leaf in a cone-like fashion. The female then lays her eggs inside the leaf roll, which keeps the eggs and larvae protected against predators.

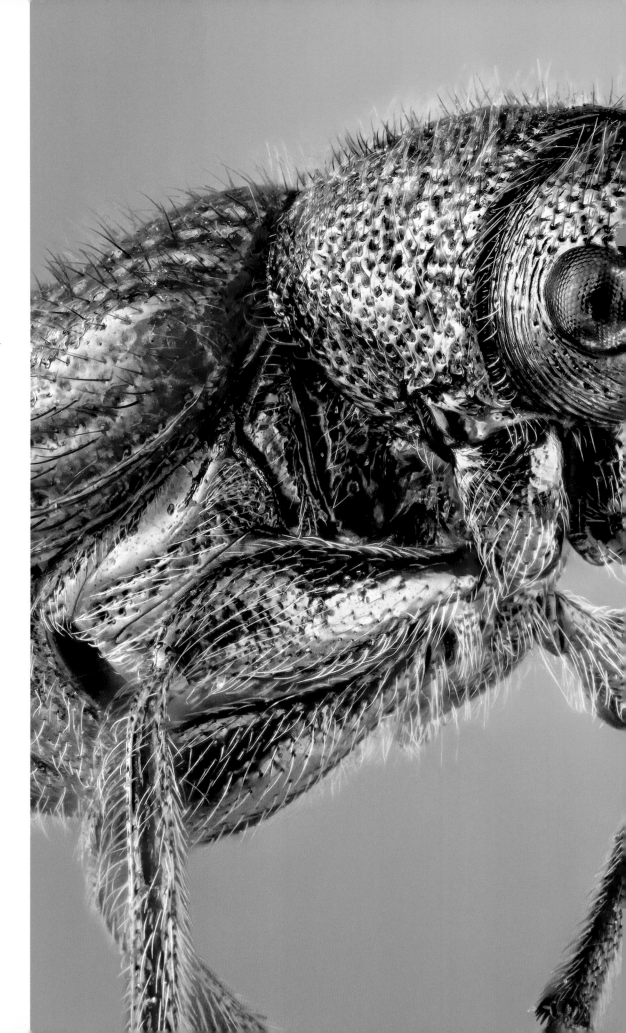

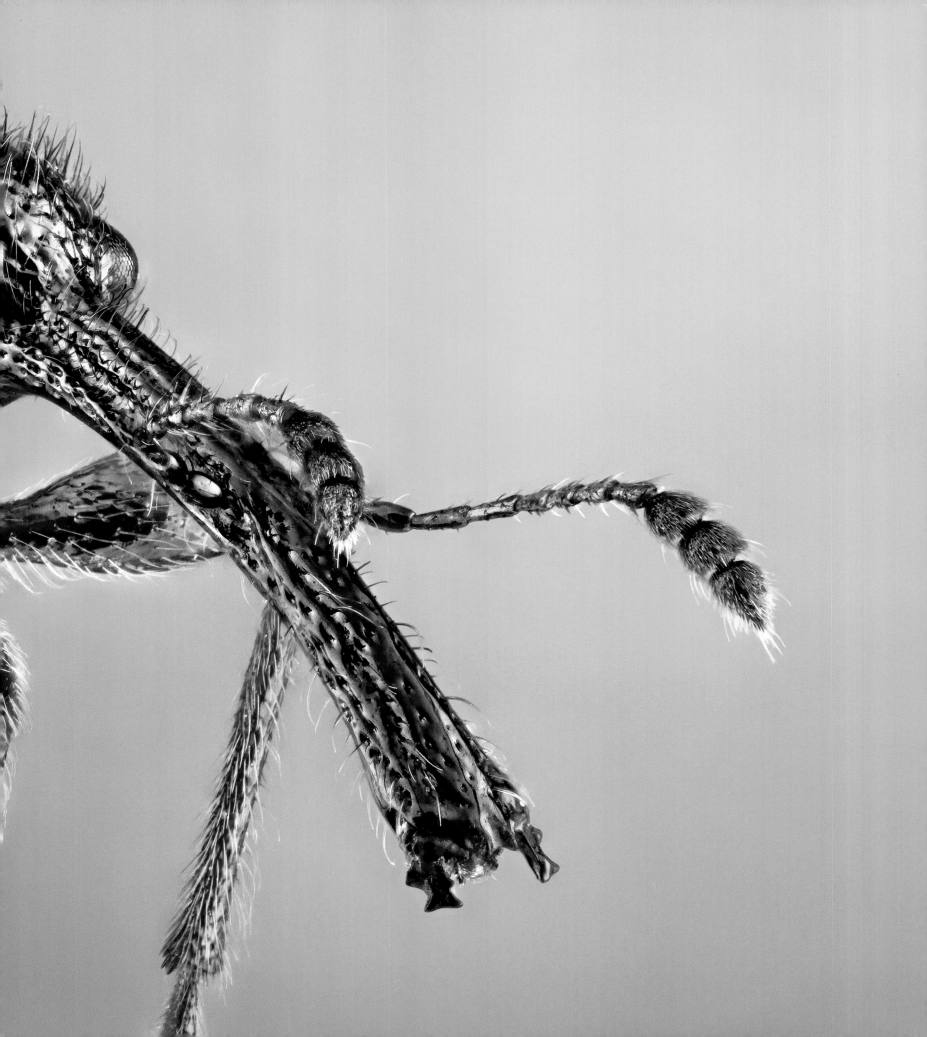

Apple fruit weevil *Neocoenorrhinus aequatus*
Body length: 4mm | Studio, 89 exposures; (opposite page) Uppland, 18 exposures

In this image is the extended muzzle of a female apple fruit weevil, which is wider toward the tip and longer than the head and the body together. The male's muzzle is only slightly broadened and is as long as the head and the body together. Apple fruit weevils are different than most weevils because of their extended muzzle. Nowadays regarded as a distinct group, they are separated from the weevils, as their antennae are straight and all the antennae segments are approximately equal in length. Other weevils' antennae, however, usually lie down with a long handle at the back.

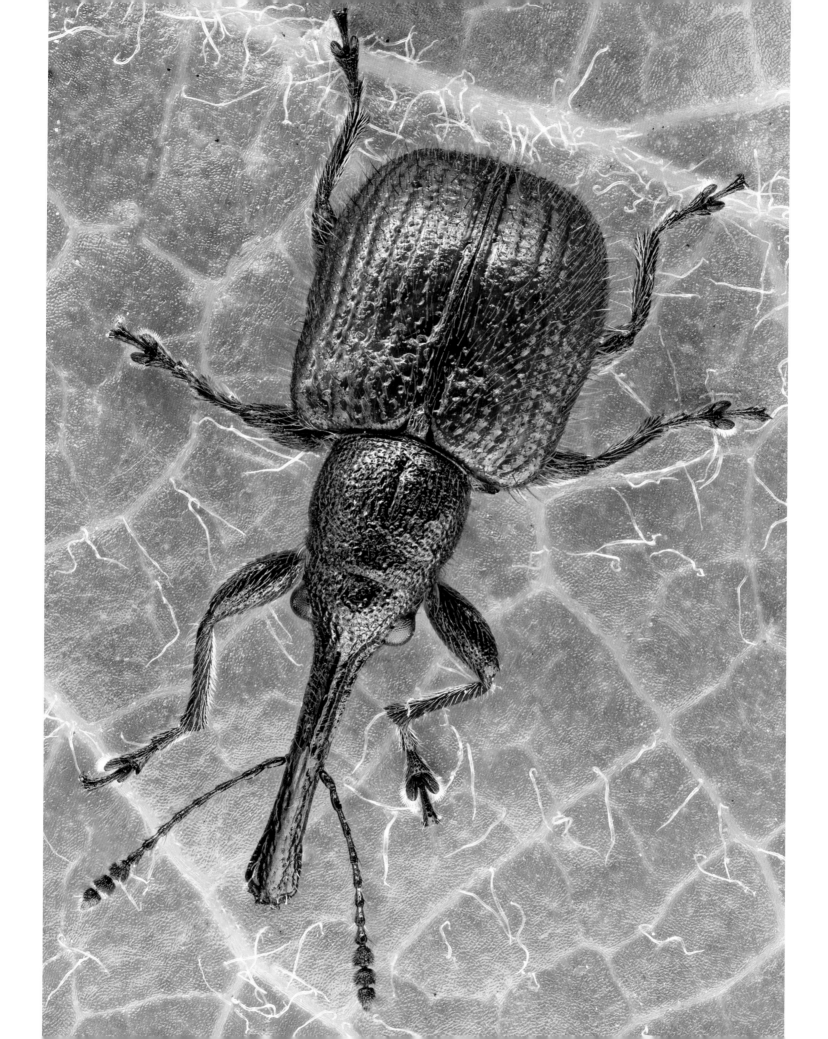

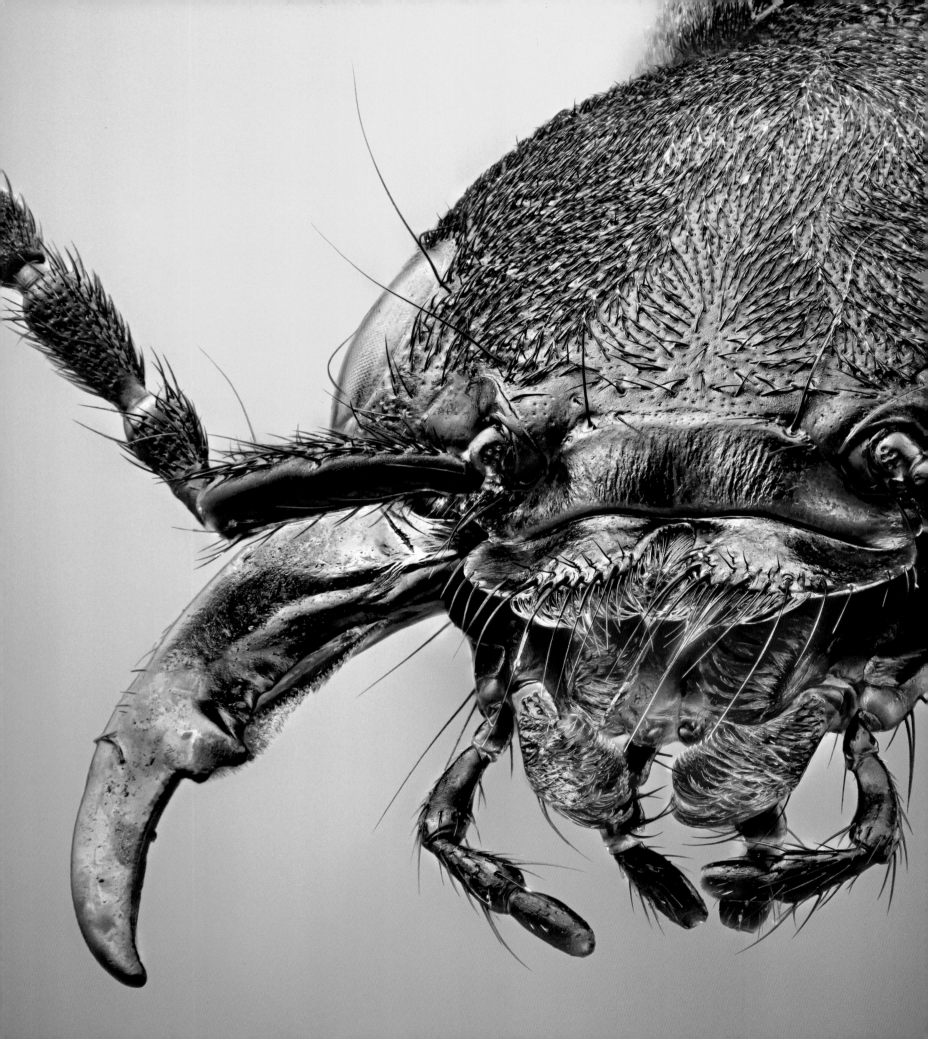

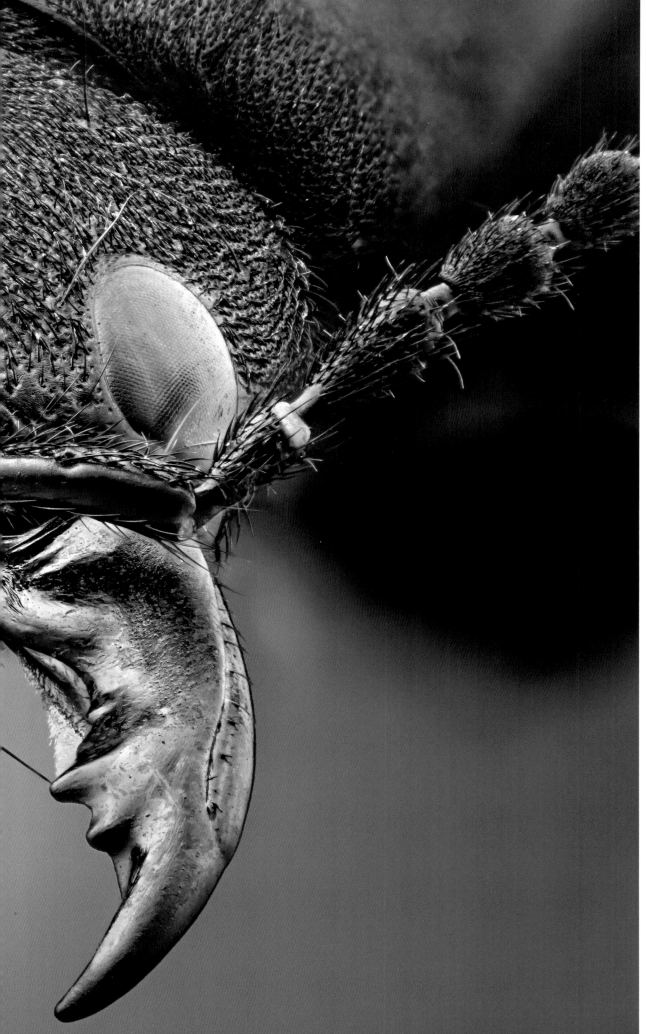

Devil's coach-horse beetle *Staphylinus olens*
Body length: 27 mm | Studio, 203 exposures

This devil's coach-horse beetle is a predator, which can be seen by its sharp, pointed, and jagged upper jaws. It's nocturnal and mainly hunts insects, earthworms, and isopods. It catches its prey with its jaws and, with the help of its front legs, chops up and manipulates the food into a small ball. This ball is chewed, swallowed, and regurgitated repeatedly until it's reduced to a semi-liquid pulp that's easily digested. All mouthparts, apart from the tongue, can be seen in this image. The thin and flexible palps are situated in the center. At the base of the palps you can see the lower lip and jaw (mandible), which are a rusty red color. The crooked, jagged jaws are widely splayed. Between them, at the very front, you can see the hairy, bristly upper lip.

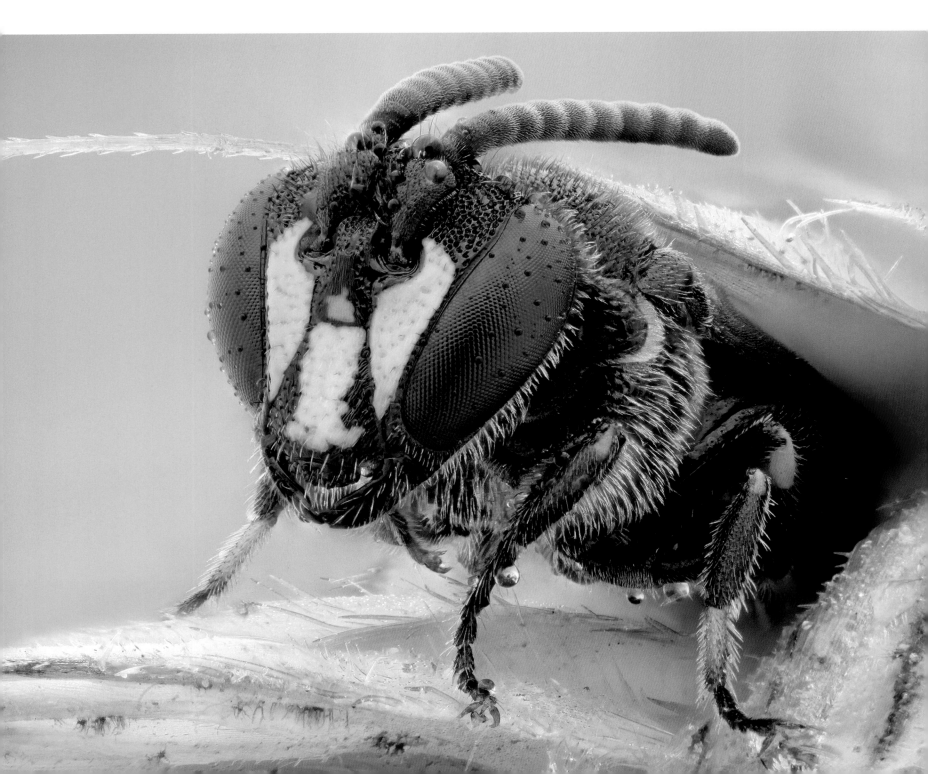

Yellow-faced bee *Hylaeus communis*
Body length: 4 mm | Södermanland (Nackareservatet Nature Reserve), 126 exposures

The yellow-faced bee's mouth has evolved and is designed to chew and lick, a way of transferring nutritious liquid from a plant to its mouth by using its tongue. The yellow-faced bee builds its nest in cavities above ground. They often utilize existing cavities created by beetle larvae digging themselves out from the wood of trees. The bees are also known to nest in woody herbs and shrubs, like the raspberry. With their strong jaws, they hollow out twigs, creating holes where the female can lay her eggs.

Musk beetle *Aromia moschata*
Body length: 26 mm | Uppland (Väddö shooting range), 1 exposure

These beetles have rugged jaws that connect to the long maxillary palps and the somewhat shorter labial palps. If you touch a fully formed musk beetle, it might excrete a white fluid with a strong smell, hence its name. An adult beetle can be found crawling in the sunlight, on flowers, or in infested tree trunks. They feed from flowers with accessible nectar, like wild angelica, cow parsley, and oxeye daisies. They also eat ripe berries.

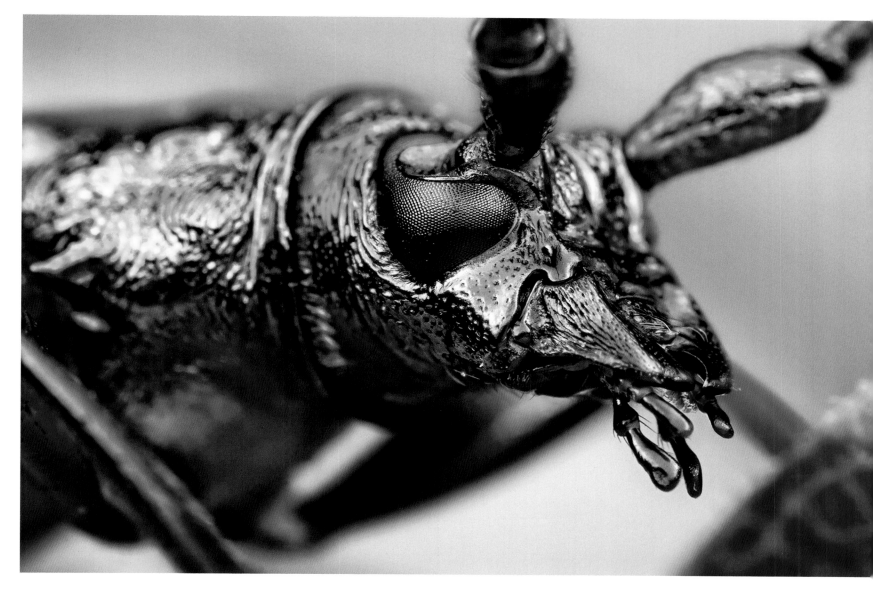

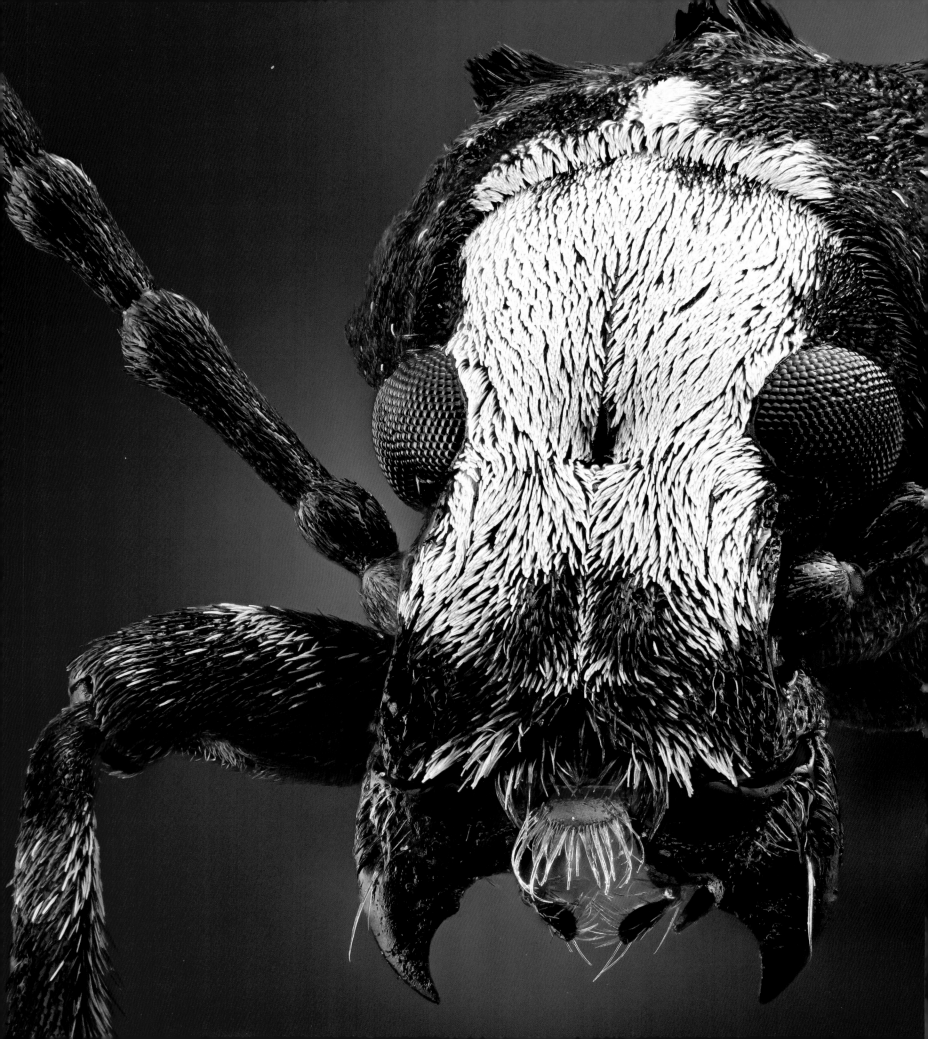

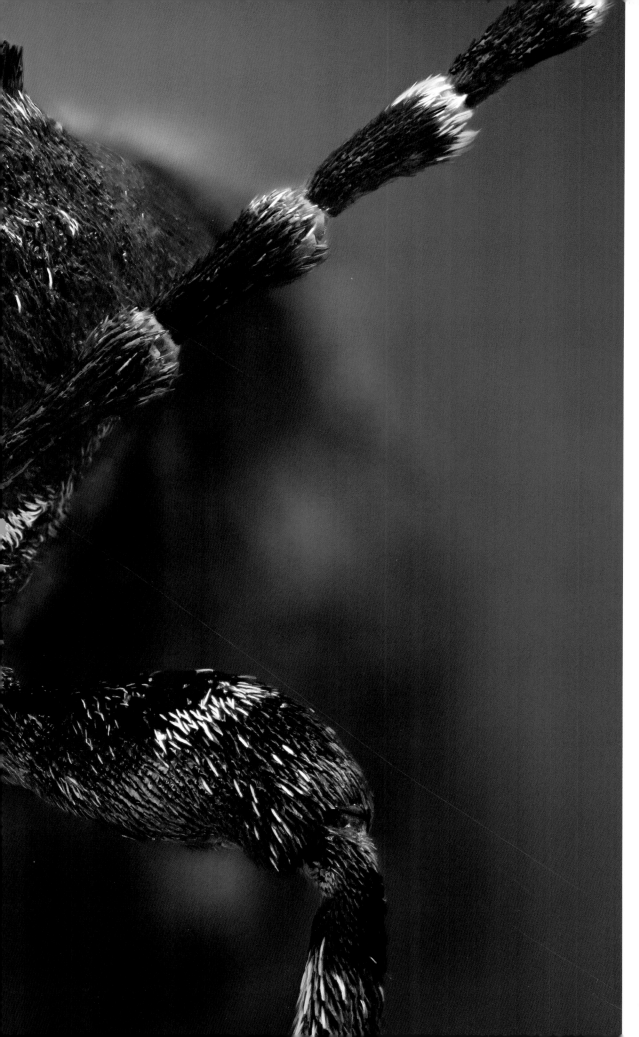

Fungus weevil *Platystomus albinus*
Body length: 7 mm | Studio, 247 exposures

The fungus weevil's upper jaw, lip, and palps are all clearly visible in this image. The upper lip looks like it's a separate segment, not connected to the mouth shield, and the lower palps are long and reaching forward. The head is extended into a wide and flat snout, hence the Swedish name, *plattnosbagge* ("flat-snout beetle"). These beetles are sometimes referred to as fungus beetles, as the adults feed on tree fungi and decomposing plants.

Idiocerine leafhopper *Idiocerus* sp.
Body length: 6 mm | Studio, 89 exposures

The mouthparts of the idiocerine leafhopper have evolved and adapted to stabbing certain parts of plants and sucking the liquid nutrition within. They use a needle-like tool that consists of a trunk with multiple joints. It is formed by the lower lip surrounding the tool in the shape of a furrow with two halves that meet at the front of the trunk. Inside the sheath there are two long, parallel bristles (the evolved upper and lower jaws). The bristles contain the salivary duct and nutrient canal. When feeding, the trunk is pushed at a perpendicular angle against the surface. When the tip of the trunk finds the appropriate spot, the idiocerine leafhopper can start sucking the juices of the plant.

Two simple eyes (ocelli) are situated on either side of the darker central portion of the indentations, giving the impression that two small brown eyes are surrounded by a greenish-yellow ring.

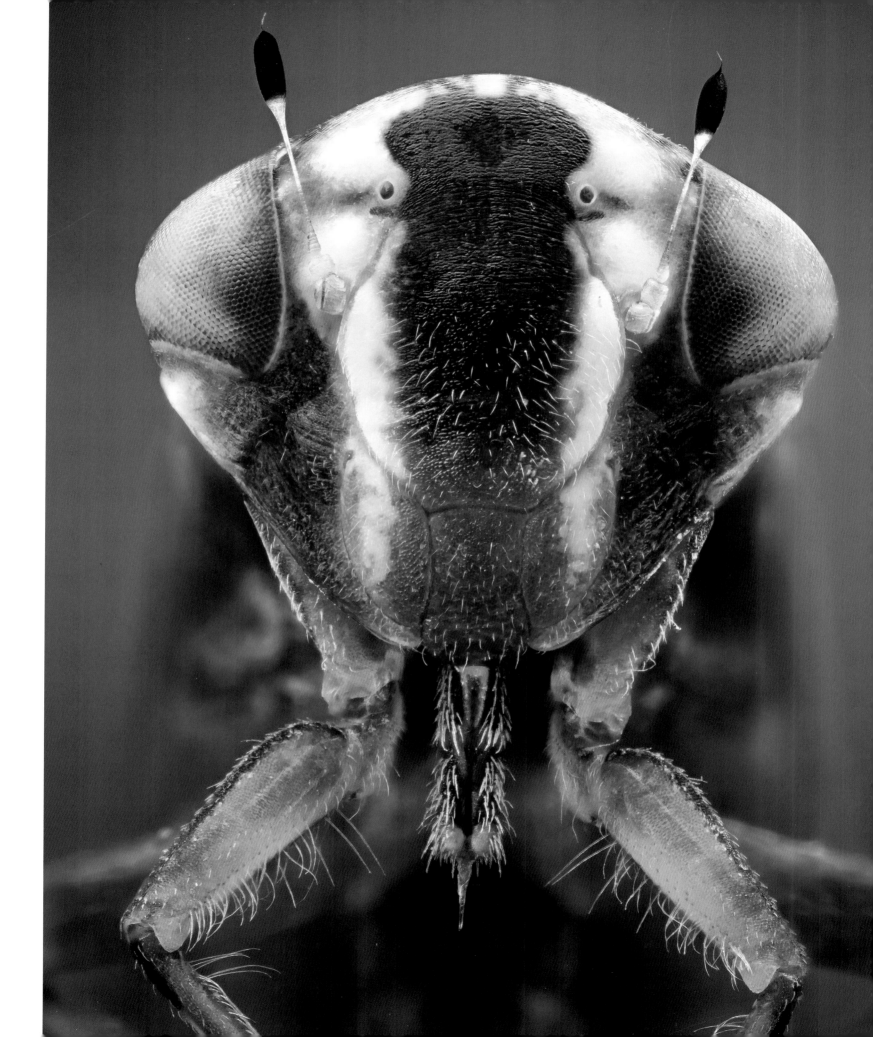

UNLIKE HUMANS, INSECTS don't have an inner skeleton.

Instead, their hard supporting parts are on the body surface and form a solid coat of armor. To maintain mobility, the body and limbs are broken into smaller parts, and the muscles so that the insects can freely move both their body and legs.

The result of these exoskeletons is a body insensitive to mechanical stimuli. Insects have certain organs that are designed to receive different forms of sensory information. These special receptors will forward information to the central nervous system.

Hair, bristles, and scales mainly respond to pressure and pain, but they are also for hearing and balance. Moderately developed tactile sensing hair—whiskers, if you will—can be found on almost all insects, especially on their antennae and legs. Extremely long whiskers can be found on insects that live in darkness and caves. The antennae are, in addition to their function for the mechanical senses, also used for smelling and tasting.

The insect's skin consists of a layer of cells that exude a cell-free layer of alternating thickness (cuticula). The main substance found in the cuticula is a nitrogenous polysaccharide (chitin), which is highly resistant to both mechanical and chemical influences. The hardening element of the cuticula is an albuminoid (sklerotin) stored within the chitin. The softer caterpillars can have a cuticula that is only 0.01 mm. To be compared with parts of hard-shelled insects, like the forewings on certain beetles, the cuticula can be almost 1 mm thick and serves as a protective armor.

Butterflies are characterized by their scales, covering not only their wings but also their bodies. In contrast to other forms of cuticula, the scales are always more or less flat. To put it another way, the scales on their wings have the same pattern as most roof tiles.

The color of the wing scales can either be induced by the pigments contained in the individual scales or by the pattern in which the scales are formed. The structure may consist of several thin layers of chitin or be shaped like a grid, with the results being that certain wavelengths are almost completely extinguished while others become gloriously clear. When it comes to signaling the surrounding world, colors created by texture significantly increase visibility and are superior to pigment colors.

Marsh ground beetle *Elaphrus riparius*, forewing
Body length: 7 mm | Studio, 106 exposures

Forewings (elytra) on beetles are often hardened wing cases that protect the abdomen and the delicate hind wings, which are used for flying. The elytra are not used for flying but are raised during flight. The texture of the shell is what gives beetles their beautifully diverse colors.

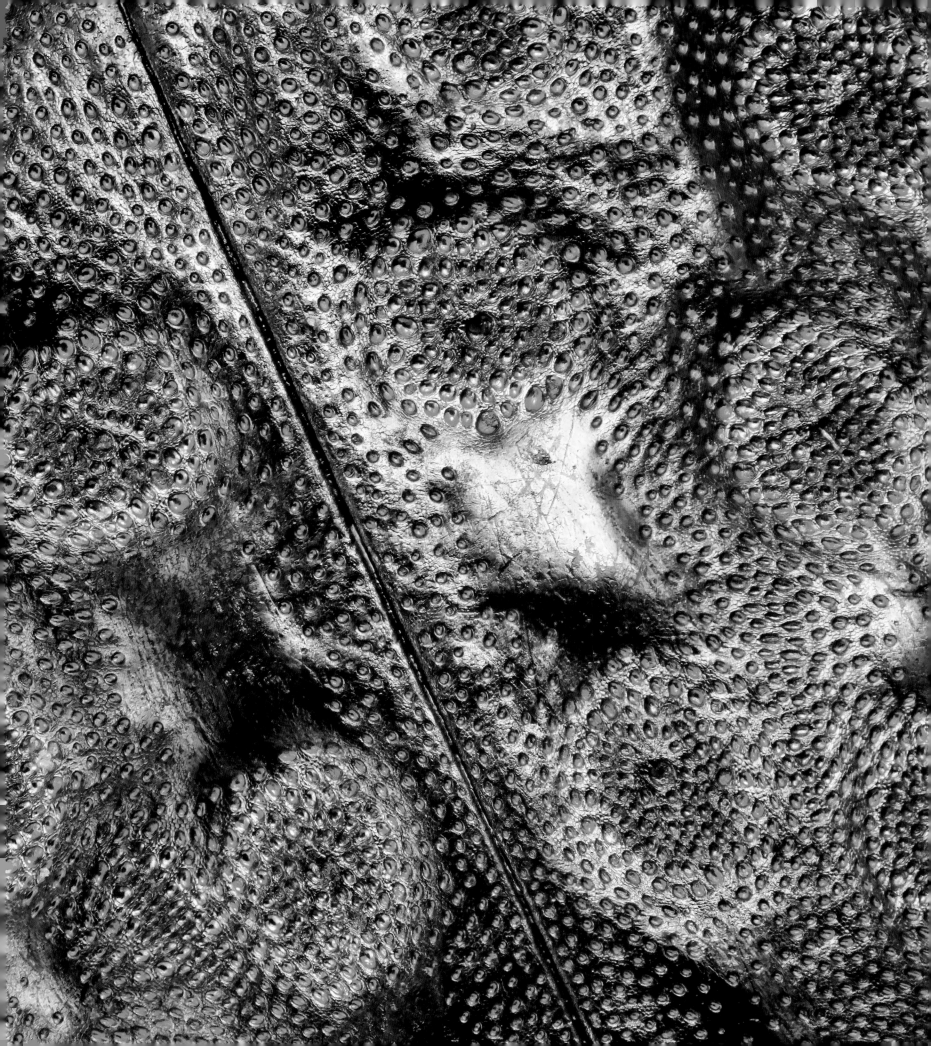

Emerald damselfly *Lestes sponsa* ▶

Body length: 30 mm | Södermanland (Nackareservatet Nature Reserve), 47 exposures

Emerald damselflies are predators, but rather poor fliers. Because of this, they are often content to hunt on land, preying on smaller insects like mosquitoes and aphids. Their legs have long bristles and are situated close to the head, forming a kind of trap that holds the prey near their mouth. The emerald damselfly is found mainly in stagnant water, preferably with abundant vegetation. It can be found in the whole of Sweden, with the exception of the interior of Norrland. The damselfly has its flight season from July to August.

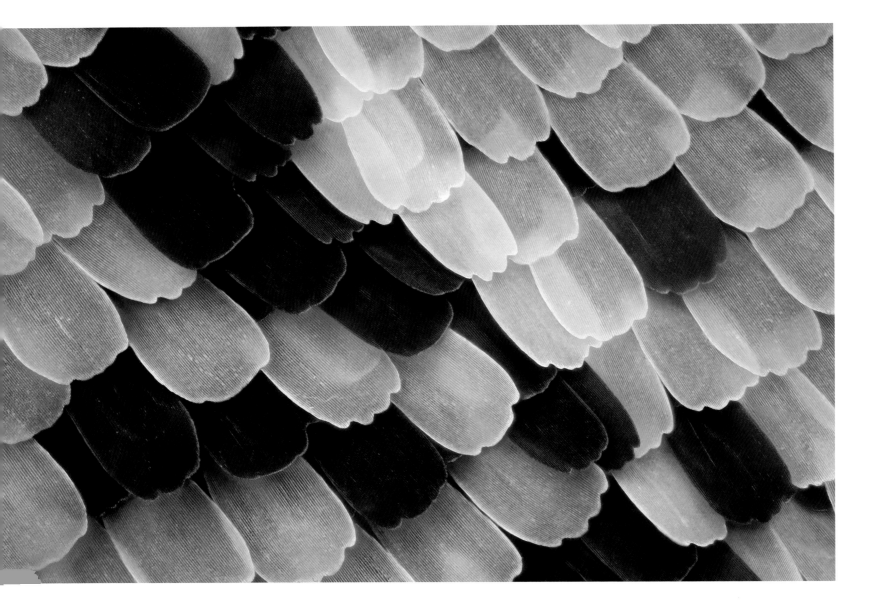

Peacock butterfly *Inachis io*, wing scales

Body length: 20 mm | Studio, 105 exposures

We should thank nanostructures for many of nature's most beautiful colors. The shimmering wings of the peacock butterfly have fascinated people for many years, perhaps particularly because of their shiny blue color. Using nanotechnology, we can now see and understand what creates such colors. It is nano-sized textures that reflect light and strengthen or weaken certain wavelengths. Colors created by textures can, for example, be found in birds, fish, and other insects. Animals use colors to communicate, to claim territory, and to attract mates. The textured colors on these species will never fade.

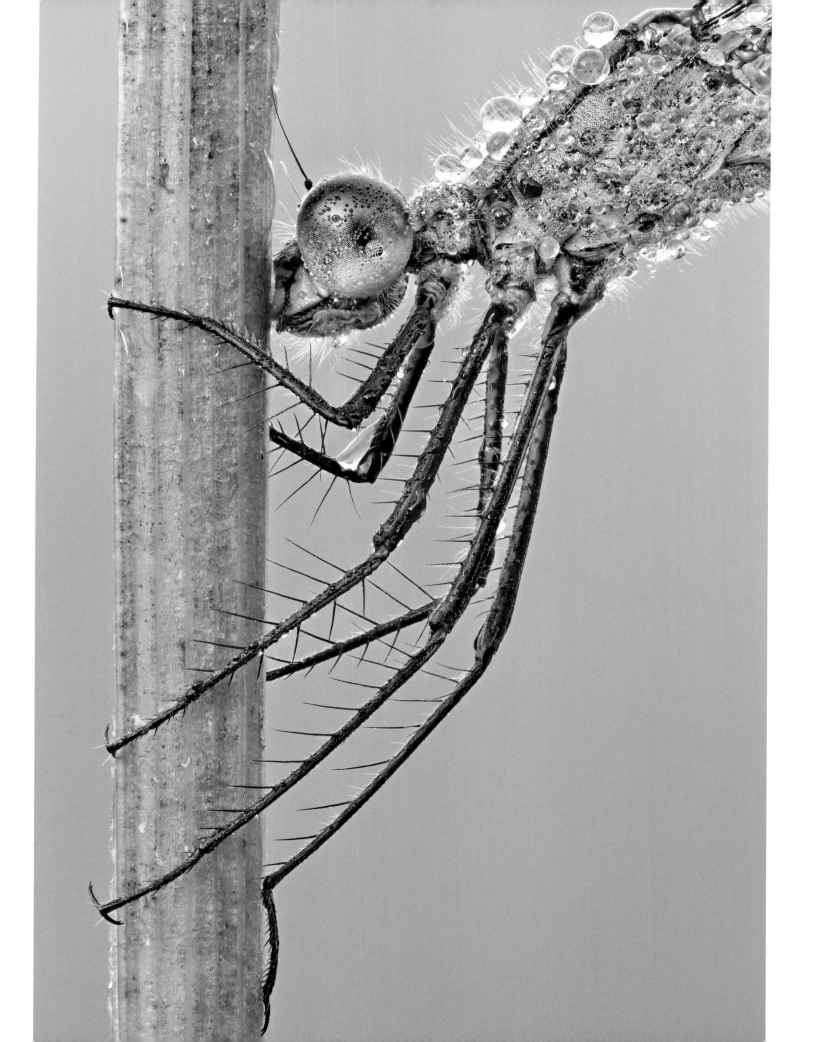

Timberman beetle *Acanthocinus aedilis*, ♂

Body length: 17 mm | Studio, 216 exposures

The timberman beetle is one of the most easily identifiable long-horned beetles. The male has coiled black antennae that are four times its body length. The area around the head and neck looks like it's covered in fur. The beetle is brown/gray with four small yellow dots on its neck shield. One can see these beetles residing on dead pine trees, on unbarked wood, or, ideally, on freshly cut pine stumps. As they are camouflaged, they might be difficult to spot if sitting quietly and motionless on pine bark.

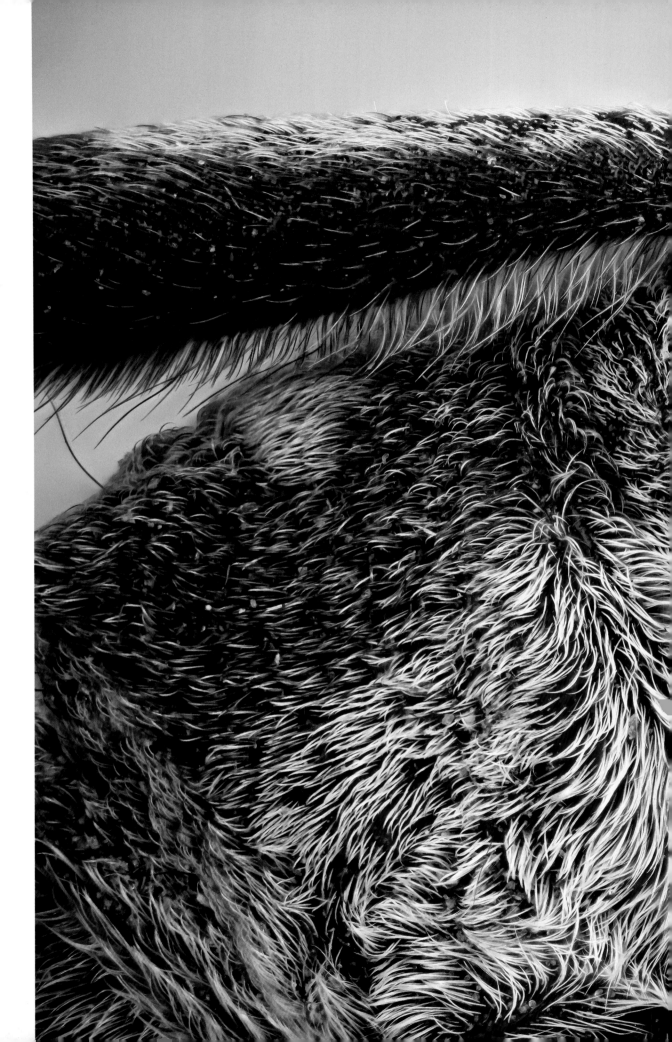

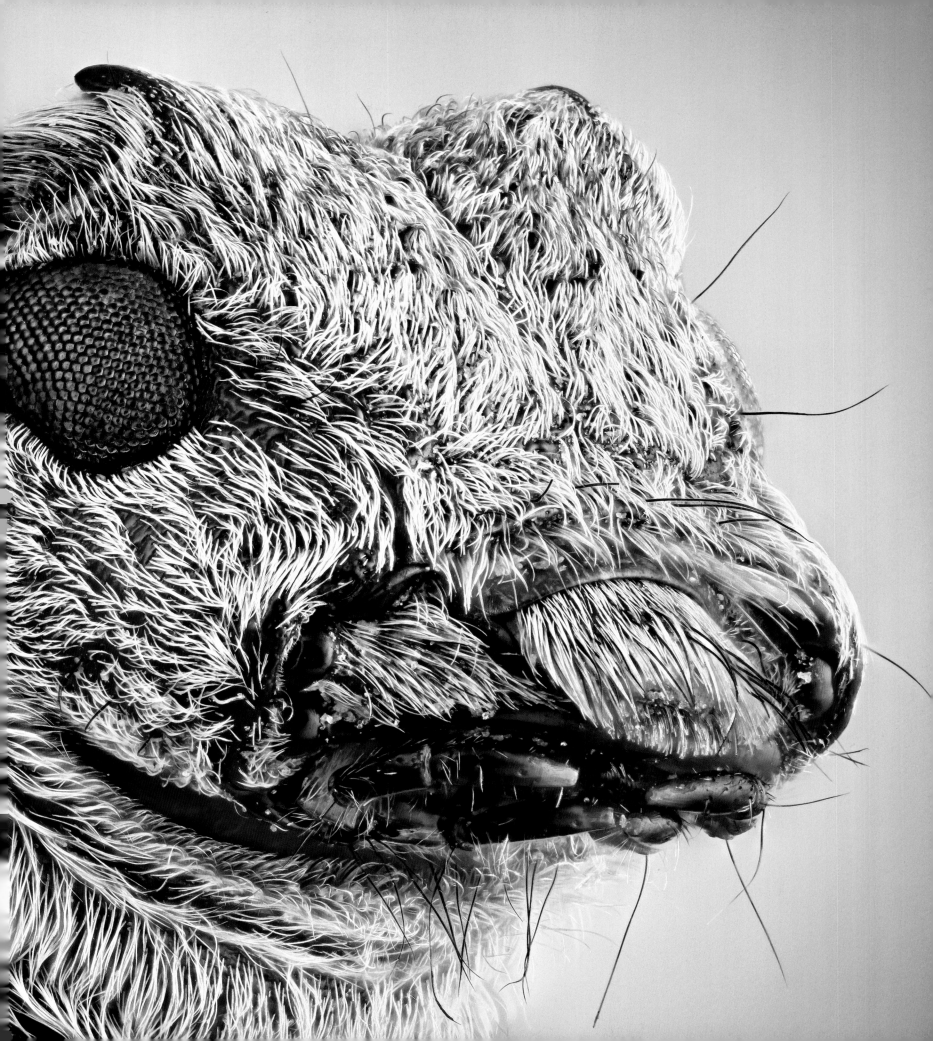

Capricorn beetle *Aegomorphus clavipes*, tarsus and claw ▶
Body length: 17 mm | Studio, 151 exposures

This image depicts the front tarsus, also known as the front foot. The foot is primarily used for clinging onto surfaces, and the last joint typically has two claws at the very tip for this very purpose. The claws hook onto any surface, unless it is completely smooth. The fourth tarsus joint is very narrow, while the other three are lobulated and both wide and hairy. The capricorn beetle is considered to be rare in Sweden, but can for short periods of time be found in clearings with old aspens.

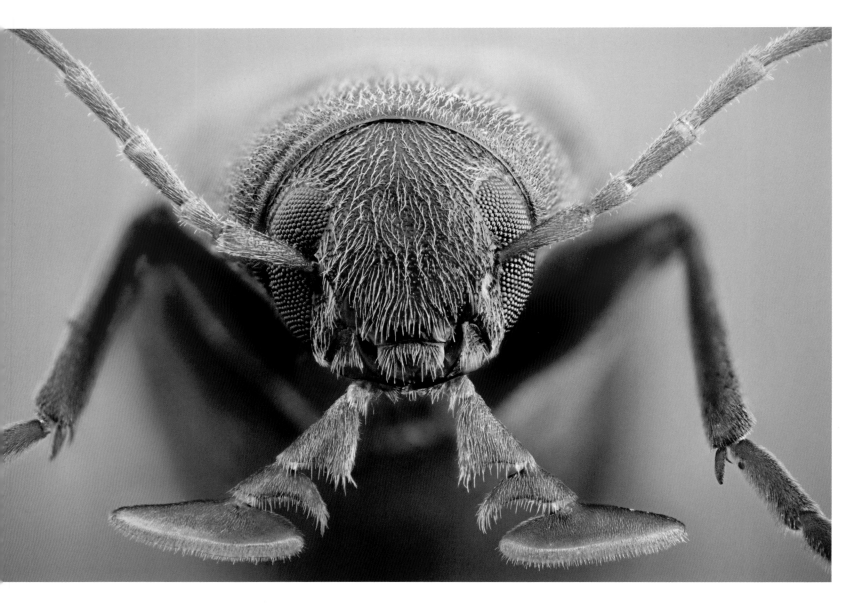

False darkling beetle *Serropalpus barbatus*
Body length: 15 mm | Studio, 29 exposures

The false darkling beetle is nocturnal, which probably explains why it has such big eyes. The prominent and powerfully widened mouthparts found on fully formed beetles might be designed to find the mushrooms their larvae feed upon. The false darkling beetle is considered to be a rare species in Sweden, but can be found in some areas between Blekinge and Norrbotten. The larvae thrive and grow in recently dead trees, and mainly prefer fir.

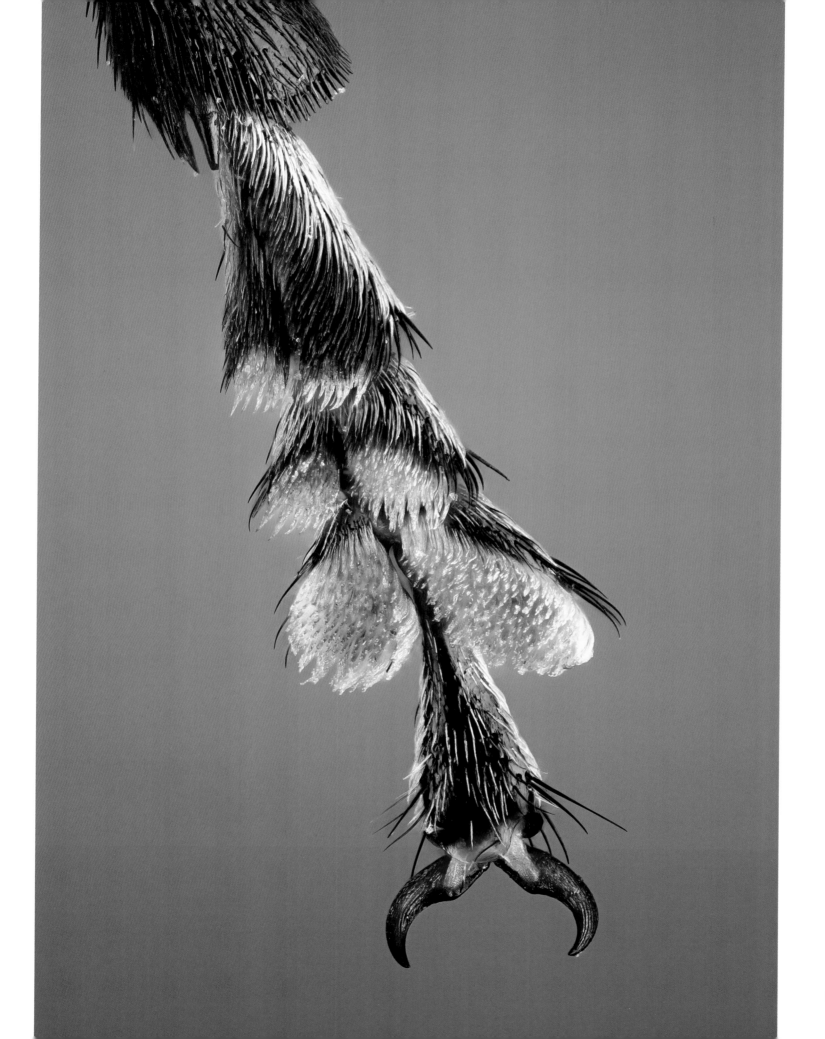

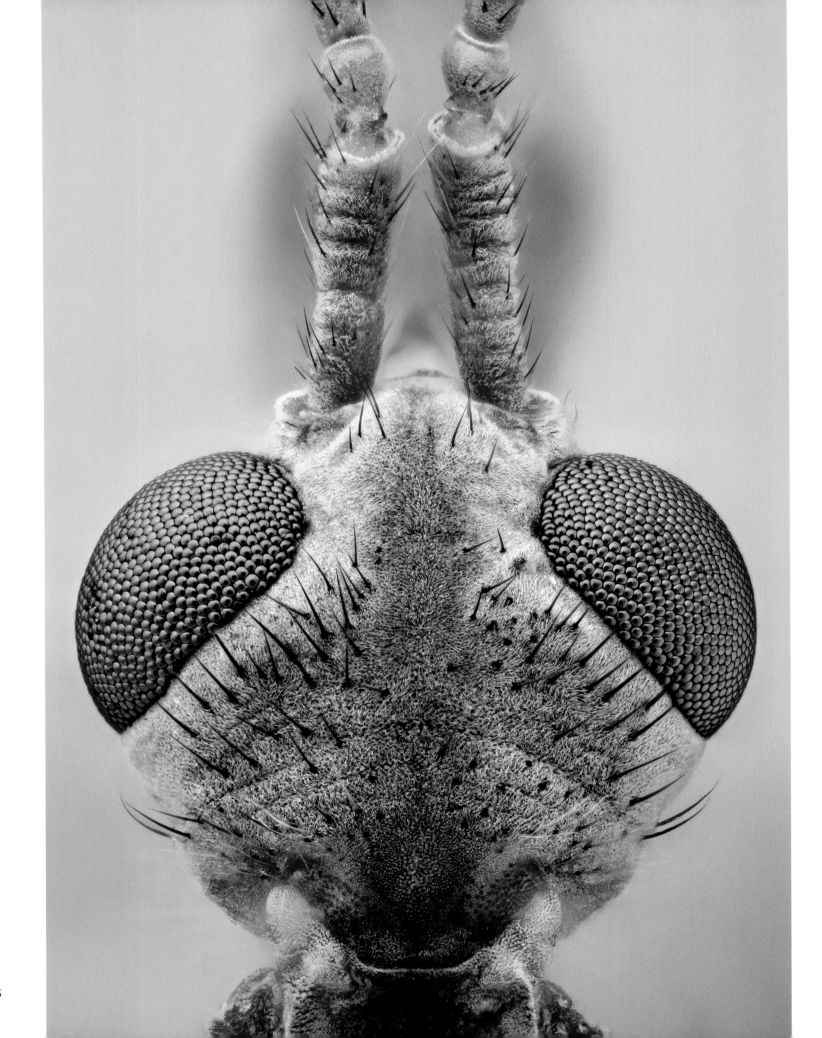

Crane fly *Tipulidae*, head seen from above
Body length: 23 mm | Studio, 52 exposures

The crane fly varies in size, from 7 to 35 mm. Because of this, they are considered to be the largest true fly. Their head has a beak-like extension, the antennae are long and thin, and they have no simple eyes. The crane fly has an elongated, thin, and lanky body held up by its very long legs. When resting, the fly keeps its wings unfolded, giving us a clear view of its halteres, the balancing organs.

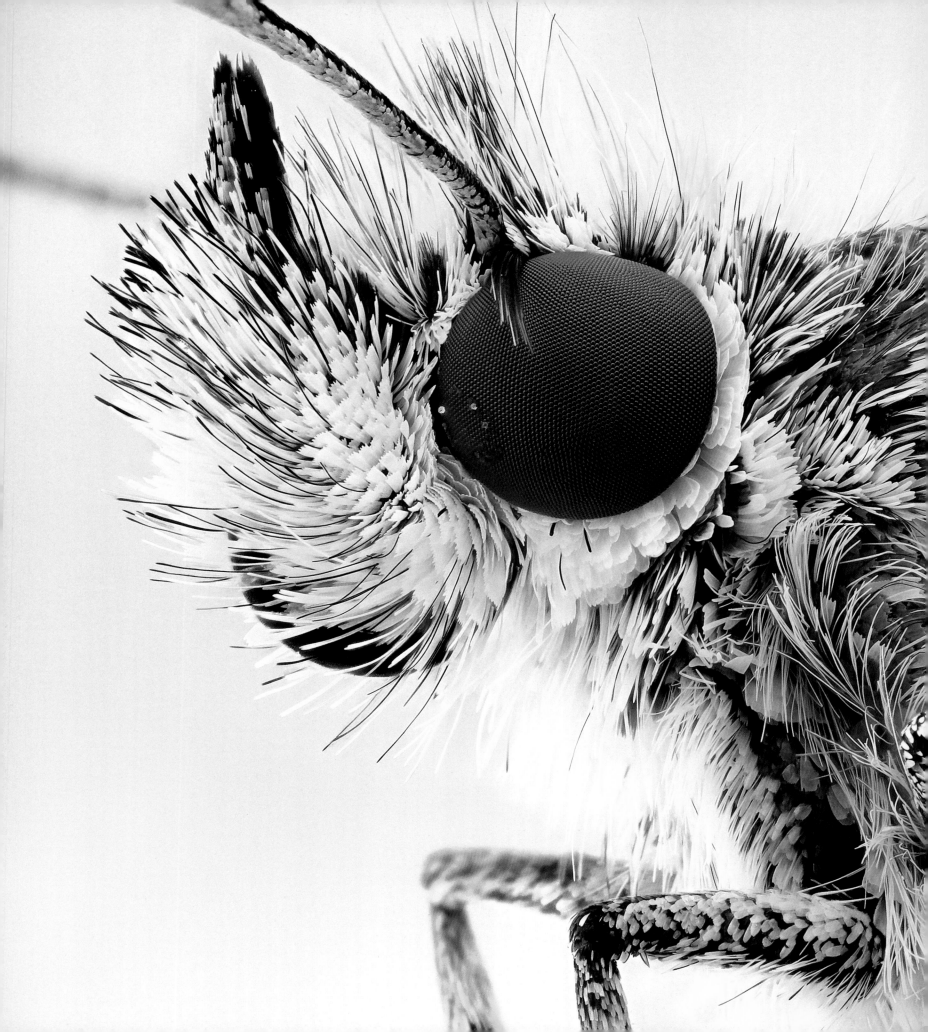

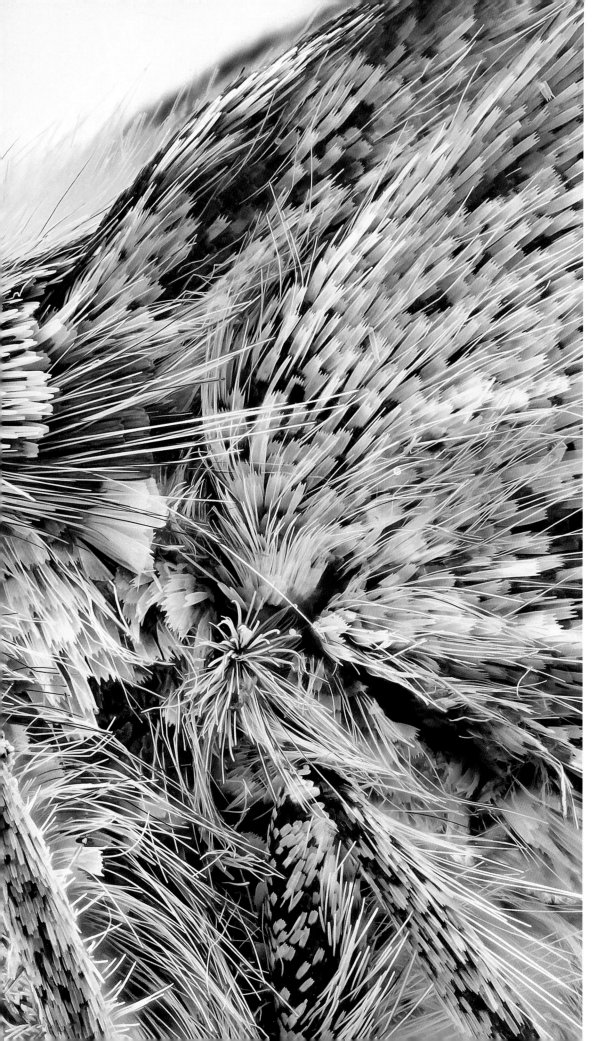

Essex skipper *Thymelicus lineola*
Body length: 12 mm | Södermanland (Nackareservatet
Nature Reserve), 50 exposures

The Essex skipper belongs to the *Hesperiidae* family, also
known as "thick-head butterflies." The head of the Essex
skipper is unusually wide, giving the family its Swedish
name, *mindre tåtelsmygare*. Each club-shaped antenna
has a slightly bent tip and a tuft of hair at the base. The
distance between where the antennae are attached to the
head is much wider than those of other butterflies. The
Essex skipper is a fast flyer that often makes abrupt and
sharp changes in direction. It can be found on grass and
meadows in the southern part of Sweden.

St. Mark's fly *Bibio marci,* ♂
Body length: 12 mm | Södermanland (Nackareservatet Nature Reserve), 18 exposures

The St. Mark's fly lives up to its Swedish name, which translates to "hairy mosquito." At first glance it might look like a fly, and the antennae are relatively short for a mosquito. The males have large eyes that occupy most of the space on their head. They also have antennae that are attached close to the mouth, below the eyes. Their eyes are two separated entities with either small or large facets. The eyes of the female are tiny and placed widely apart on much smaller and narrower heads.

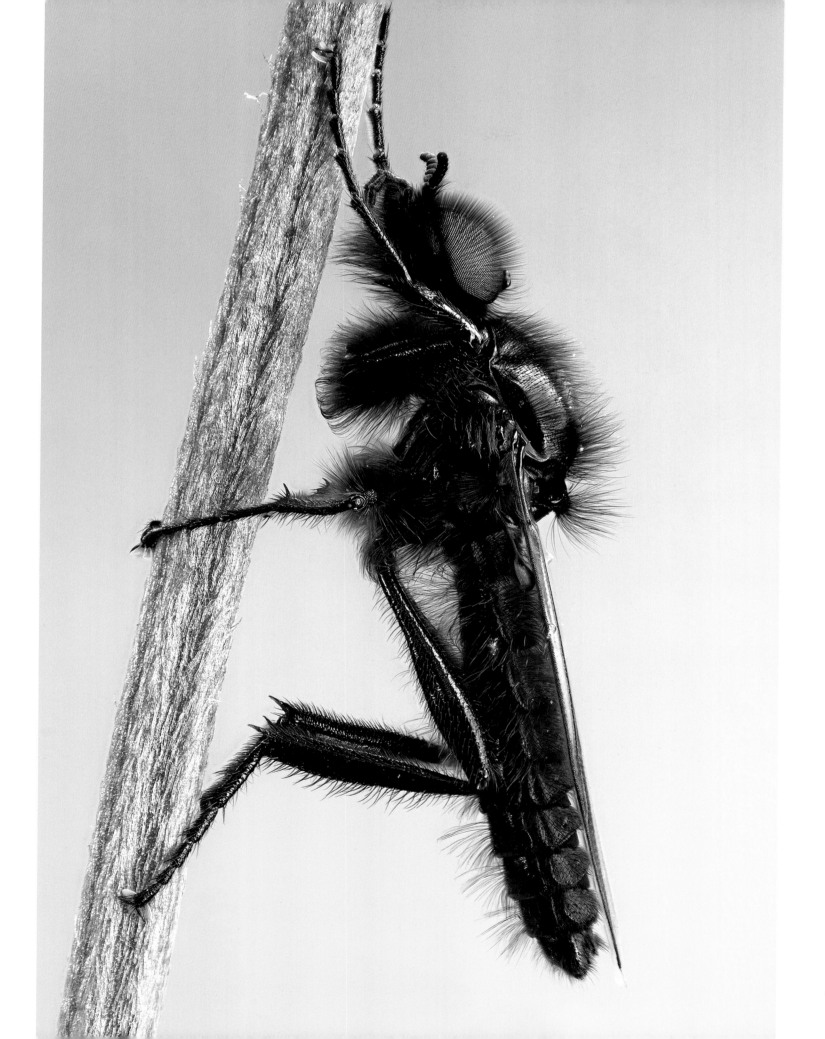

Mason bee *Anthidium punctatum*, ♂
Body length: 7 mm | Södermanland (Nackareservatet Nature Reserve), 19 exposures

Of the nearly 290 species of wild bees, the mason bee (with two species found in Sweden) is easy to recognize, mainly because of its hairy head and thorax. Also, the almost bare abdomen has pronounced yellow markings. You can tell the two species apart by the sharp (or blunt and tooth-like) point on the very last tergite of the male. Pollen is collected from stonecrop, legumes, and plants from the *Reseda* family.

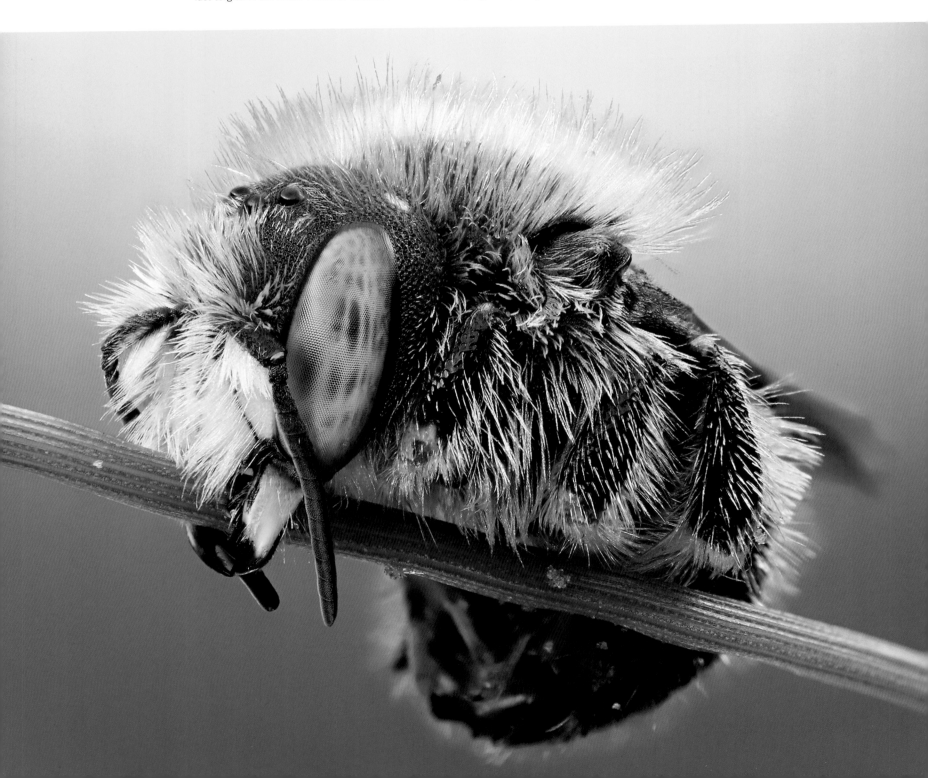

Tortoise beetle *Cassida* sp., pupa
Body length: 7 mm | Ångermanland, 1 exposure

The pupa in the image might be a *Cassida sanguinosa*, which is the most widespread thistle-living species in Sweden. There are three or four tortoise beetles that are mainly associated with thistles (in Sweden). Tortoise beetles are among the species that undergo a complete metamorphosis—that is, they evolve from egg, to larva, to pupa, and finally become fully formed insects. Between the larval and final stages, the beetle is totally dormant, a pupa. Characteristics of a pupa are that it cannot move and does not consume any nutrition. The pupa, often hard shelled, is often camouflaged to resemble the surface it resides upon in both color and texture. In this case one could say that the pupa is imitating the bract on a thistle.

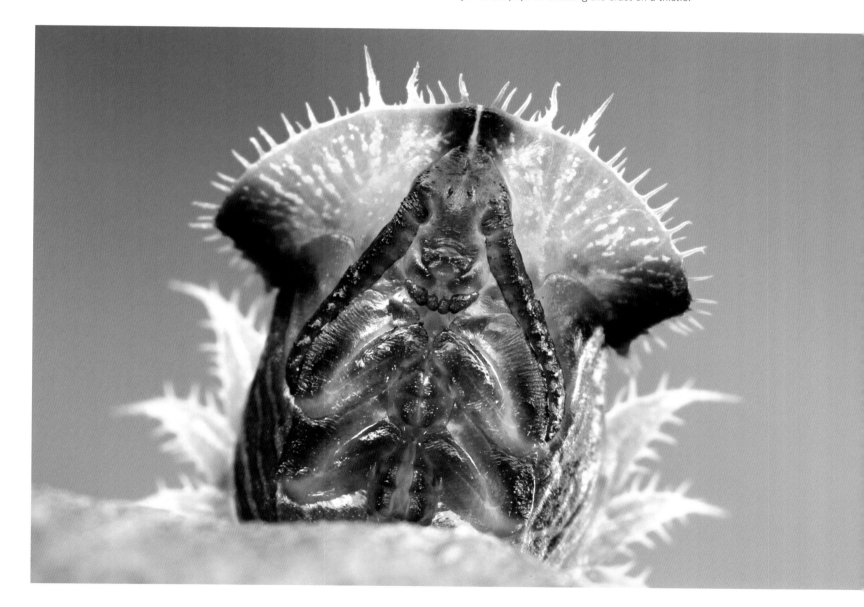

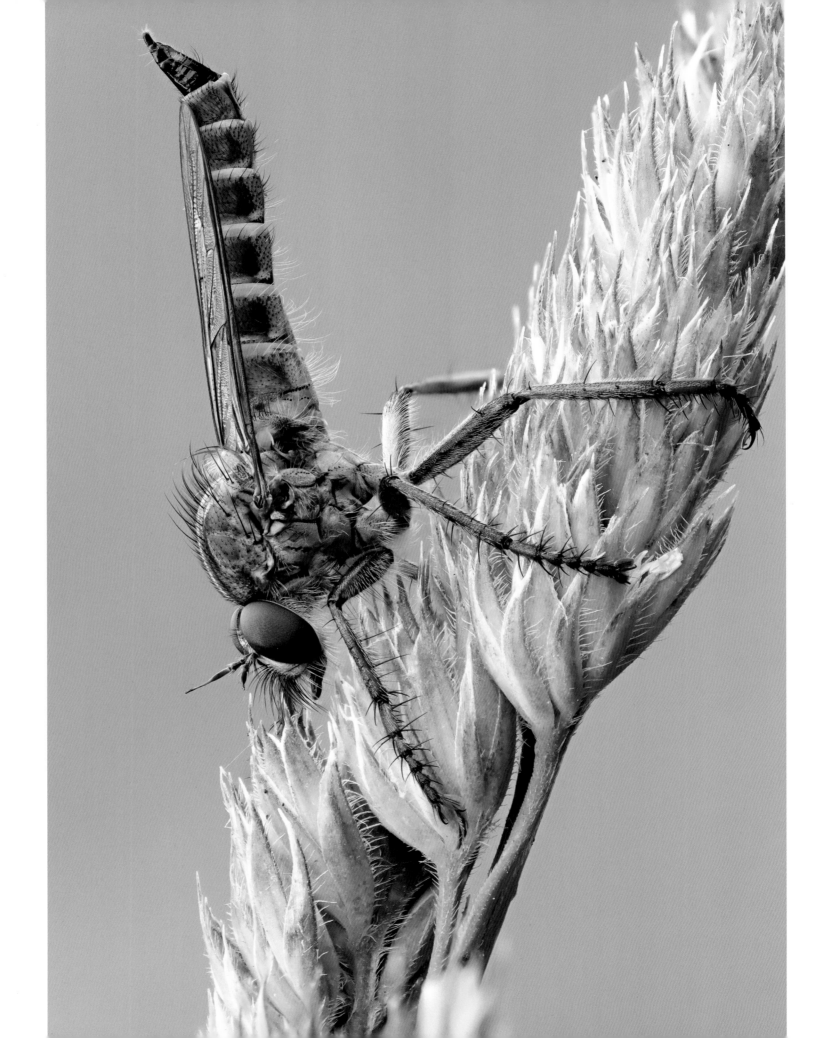

Robberfly *Tolmerus* cf. *atricapillus*, ♀
Body length: 16 mm | Södermanland (Nackareservatet Nature Reserve), 36 exposures

Most robberflies look terribly intimidating when you observe them at close range. Their bodies are often covered in thorns, bristles, and hairs. But when it comes to armor, they are meekly equipped. It was once thought that robberflies survived by drinking the blood of livestock and larger mammals, but we now know that they hunt insects, though some also prey on spiders. The fly in the image might be the species *atricapillus*, but it might also be some other related species.

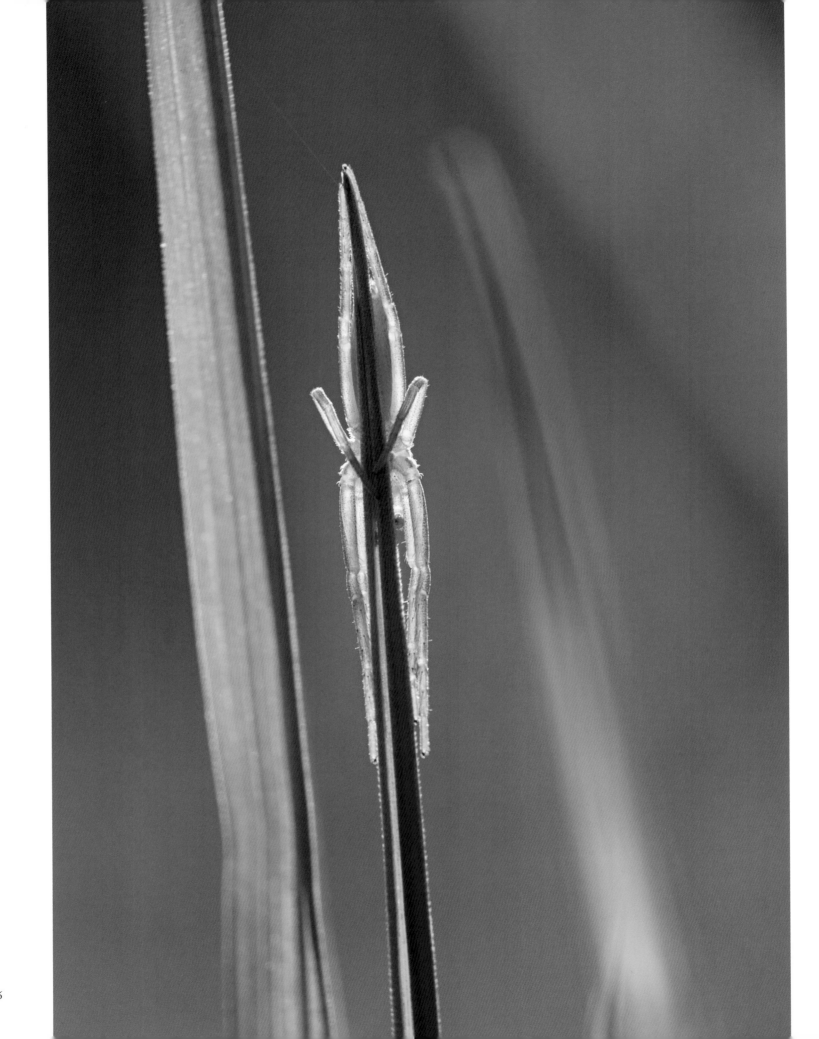

"TO SEE, BUT NOT BE SEEN"** is perhaps the most important survival strategy in the animal kingdom. For millions of years, the prey have been refining their methods of avoiding detection, and the predators have become better at detecting them. It's a race with only one goal: to always be one step ahead of the other. The battle between the predator and its prey is a never-ending battle.

Animals have developed different methods to become one with the environment and make themselves "invisible." This is true mainly with animals that are preyed upon, and almost all animals are prey sometime in their lifetime. In some cases, the way of moving is a part of the camouflage.

The colors of the camouflage can be permanent but may also be ever changing. Among the permanently camouflaged we find some species of caterpillars. They move slowly and have a certain coloring and shape that is confusingly similar to the surface on which they spend most of their time. This is also true with some arachnids, like running crab spiders and stretchspiders—sitting still and being camouflaged makes it easier to evade predators, such as birds. Camouflage can be enhanced by spots and patterns that make the animal disappear into the surface on which it's situated.

Of course, camouflage can also be used the other way around, by predators that don't want the prey to catch sight of them.

Slender crab spider *Tibellus* sp.
Body length: 11 mm | Södermanland (Nackareservatet Nature Reserve), 1 exposure

Slender crab spiders are unusually elongated members of the running crab spider family. Their body shape, coloration, and posture help them blend into their favorite environment—tall grasses. In Sweden, there are two species that are hard to tell apart: the *Tibellus oblongus* and *Tibellus maritimus* (common names unknown).

Bishop's mitre *Aelia acuminata*

Body length: 7 mm | Södermanland (Nackareservatet Nature Reserve), 13 exposures

The bishop's mitre mimics the color and shape of the different types of grass that both larva and adult insects drink sap from. In late summer and early fall, you can find it flying around and sitting on herbs, shrubs, and trees. The fully formed insects spend their winters in plant seeds, preferably close to hedges and forest edges. The bishop's mitre is commonly found in the dry, fresh, and open grasslands north of Medelpad. Up until the mid-twenty-first century, the species was a pest that ate cereal in south and southeast Europe.

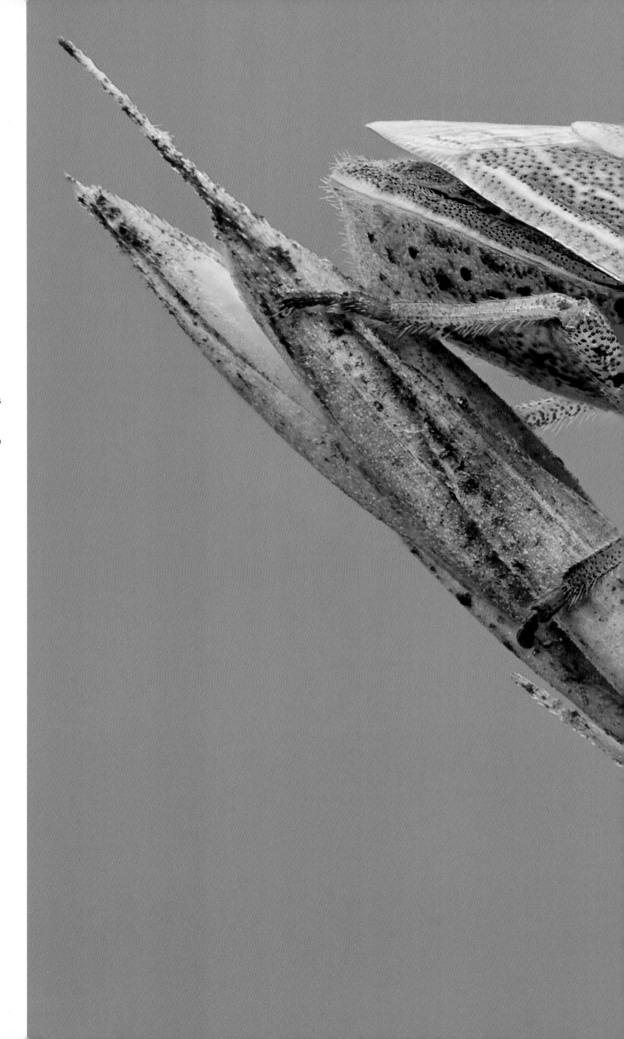

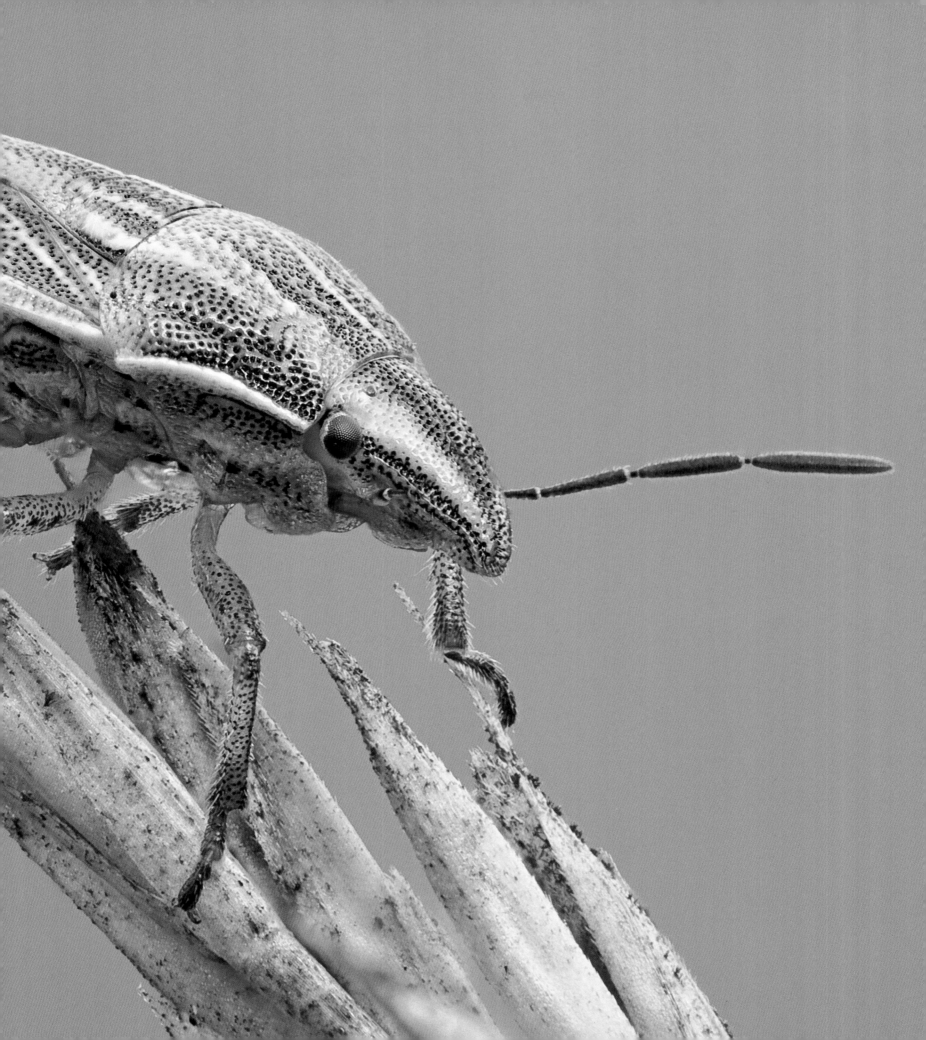

Lichen running spider *Philodromus margaritatus* ▶
Body length: 8 mm | Öland, 1 exposure

The lichen running spider has many different colors and patterns, but the coloration is typically in the gray or gray-brown color scheme that resembles the surface it resides on. They camouflage themselves to resemble lichen that grows on pine and certain hardwoods. In this case, the camouflage happens to resemble a skull. You will normally find these spiders on trunks with lichen in western and central Europe.

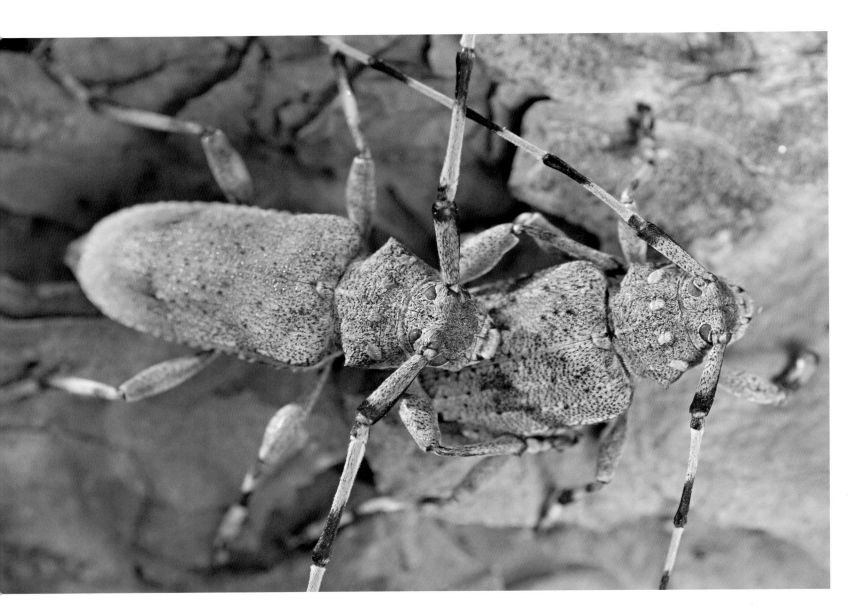

Timberman beetle *Acanthocinus aedilis*
Body length: 18 mm | Södermanland (Nackareservatet Nature Reserve), 1 exposure

The males have extremely long antennae (nearly three times their body length), with the females' being slightly shorter. When an adult beetle sits on coarse pine bark it is very difficult to detect. Often, you see it only when it moves its black-and-white striped antennae. The timberman beetle can be found in coniferous forests, especially where there are pine trees. Their larvae can be found in the inner bark of conifers that have recently died, preferably in pine, but sometimes also in spruce.

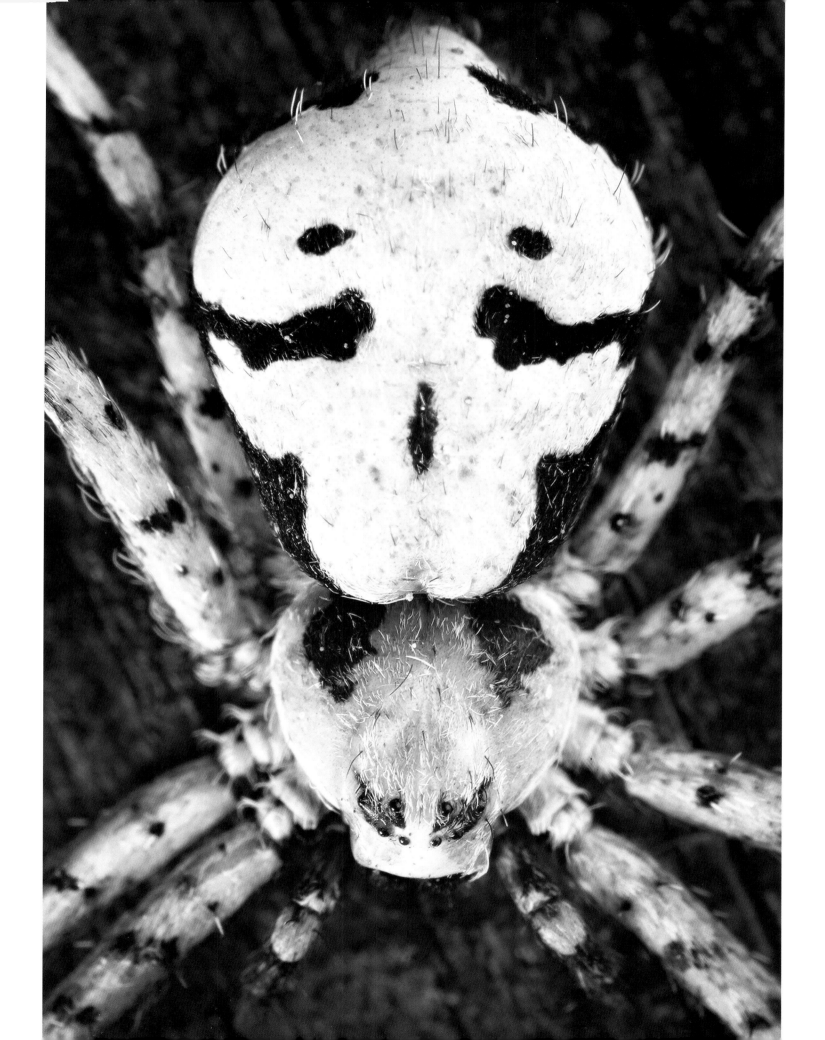

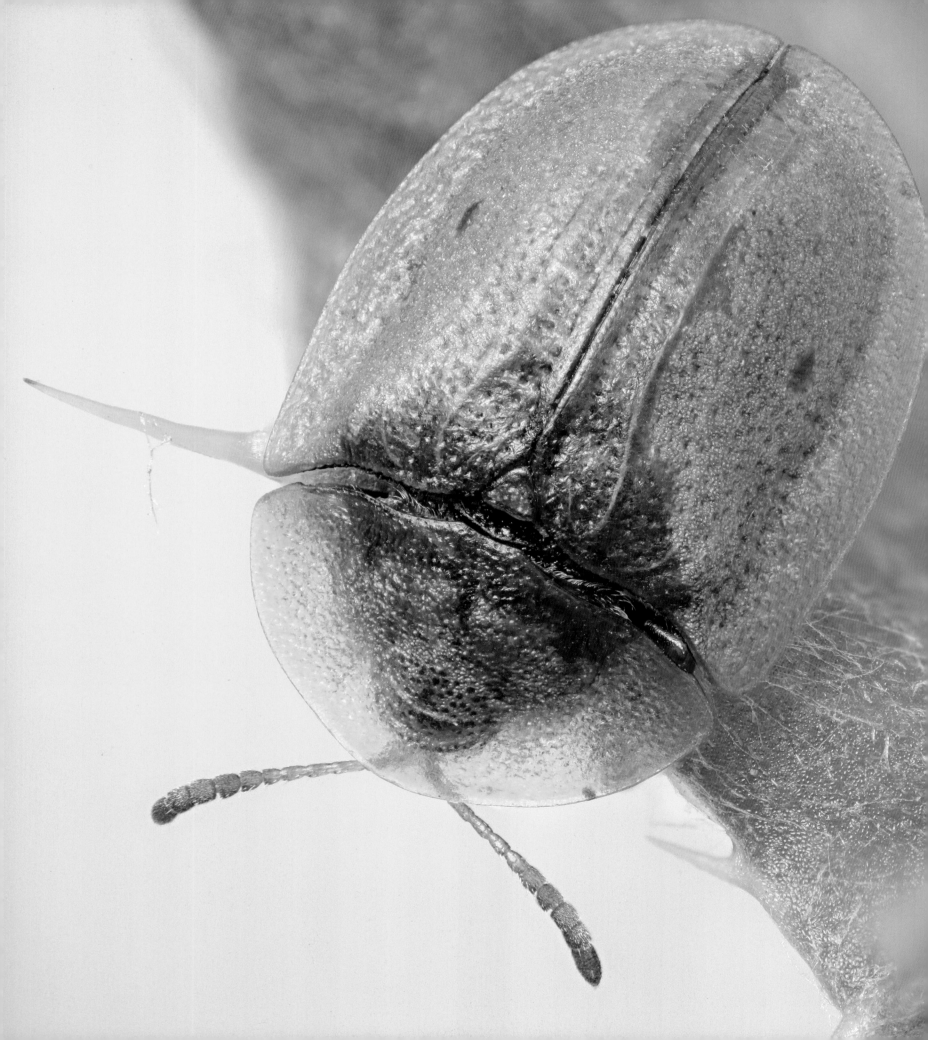

Thistle-feeding tortoise beetle *Cassida vibex*
Body length: 7 mm | Södermanland (Nackareserva-tet Nature Reserve), 18 exposures

This beetle is a species of leaf beetle. The main color of its body is green, often with a wide, brown line along the seam of the elytra (wing covers). The head and legs are completely hidden by the neck shield and elytra. All of this, along with its flat and oval body shape, makes for great camouflage when it sits firmly against a leaf. This rather rare species can be found on thistles and other composite flower types in southern Sweden, and as far up as the border of Norrland.

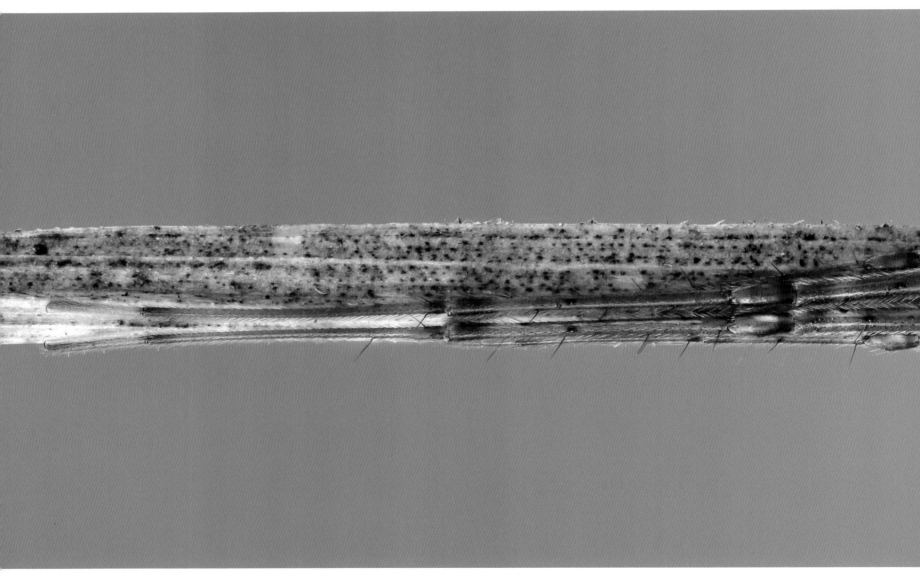

Stretch spider *Tetragnatha* sp.

Body length: 6 mm (full length 20 mm) | Södermanland (Nackareservatet Nature Reserve), 55 exposures

These stretch spiders have cream-colored markings and elongated bodies. When disturbed, they hide along the stem of a plant, usually on a strand of grass or along the midrib of a larger leaf. The four front legs are then pointed forward and the four rear ones are stretched backward in an attempt to camouflage themselves. You can find these spiders in damp areas with low vegetation. They build wheel-shaped webs with holes, in which they catch insects like mosquitoes, gnats, and butterflies. The stretch spiders can walk on water, and there they move faster than on land.

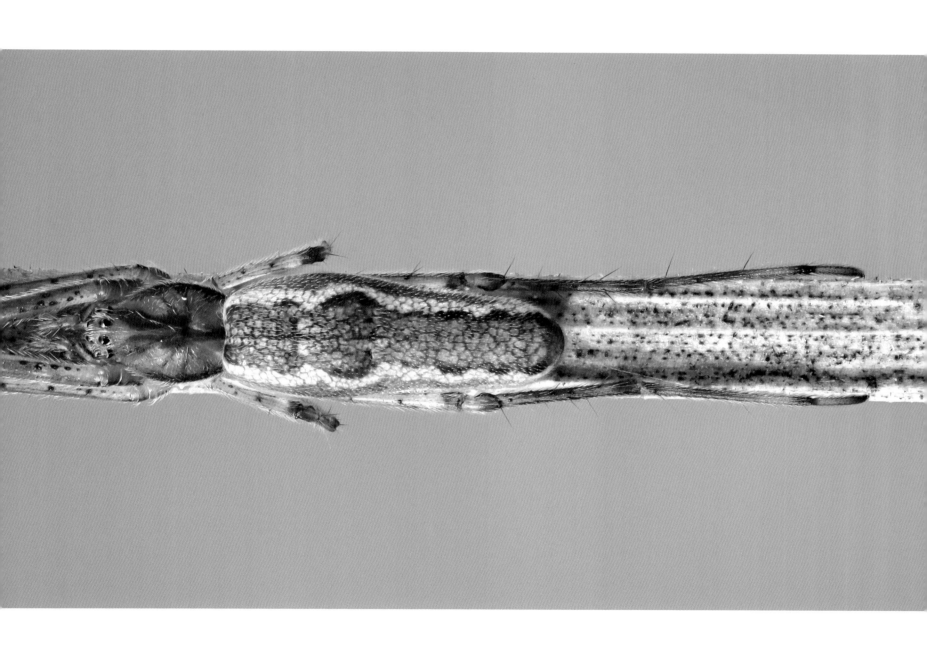

Shield bug *Syromastes rhombeus* ►
Body length: 9 mm | Öland, 38 exposures

This shield bug has a discreet camouflage in brown, yellow-gray, and gray-green hues. The mouthparts are of the stinging and sucking variety, and they feed on sap from flowers of the carnation family, such as mouse-ear chickweeds and smooth rupturewort. They prefer to live and feed in dry and sandy soils.

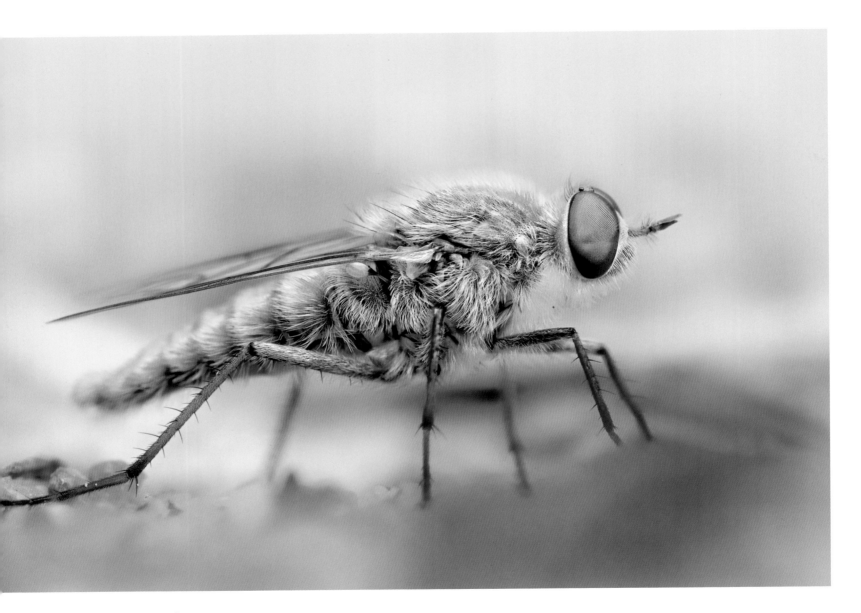

Coastal silver-stiletto *Acrosathe annulata*

Body length: 10 mm | Södermanland (Nackareservatet Nature Reserve), 1 exposure

The image depicts a coastal silver-stiletto, so named for its tapered abdomen. The flies prefer to stay on the ground and on surfaces that resemble themselves, rarely flying. Adult flies can be found in varying habitats, but often in open, dry, and sunny places. The adult flies live off of nectar and smaller insects. In Sweden, there are eighteen different species of stiletto flies.

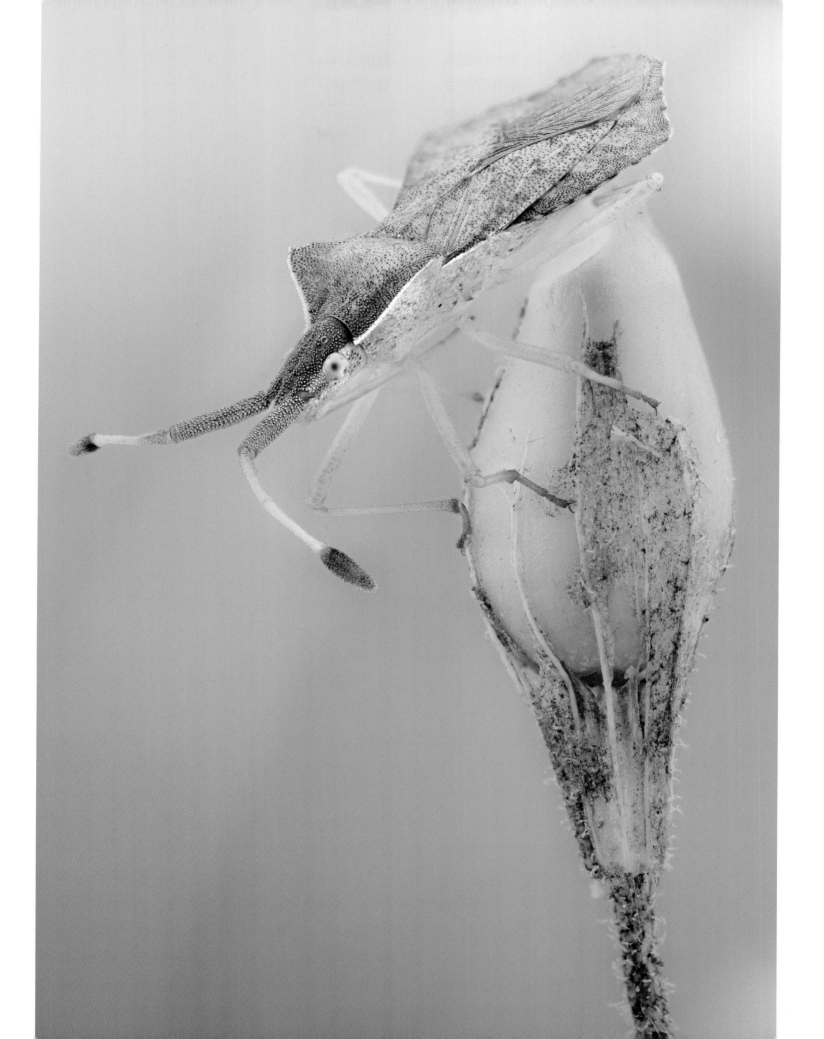

Flower crab spider *Misumena vatia*, ♀
with prey
Body length: 7.5 mm | Södermanland
(Nackareservatet Nature Reserve), 28
exposures

This species is called the flower crab spider
or goldenrod crab spider. It is an expert at
camouflage and often waits for its victims in
flowers that are consistent with the color of
its own body. In this image, it can be seen
attacking a damselfly. The spider uses venom
to paralyze its victims; the lower damselfly
is what remains from a previous meal.
The females are easier to spot, and their
appearance varies from bright yellow without
any markings to white with green stripes. The
male is much smaller and has an oval abdomen
with wide, almost parallel markings. Often the
four front legs are dark while the rear ones are
bright.

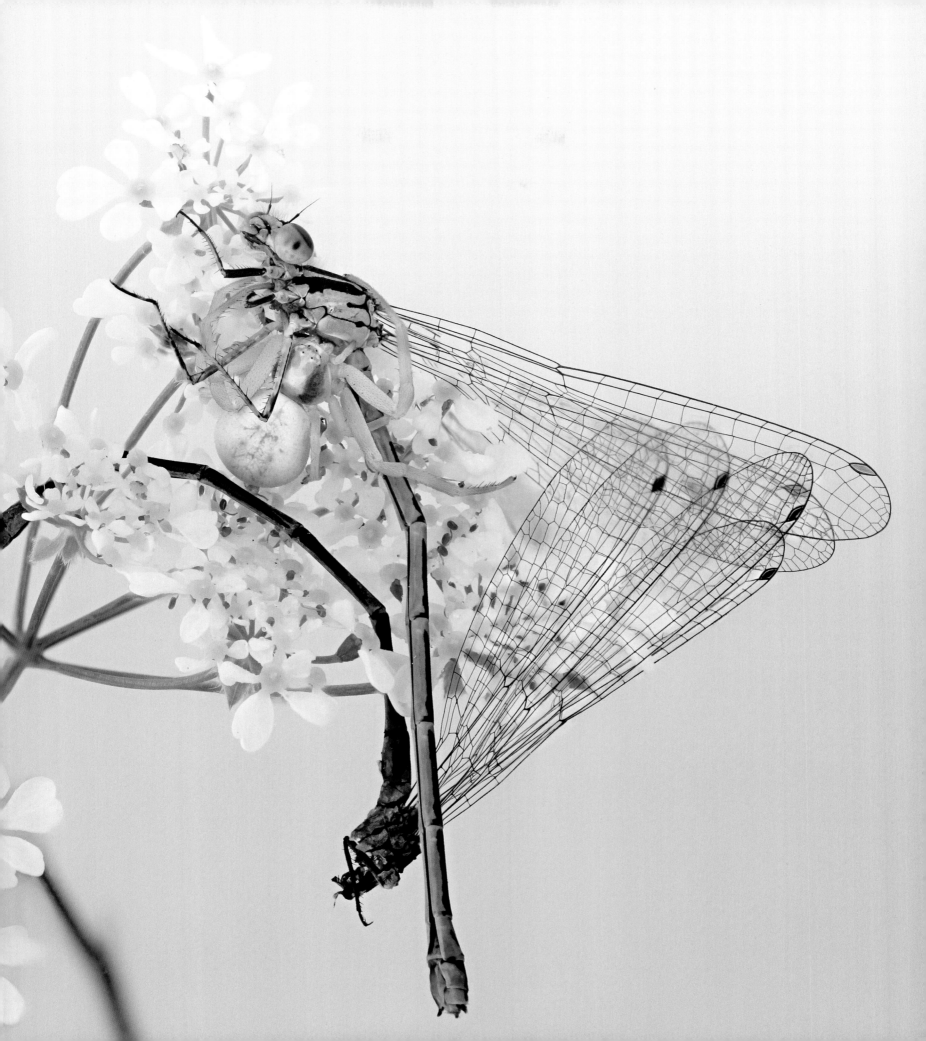

Horned treehopper *Centrotus cornutus*

Body length: 8 mm | Södermanland (Nackareservatet Nature Reserve), 52 exposures

The horned treehopper is the only species of treehopper in Sweden. The neck shield is extended on each side and looks like short, ear-shaped horns. In the middle it has a wavy growth over the back that goes all the way down to the tip of the abdomen. The horns are mainly for camouflage purposes. When resting on a branch with its legs folded, the horned treehopper looks like part of the twig. This treehopper is quite common and can be found on most leafy trees and shrubs between Skåne and Ångermanland.

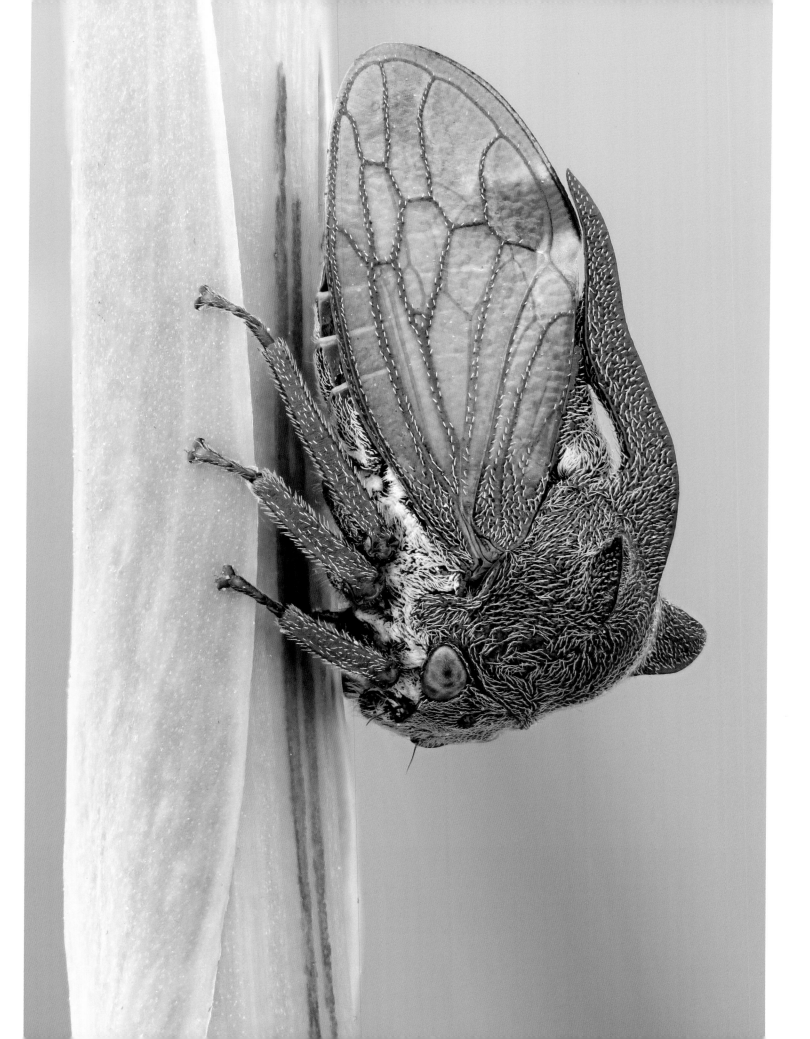

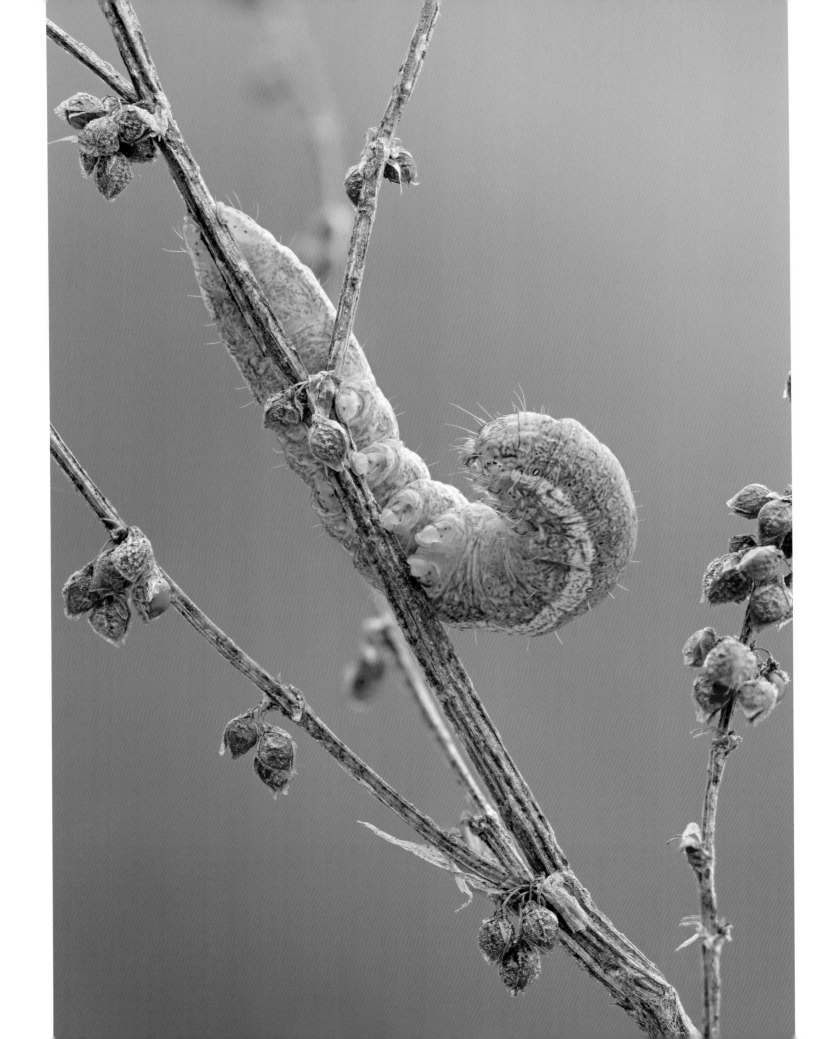

◄ **Noctuid moth** *Noctuidae*
Body length: 14 mm | Södermanland (Nackareservatet Nature Reserve),
58 exposures

Many caterpillars—both butterflies and moths—are permanently camoufla-
ged to avoid detection by predators. The caterpillars also have a body shape
and movement pattern that are confusingly similar to whatever they are
trying to portray. The caterpillar in the image might be from the *Hadenini*
family.

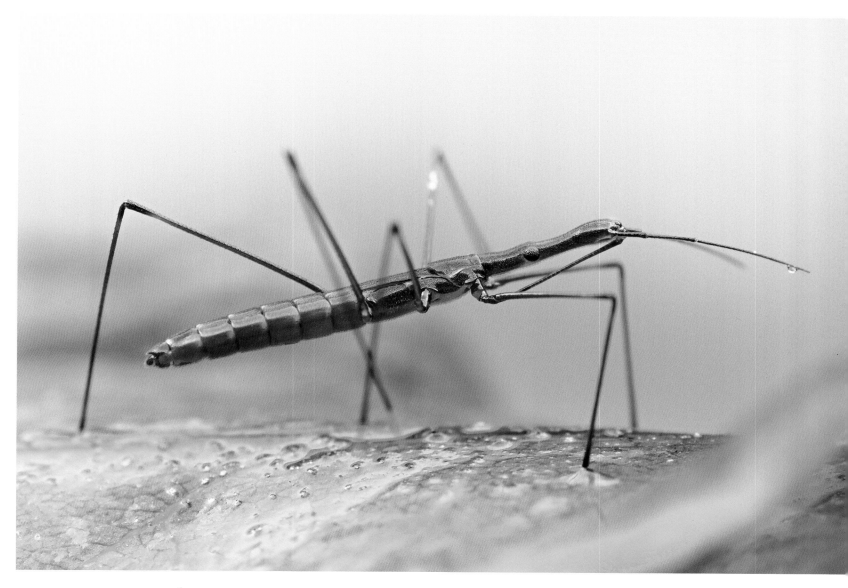

 Water measurer *Hydrometra stagnorum*
Body length: 10 mm | Öland, 1 exposure

This water measurer is an aquatic bug that belongs to the suborder of "true bugs" (*Heteroptera*). It has an unusually
narrow and thin head that is attached to a thin body with antennae that look more like a fourth pair of legs. They nor-
mally don't have any wings, but there are cases where the specimen has a full set of wings. As to the reason for this
anomaly, we have yet to answer why this is. Water measurers move slowly across the water, in search of prey on or just
below the water's surface. Usually it's mosquito larvae and water fleas that fall victim to the spearing proboscis. Water
measurers reside in ditches, ponds, and slow-flowing streams.

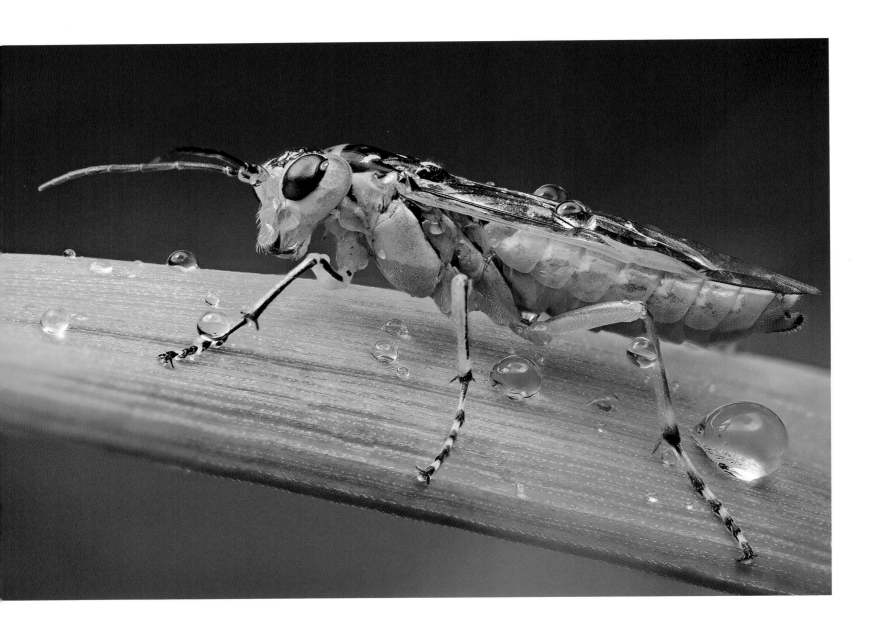

Green sawfly *Rhogogaster viridis*

Body length: 10 mm | Södermanland (Nackareservatet Nature Reserve), 8 exposures

Reaching up to 15 mm long, the green sawfly can often be found residing in panicles, where it captures smaller insects and draws liquid from flowers with accessible nectar. The green sawfly is much more difficult to spot when sitting on a leaf, as its dark markings make it almost invisible to the human eye. The green sawfly is distributed across the whole of Sweden, but there are several very similar species. Its larvae live on woody plants and herbs.

MIMICRY

MIMICRY actually means protective resemblance. To explain, there is one species, the mime, which has very similar visual characteristics to another species, usually for defense purposes. There are two kinds of mimicry: Batesian and Müllerian.

Batesian mimicry is when nontoxic, otherwise defenseless, and perhaps also palatable species resemble species that are capable of defending themselves. Poisonous species might have dominant colors warning predators of their deadliness (usually yellow, red, or black). This mechanism is based on predators remembering unpleasant experiences with species of those colors. The risk of a predator first attacking a nontoxic or defenseless mime grows as the number of mimes increases. Therefore, the mimes must always be fewer than the one they're mimicking. As an example, there are many hoverflies that mimic poisonous wasps or other stinging *Hymenoptera*. (This is also widely seen in the reptile world, as for example, the nonvenomous milk snake has a striking resemblance to the highly venomous coral snake.)

Müllerian mimicry is when poisonous or otherwise defense-capable species resemble each other, reducing the risk for each species to be the one that inexperienced predators encounter first. After such an experience, the predator simply avoids all individuals with that species's features.

There are other kinds of mimicry as well. Flowers imitate females of *Hymenoptera*, so that mating males are lured closer and used as pollinators. Even chemical and acoustic signals can be mimicked. In some cases the mime is the sole beneficiary, while in others the mime and model both reap the benefits.

Pearly heath *Coenonympha arcania*
Body length: 12 mm | Södermanland (Nackareservatet Nature Reserve), 28 exposures

The pearly heath is a brownish-gray butterfly that has a thick white line and four to five eyespots of varying sizes. They also occasionally have a small eyespot near their lower back. After impact, the butterflies fold their wings immediately, pulling down their upper wings so that only the back pattern can be seen. The dormant butterfly often sits on strands of grass and blends into its surroundings. The markings on the back of the lower wings might be seen as disruptive, but the eyespots might be intimidating to insectivorous birds.

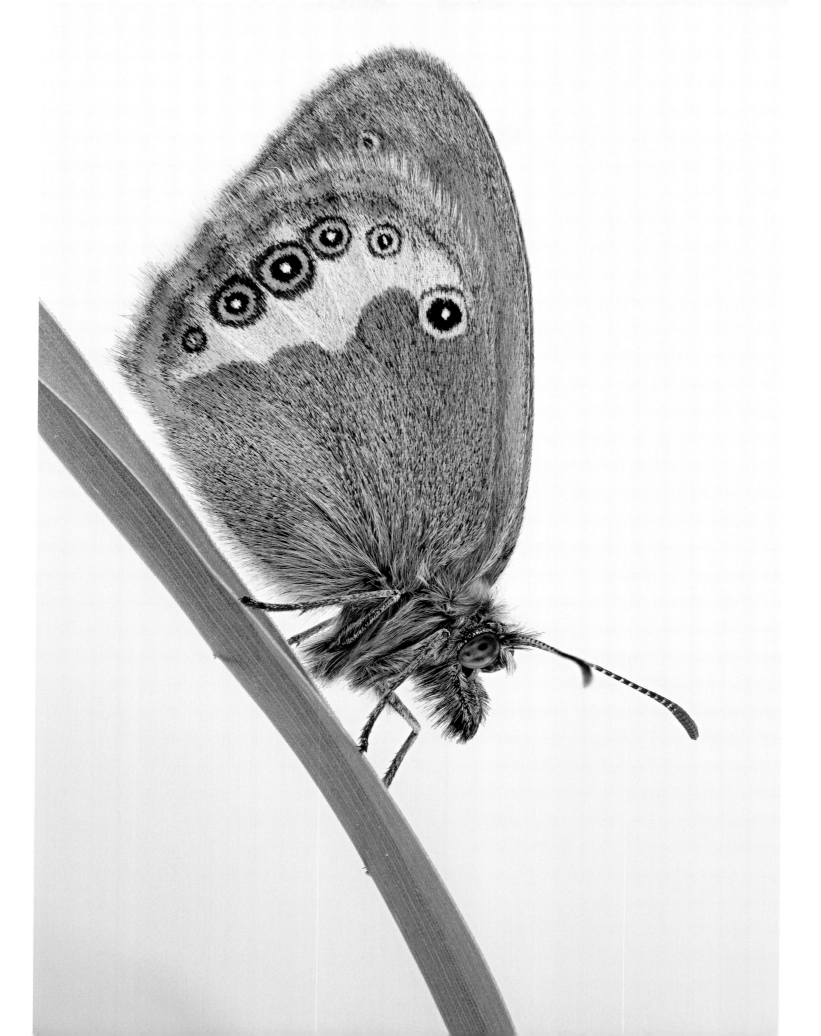

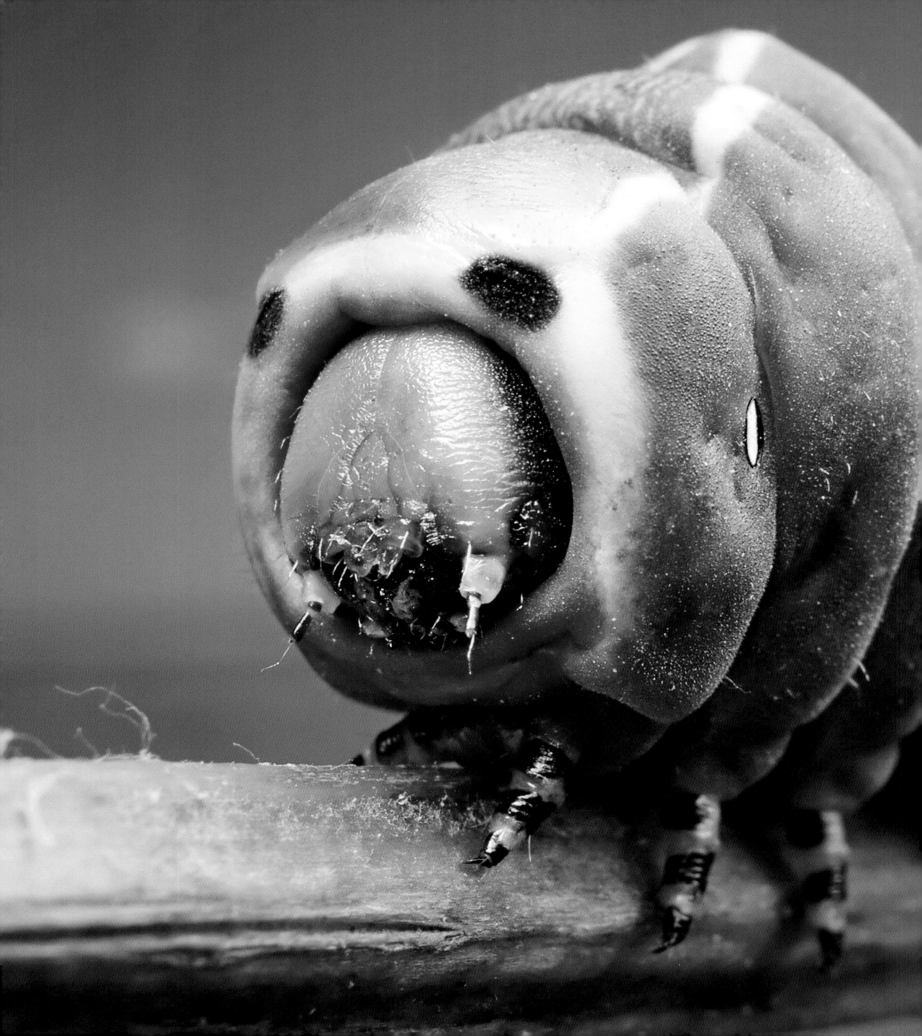

Puss moth *Cerura vinula*, caterpillar
Body length: 70 mm | Uppland (Väddö shooting range), 1 exposure

The fully grown larva is 55 to 70 mm long and has large spots of bright grass-green color on its sides. The first segment of its body surrounds the head with a red ring and two black spots at the top that resemble eyes.

This type of camouflage is called countershading. The shadow of the animal's body might inhibit the effect of the camouflage, and therefore it uses countershading to reduce the ease of detection. Light usually comes from above and casts a shadow, so the shadow is counteracted when the darker back of the animal blends into its lighter sides and abdomen. The result is that the three-dimensional impression of the animal is diminished. Countershading is especially common among mammals and also occurs in species of caterpillars that live on the undersides of leaves.

Lobster moth *Stauropus fagi*, caterpillar
Body length: 40 mm | Öland, 1 exposure

In the first larval stage, the lobster moth resembles an ant or a small spider. With each skin change it grows stranger and stranger in appearance. Its head grows larger and the two thoracic legs are extended. The joints in the front part of the back are equipped with sharp, raised humps. The last greatly swollen anal segment has claspers that have been modified into long, thin ribs. When in danger, the caterpillar raises itself up on both its front and rear body sections. This position, combined with its reddish-brown color, makes the caterpillar resemble a sitting squirrel. The long thoracic legs move back and forth, making the front part of the animal look like a spider, its head representing the spider's abdomen. The raised rear body parts resemble a species of *Heteroptera*. This rare caterpillar can be found on leaves of oak, linden, beech, and birch from May to July in southern Sweden up to Mälardalen.

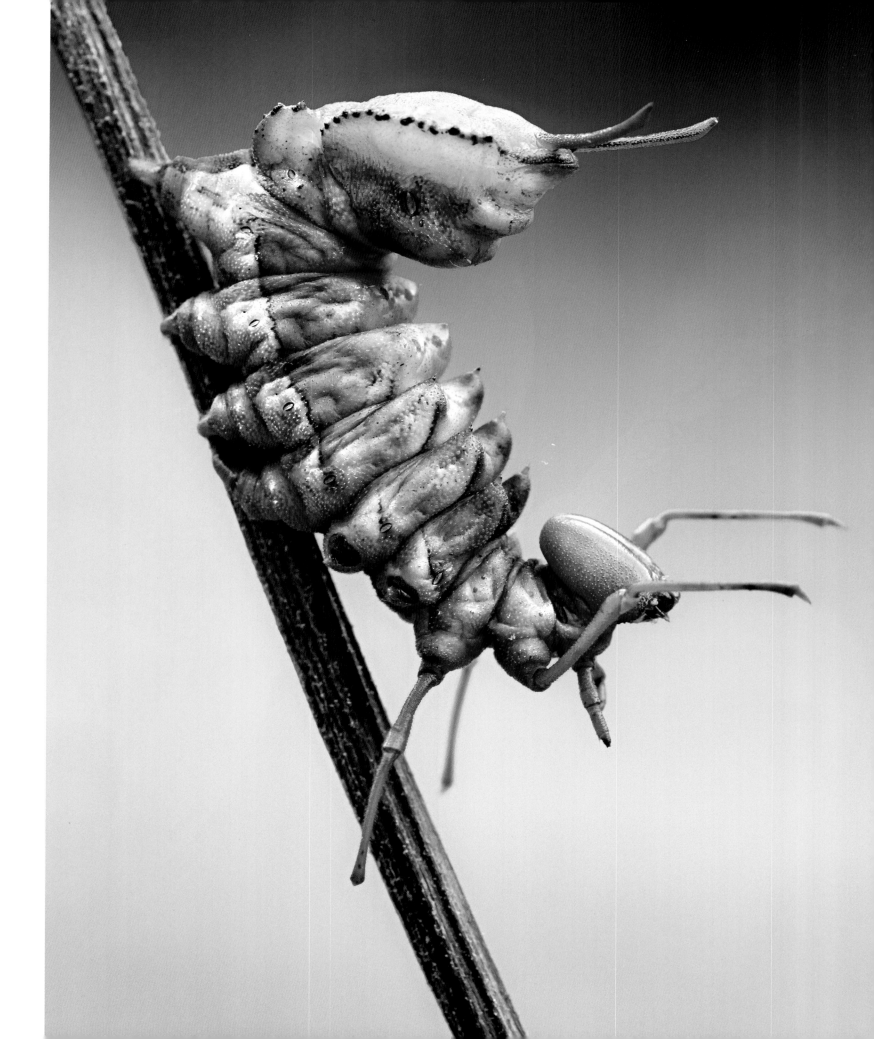

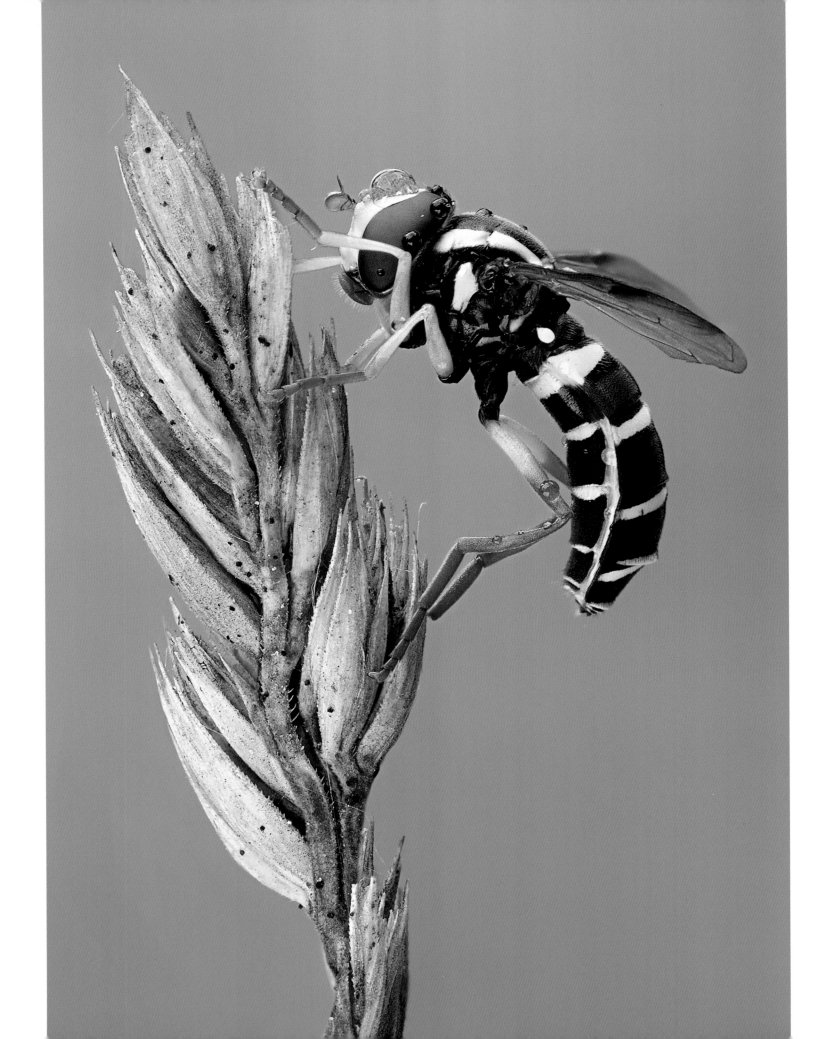

Barred ant-hill hoverfly *Xanthogramma citrofasciatum*
Body length: 10 mm | Södermanland (Nackareservatet Nature Reserve), 9 exposures

This hoverfly is an example of Batesian mimicry. The barred ant-hill hoverfly, harmless and defenseless, resembles a poisonous insect; in this case a social wasp. Wasps can sting and are therefore avoided by birds and other animals. The flies themselves do not have a sting to attack or any other way to defend themselves, but rather mimic the dominating warning colors of the poisonous species, often yellow, red, and black.

Thick-headed fly *Physocephala rufipes*
Body length: 11 mm | Södermanland (Nackareservatet Nature Reserve), 43 exposures

This fly cannot sting, but it resembles a solitary potter wasp that does. The colors of the wasp are black and yellow, which it uses as a warning to potential predators. The first segment of the fly's abdomen is long and narrow, while the others are broader and shorter, in the shape of a small ball. The name "potter wasp" is derived from the shape of the nests the wasps build, which resemble old-style clay pots.

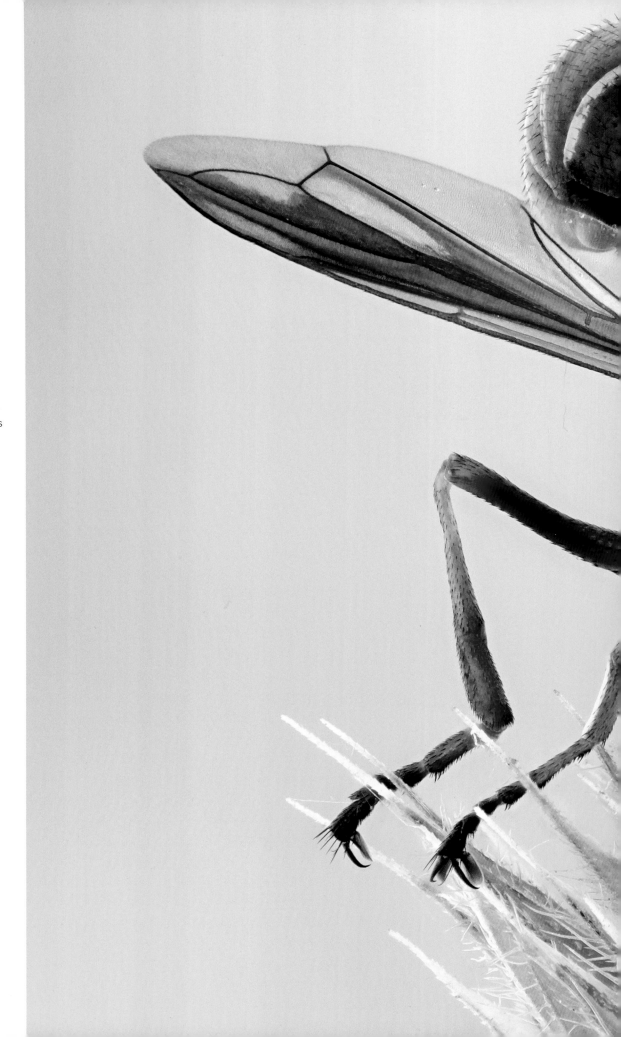

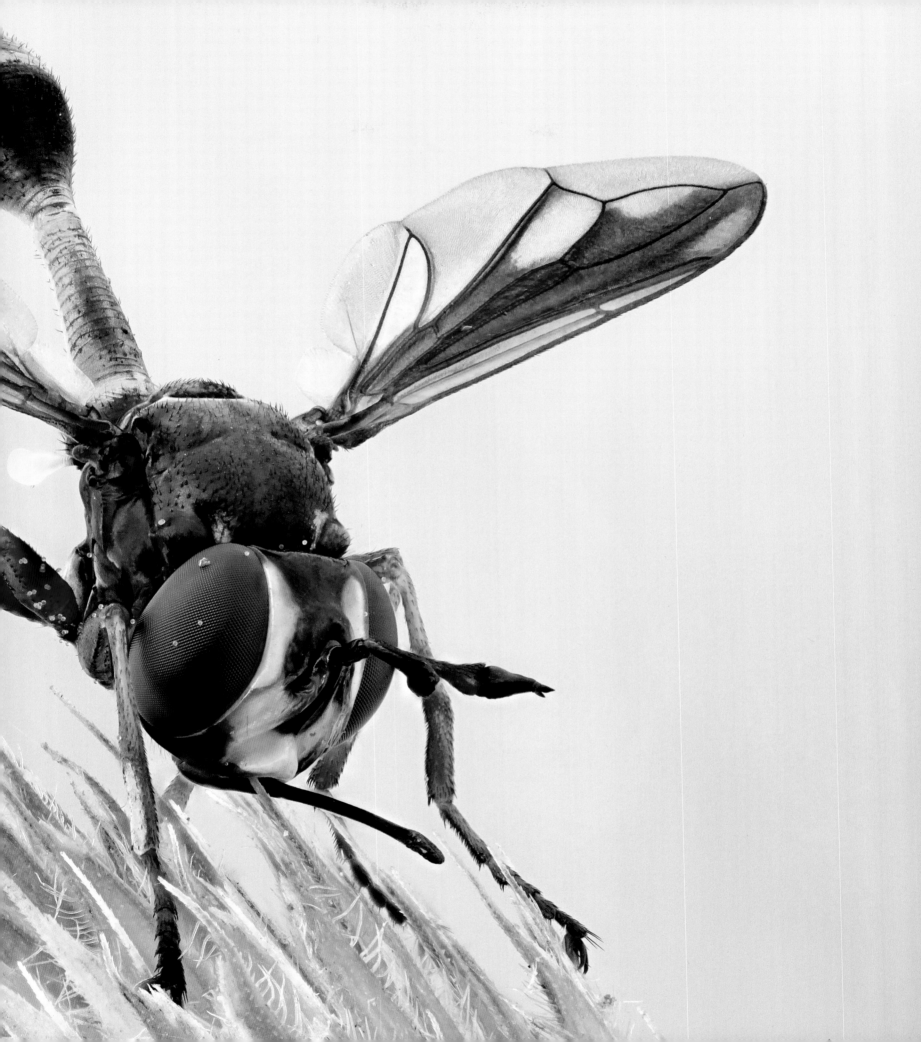

IN THE WORLD OF INSECTS, circumstances may quickly shift and change. Any species that is a hunter/predator may end up being hunted itself. Diet constitutes an important and central part in the lives of insects, and food shortages affect the population negatively. When studying insects and searching for connections and patterns in nature, one observes what insects eat—as well as what eats them. Usually these connections are very complicated. Herbivorous insects are an important nutritional resource for the predators.

There are many ways in which a predator will hunt its prey. Some sit very still in a suitable environment, waiting for prey to come close enough to be captured, paralyzed, or killed. Many predators using this technique are camouflaged so that they, in turn, can't be detected by birds, for example. Spiders have their own version of the "sit and wait" method, as they spin webs that trap flying insects. Predators may also be active hunters that, by flying or walking, find their prey. Others attract prey with the help of chemicals or light.

Long-legged fly *Dolichopus* sp., with the larva of a non-biting midge
Body length: 6 mm | Öland, 1 exposure

The long-legged fly has long, slender legs, hence the Swedish name, *styltfluga* ("stilt-fly"). The legs—especially the shins—usually have long bristles that can be helpful when capturing prey. The fly stretches its legs when sitting on the ground or in the vegetation, giving itself a full view of its surroundings. Fully grown flies and larvae are predators and mainly hunt smaller insects. The *Dolichopus* family prefers mosquito larvae, but the larva of a non-biting midge seems to work as well.

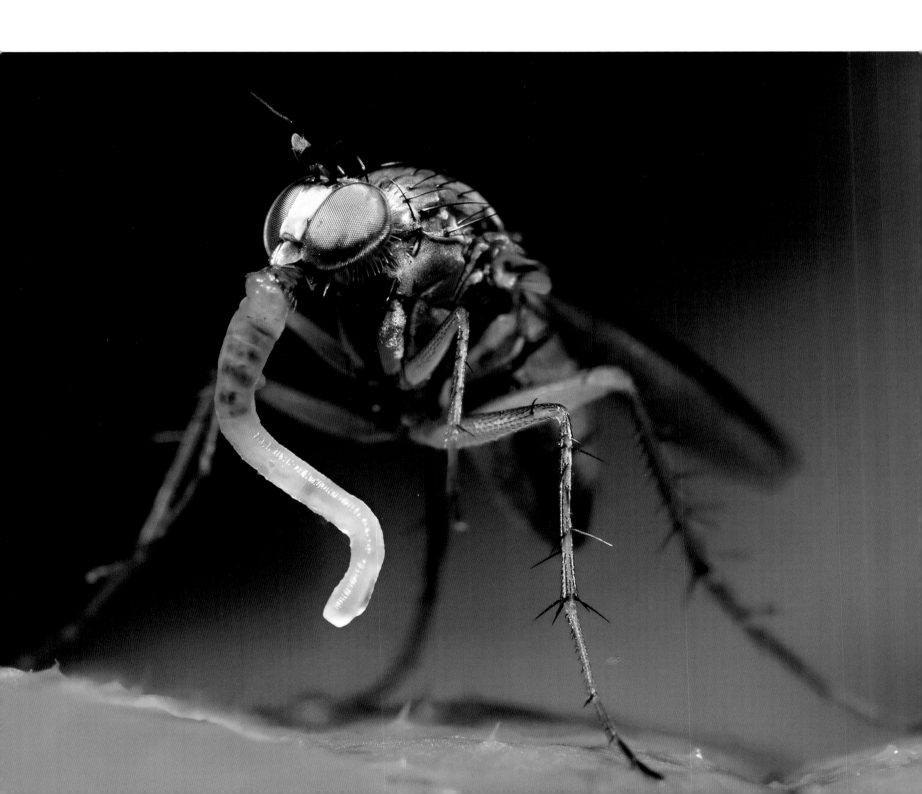

Golden-haired robberfly *Choerades marginatus*, with a 14-spotted ladybird beetle *Propylea quatuor-decimpunctata*
Body length: 13 mm | Öland, 1 exposure

It's not only the species with camouflaging markings that uses the "sit and wait" method. Fast-flying insects like the robberfly spend a lot of their time sitting on their exposed lookout posts. With their keen eyesight, they detect potential prey that may fly by, and with a quick and precise attack they capture their prey. This strategy is both energy and time efficient.

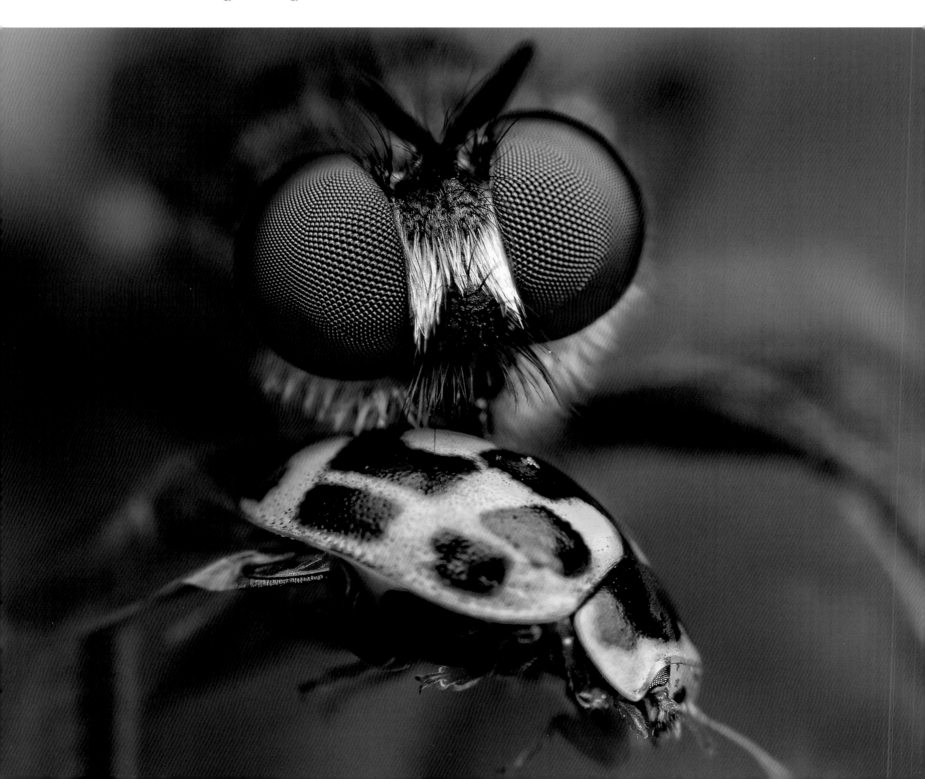

Robberfly *Neoitamus* sp.
Body length: 16 mm | Öland, 1 exposure

Here we see a typical example of the "sit and wait" position. You can almost see how eager the fly is to start hunting, even when it is absolutely still. It is like watching a sprinter in the starting blocks, between the "set" and "go." The fly's long and powerful legs are reinforced with long bristles. The robberfly's prey, which are mostly flying insects, are quickly caught using sharp claws, mouthparts, and bristles.

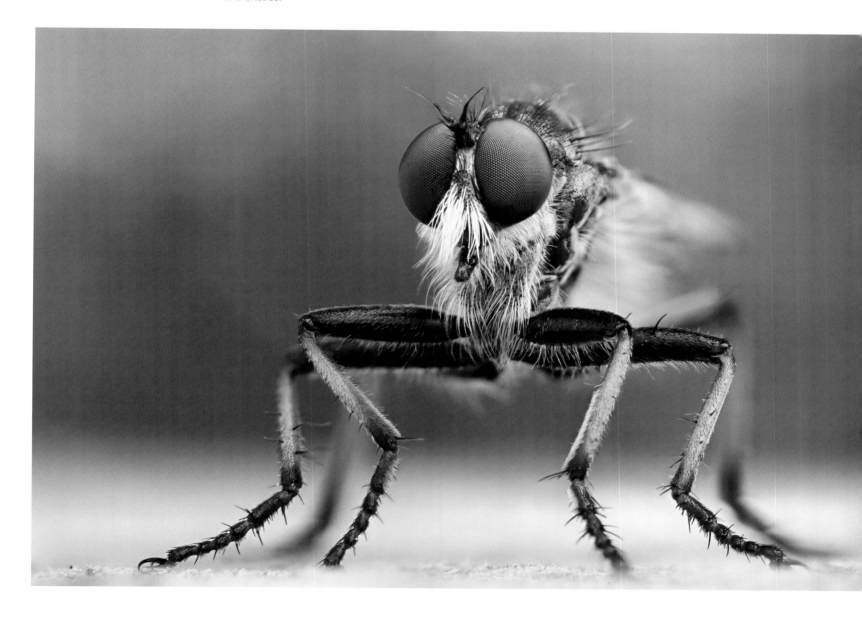

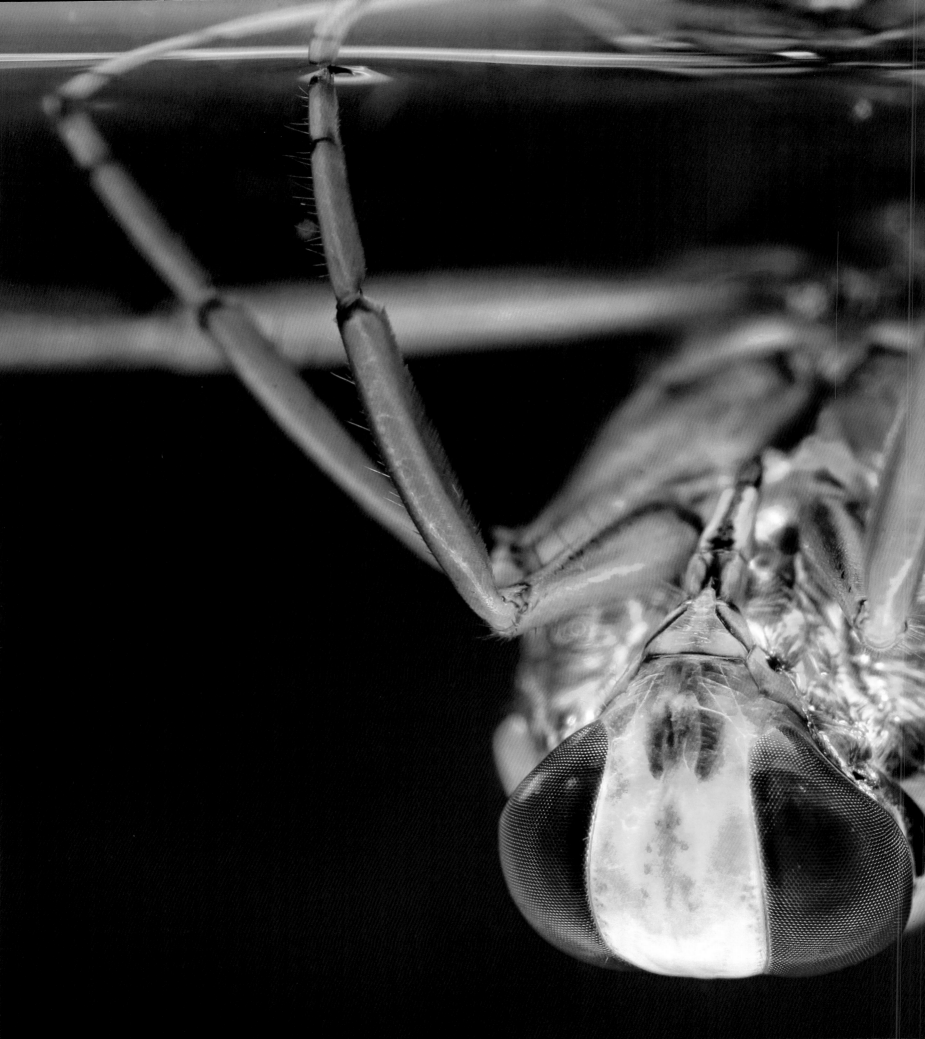

Common backswimmer *Notonecta glauca*
Body length: 18 mm | Öland, 1 exposure

This bug swims on its back and moves using its long hind legs that are equipped with long fringes for swimming. The backswimmer has a supply of air on the underside of its body (abdomen) and must occasionally refill it above water. It usually waits just below the surface, waiting for vibrations from potential prey. It lives on insects and other arthropods, small fish, and tadpoles. Once its prey is close enough, the backswimmer uses its piercing mouthpart to spear into the victim. A poison is transferred into the prey, which paralyzes and slowly turns its innards into a fluid mass, which can be sucked up by the backswimmer. Humans can also feel the sting of a backswimmer.

Marsh ground beetle *Elaphrus riparius*
Body length: 7 mm | Studio, 146 exposures

This marsh ground beetle is a predator that belongs to a large family of ground beetles. Several of the species in this group are typically colored in metallic green and bronze. They are markedly terrestrial and quick in their movements, with thread-like antennae and long, strong legs. They love the sun and stay out of the shade. This fast and cryptically marked species can be found at the edge of stagnant or slow-flowing water, often on bare soil or sand, but also on more muddy grounds. They prey on mosquitoes. Some ground beetles have specialized in searching for the pupae of midges.

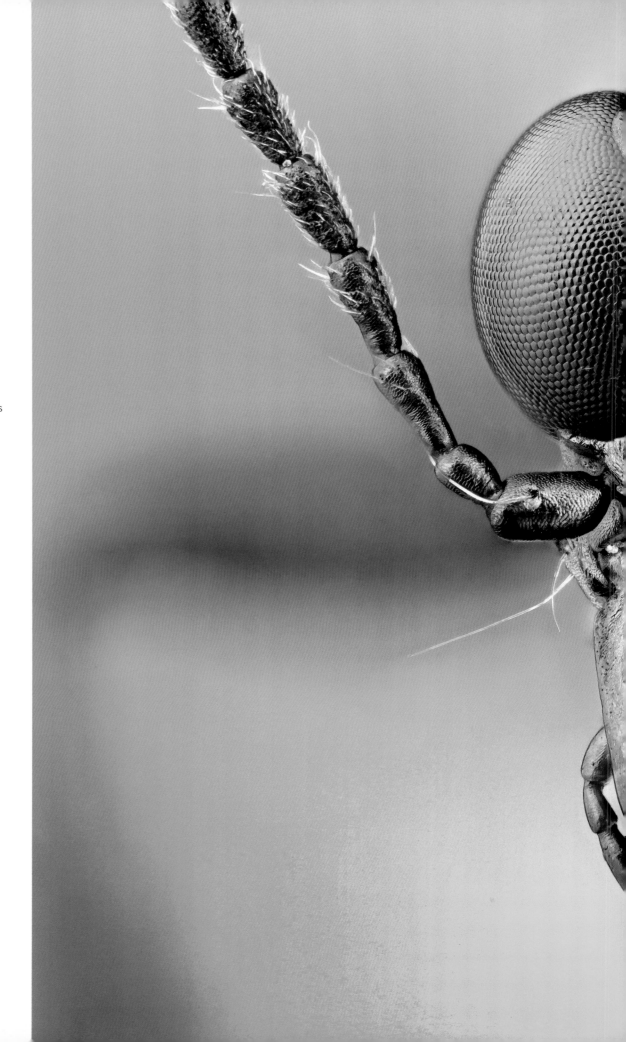

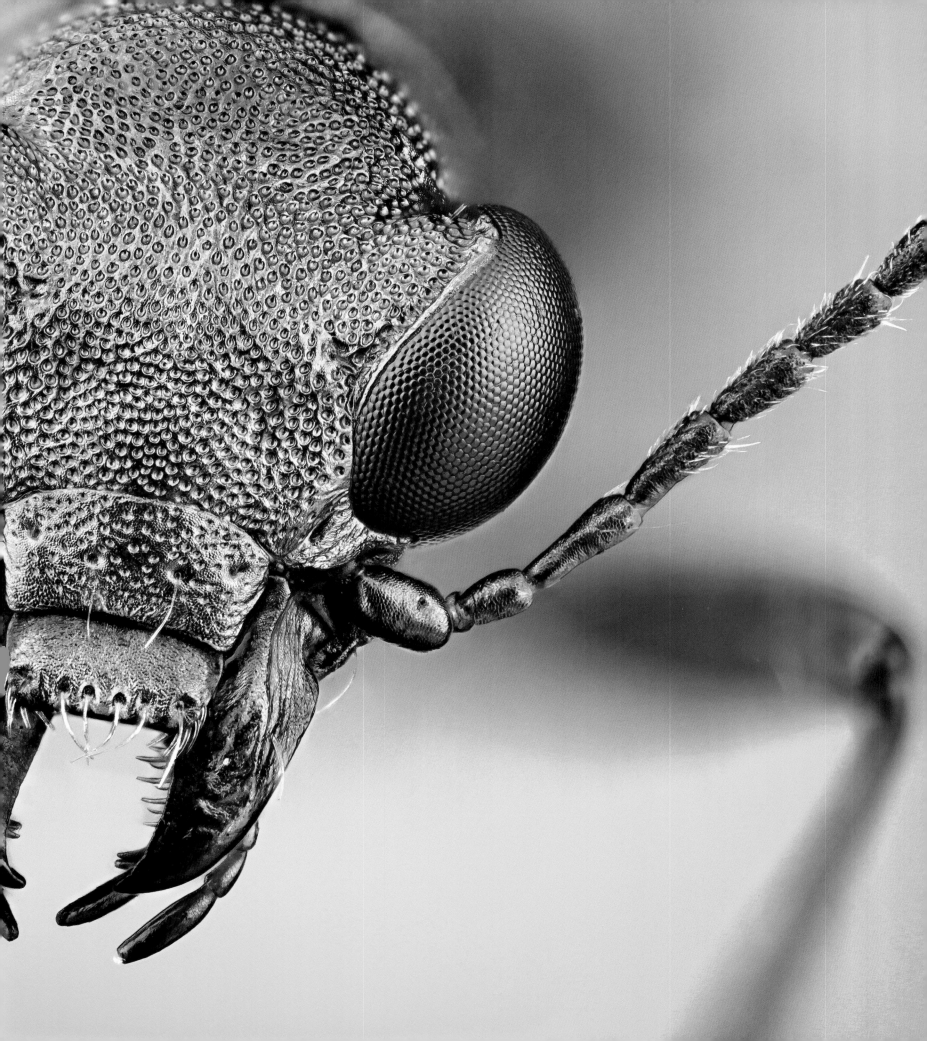

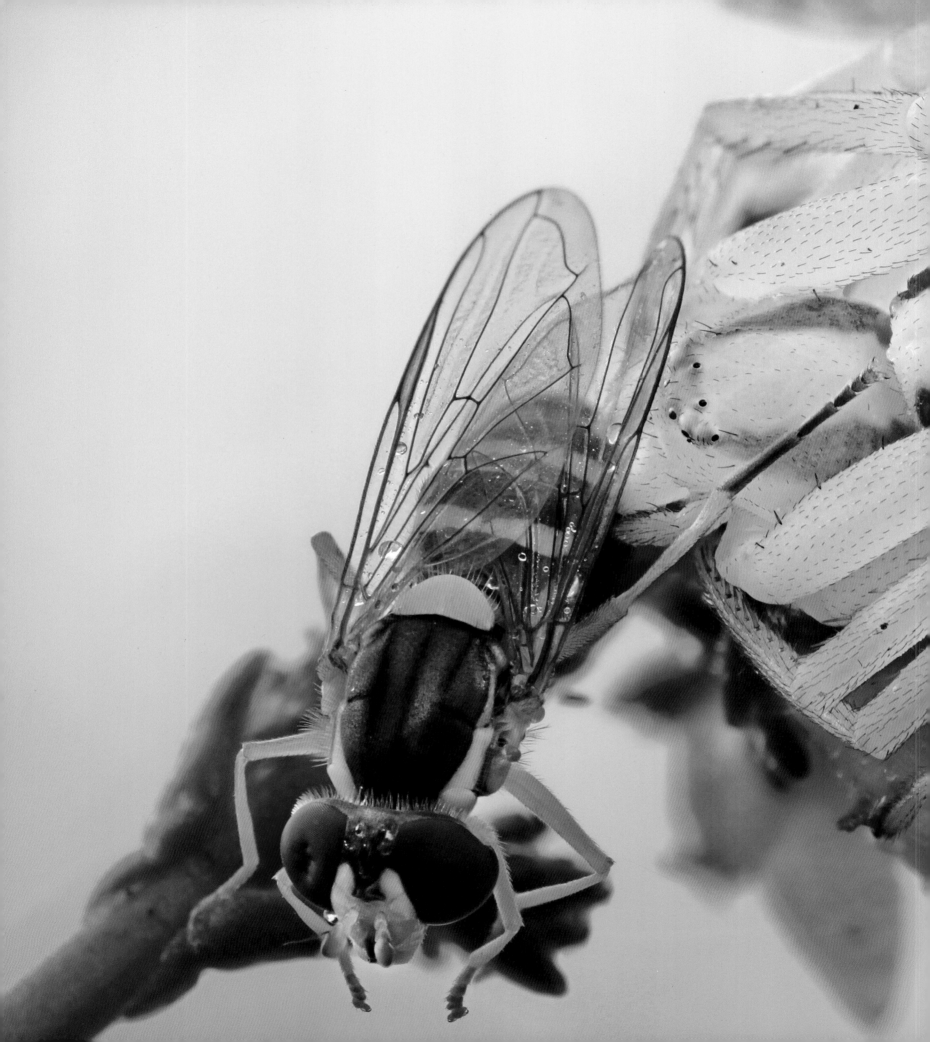

Flower (crab) spider *Misumena vatia*, with a long hoverfly *Sphaerophoria scripta*
Body length: 6 mm | Södermanland (Nackareservatet Nature Reserve), 20 exposures

The "sit and wait" method is often used by cryptically marked species like this female flower spider. The spider often has the same color as the flower it sits in. Often the female is found in flowers with accessible nectar, where many different species come to feed. A female will attack prey that is larger than her, such as bumblebees and honeybees. The flower spider's eight eyes are located on two rows. Actively hunting species need good eyesight, and they often have two eyes larger than the rest, centrally placed on the front of their head. Spiders can eat only liquid food; therefore they inject a poison that paralyzes, kills, and starts to break down the innards of their prey. The spider then sucks up the fluids.

Long-jawed orb weaver *Pachygnatha clercki*, ♂
Body length: 6 mm | Studio, 301 exposures

Semi-adult and adult long-jawed orb weavers have long and forward-facing serrated jaws. Amongst spiders, it is not uncommon for the female to eat the male after mating. The male long-jawed orb weaver avoids this by prying the female's jaws open and locking them. Long-jawed orb weavers are indirect hunters that build webs, trapping the flying insects that pass by. The webs of these spiders are wheel shaped, but unlike orb weavers such as the cross spider, the long-jawed orb weaver leaves the center of its webs open.

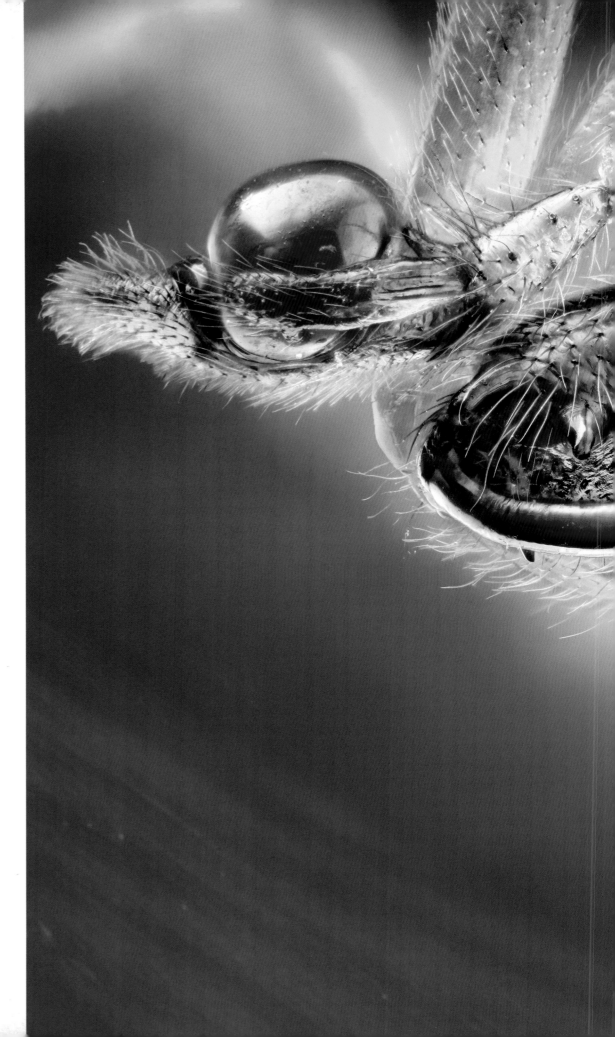

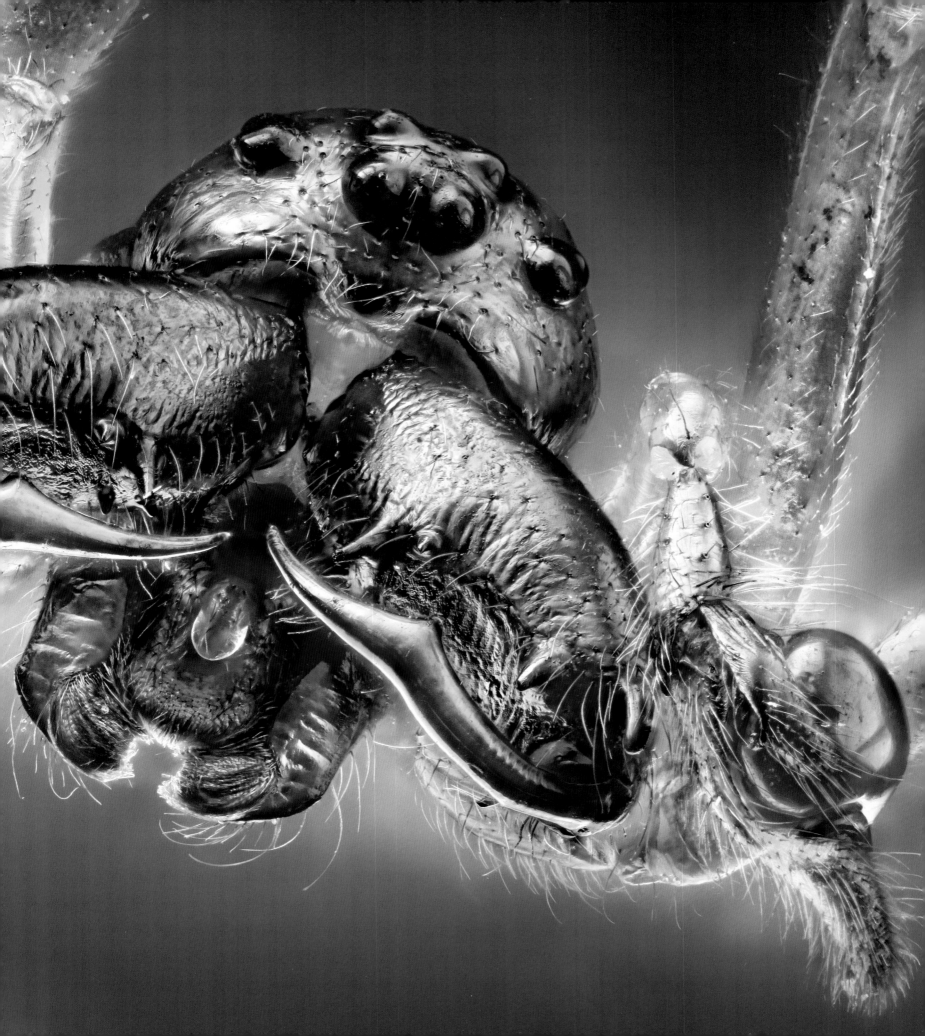

PARASITISM is a symbiotic relationship between species, where the parasite benefits at the expense of the host, sometimes even killing it. "Parasite" is the collective name for all the organisms that suck nourishment from other living organisms. The word comes from the greek *para* ("besides") and *sitos* ("food").

In the world of insects, we often associate parasites with parasitoid wasps. They are a large group of insects that lay their eggs in other insects. In Sweden alone, there are over 6,000 species that belong to the group *Parasitica*. The parasite larva that hatches from the egg can live outside or inside the host. The larva feeds, grows, and develops in or on the host. When the larva pupates, the host dies. The fully developed parasitoid wasp then lives a nonparasitic life, and with a diet that mainly consists of nectar. Few insects live their entire lives as parasites, as they would then die with their hosts. But there are permanent parasites such as the pure lice (*Anoplura*), which live on mammals.

A fairly frequent fraudulent behavior that exists among insects is freeloading, or brood parasitism. For example, female cuckoo bumblebees infiltrate an existing bumblebee nest and then either kill the queen or eat her eggs as they are laid. From then on the workers of the host nest will feed and grow the female cuckoo bumblebees' young.

A predator kills its prey at once, while the parasite uses its host for quite some time. The difference between predator and parasite is not completely clear, however, and therefore parasites are sometimes considered to be specialized predators.

Black tinder fungus beetle *Bolitophagus reticulatus*, with mites *Astigmatina*
Body length: 6 mm | Södermanland (Nackareservatet Nature Reserve), 9 exposures

The animals on this beetle's back belong to a group of mites called *Astigmata*. They sit on the beetle until they've been transported to a new suitable food source. Many of the *Astigmata* mites have a particular transport stage, which corresponds to the insect pupal stage. They are not subject to any transformation, but purely dormant, with no active mouthparts or anus. They often attach themselves to their host using either suction plates or claws, clinging on to a strand of hair or anything similar. These animals have a very high reproductive potential, which can be seen in this image, and can quickly and completely invade a new food source.

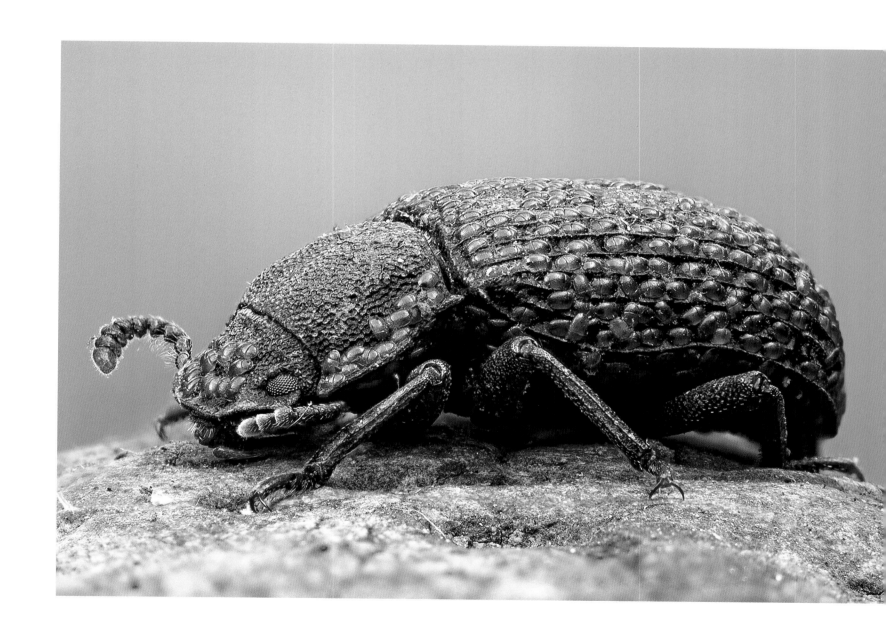

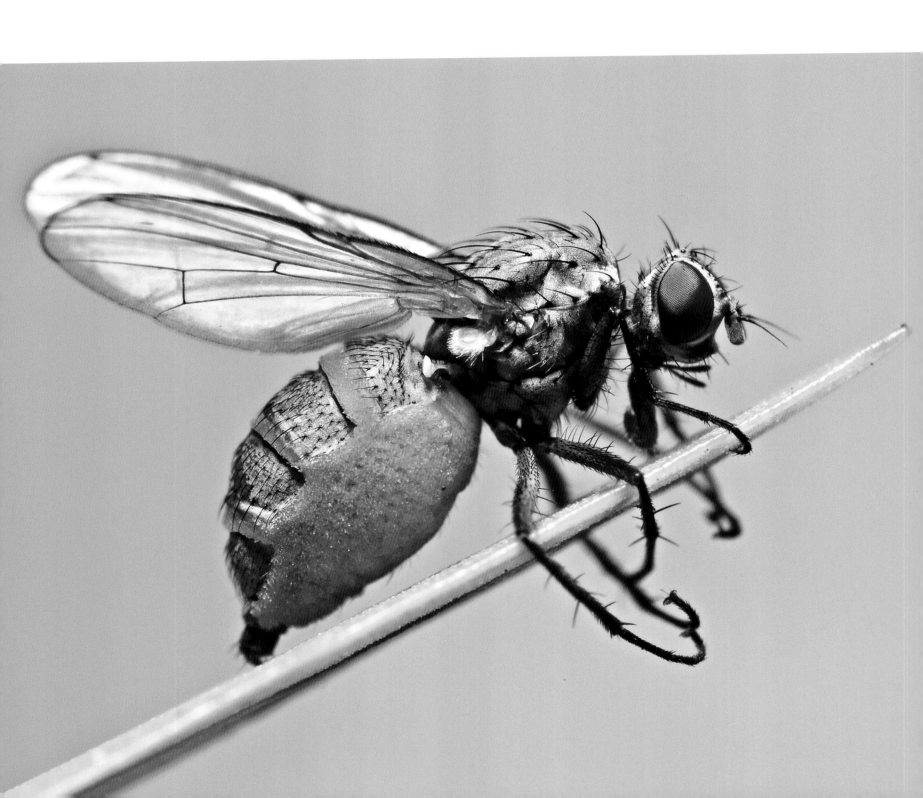

Anthomyiidae fly *Anthomyiidae*, infected by fungus
Body length: 6 mm | Öland, 1 exposure

This picture depicts a parasitic fungus growing out of the dying fly's body. Maybe the fly is being *forced* to climb the blade of grass so that the fungal spores can be spread over a large area. Fungi, which kill insects, are common in nature, and there are thousands of different species. These fungi penetrate the body of the insect, killing it in the process. There are two particular types of parasitic fungi, green and white muscardine fungus.

It has been observed that green muscardine fungus kills many different types of insects by penetrating their bodies with the cell threads (hyphae) of the fungal spores. A few days after the insect's death, the fungus grows out through the body of the insect, where it becomes reproductive. In the beginning, you can see only the white hyphae, but as the fungus matures, it takes on a distinctive olive-green color. The spores can vary in color from white to brown or green. A mixture of this fungus and oil is currently being used in Africa to fight off the migratory locusts.

Muscardine fungus is an aggressive fungus that attacks a wide variety of insects, both larvae and adults. The fungus produces tiny spores that penetrate the insects' exoskeleton. After the attack, when the insect is dead, a powdery white substance settles on its surface. The fungus can be found naturally in soils worldwide.

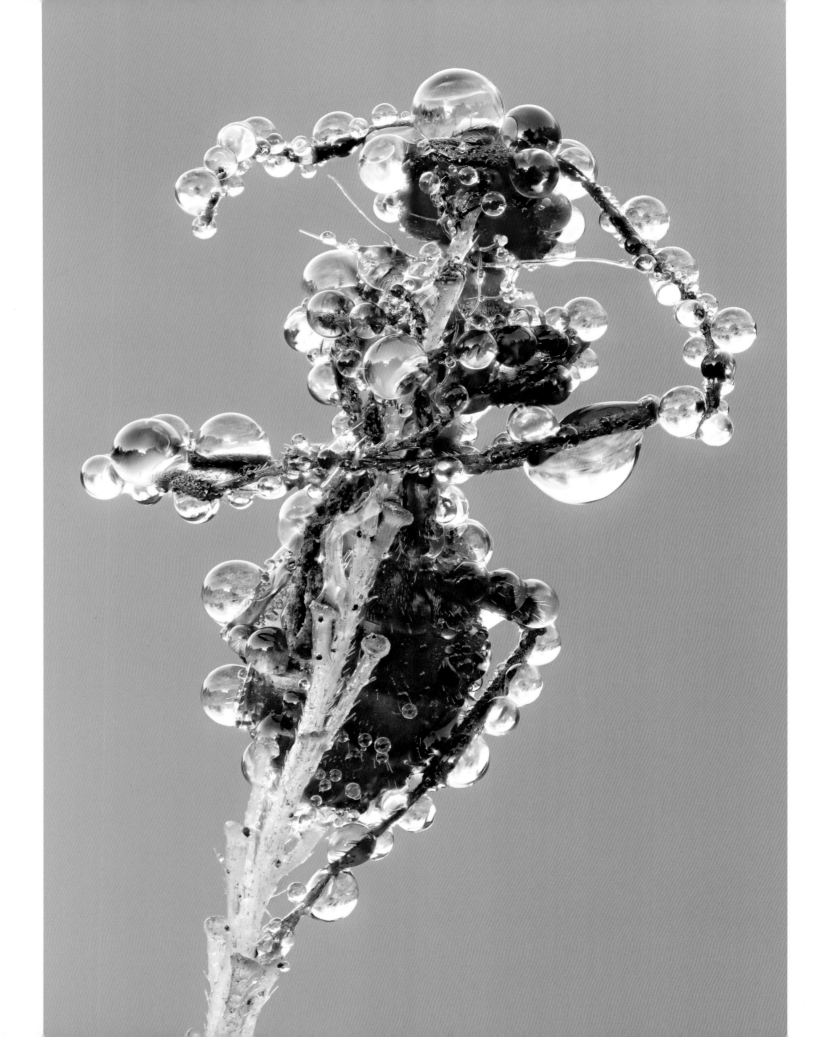

Wood ant *Formica* sp., infected by fungus
Body length: 7 mm | Södermanland (Nackareservatet Nature Reserve), 94 exposures

Earwig *Forficula* sp., infected by fungus
Body length: 13 mm | Södermanland (Nackareservatet Nature Reserve), 74 exposures

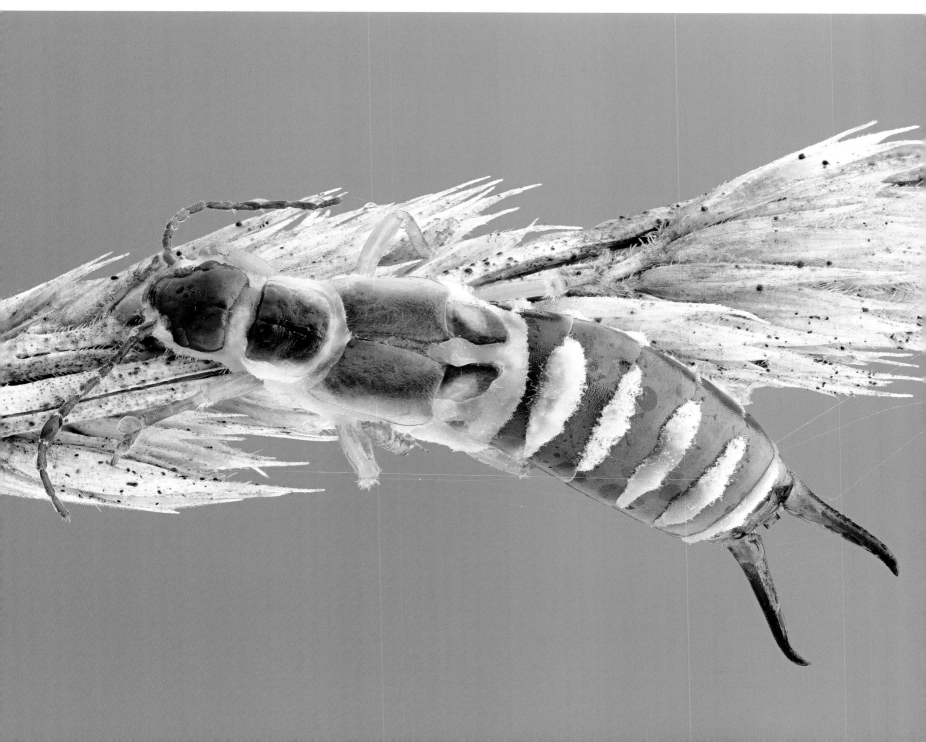

Parasitic wasp *Lissonota halidayi* ▶
Body length: 9 mm | Södermanland (Nackareservatet Nature Reserve), 32 exposures

Here is a fully formed parasitic wasp (parasitoid), of the species that sometimes are referred to as scorpion wasps (or ichneumon wasps). In the fully developed stage, like the wasp in the picture, it's no longer a parasite, but rather feeds on nectar from flowers. There are about 2,700 species of true parasitoids in Sweden alone. They are characterized by their multi-jointed antennae and wing venations. The abdomen has a tube-like shape, and the females are usually equipped with long ovipositors. They generally lay their eggs in other insects, and the larvae live like parasites in their hosts' bodies, but there are also other species that live outside the body.

In the genus *Lissonota*, there are five species, of which *Lissonota halidayi* is the only one that resides in Sweden. Its larvae live as parasitoids inside snouth moths (or *Pyralidae*).

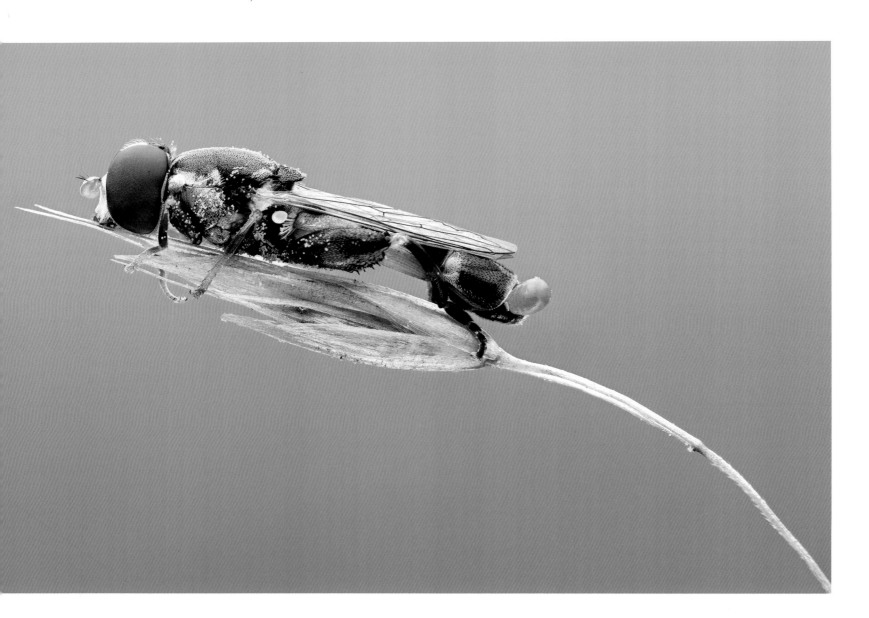

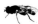 **Thick-legged hoverfly** *Syritta pipiens*, with parasitic velvet mites *Prostigmata*
Body length: 8 mm | Öland, 6 exposures

The mites on this hoverfly are larvae of a species that usually carries the name velvet mite. Many of the fully formed mites are bright red and hairy, hence the name velvet mite. It's only the larvae that are parasites, as the other stages—two chalimus and one adult—are predators. There are about twenty species in Sweden, and one thing they all have in common is that their larvae are parasites, mostly on insects or other invertebrates such as spiders. The hoverfly in the image is dusted with yellow pollen, most likely from a daisy, aster, or sunflower.

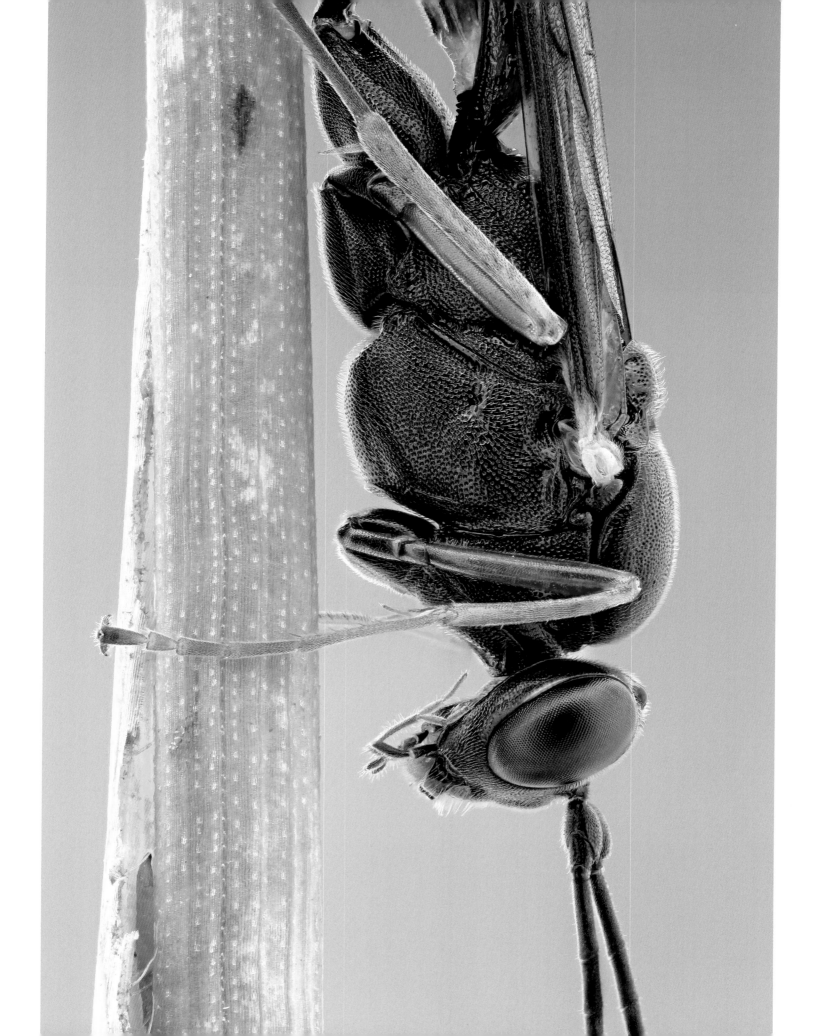

Black oil beetle *Meloe proscarabaeus*, ♂

Body length: 19 mm | Södermanland (Nackareservatet Nature Reserve), 1 exposure

This black oil beetle is a large, clumsily built beetle with a peculiar appearance where only stubby, shortened wing pads are left. They are bluish black and vary in size from 11 mm (often males) to 35 mm (often females). The abdomen of the female is swollen and can contain several thousands of eggs. Their legs are strongly built and their feet are long. The males have a grappling hook in the middle on their antennae that they latch onto the female's antennae during courtship.

The larvae grow inside the nests of solitary bumblebees, mainly those of the *Andrena* genus. The fully developed beetles are diurnal herbivores, seen in the spring and early summer when they're mating. The female then digs a hole in the ground for the eggs, and by the middle of June, you can see the odd, yellow larvae (called tringulins) climbing up onto flowers. There they wait for a host bee that they can attach themselves to. They cling onto the bees and take a free ride down into the host's burrow. Once there, their bodies change shape and they start feeding on the bees' eggs and larvae, as well as the pollen and nectar stores that have been collected.

When the larva has emptied the cell where it was first placed, it proceeds to the next—and so it continues—until it is fully grown. The black oil beetle is classified as vulnerable, which means that the species has drastically declined in recent years, a direct reflection of the decline in populations of solitary bees in the Nordic countries. Increasing threats are disappearing pastures, asphalting of sandy back roads, and active reforestation of dry meadows. The restorations of gravel pits and the rapid overgrowth on dry, often sandy or gravelly slopes have eliminated the habitats of both the black oil beetle and its host species.

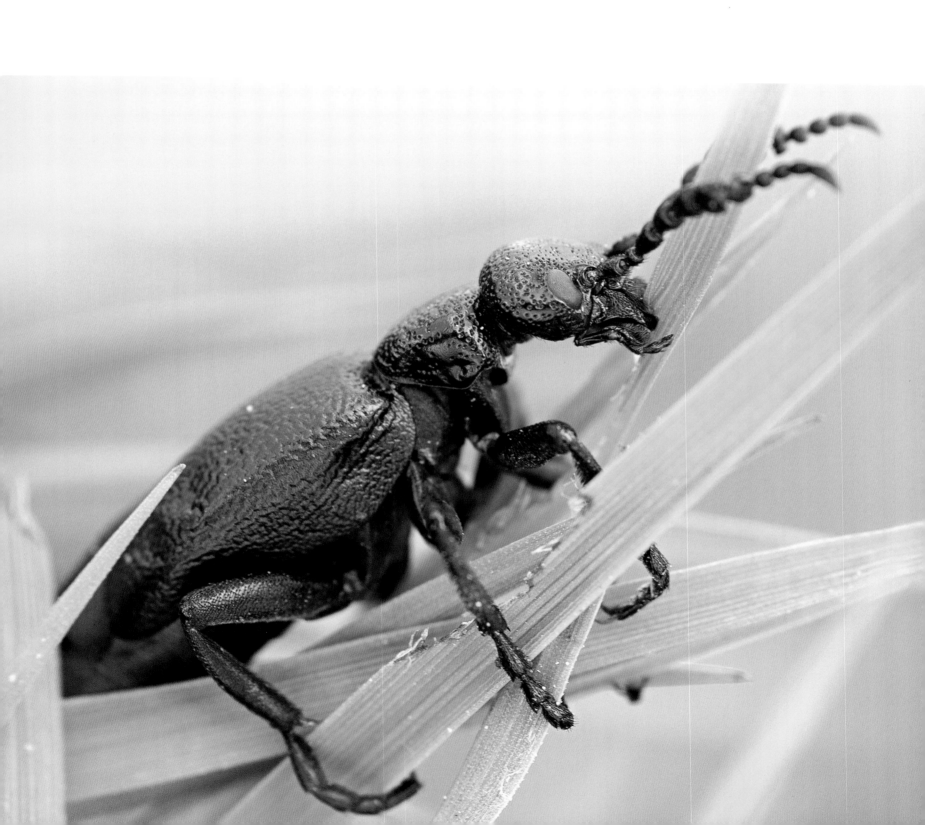

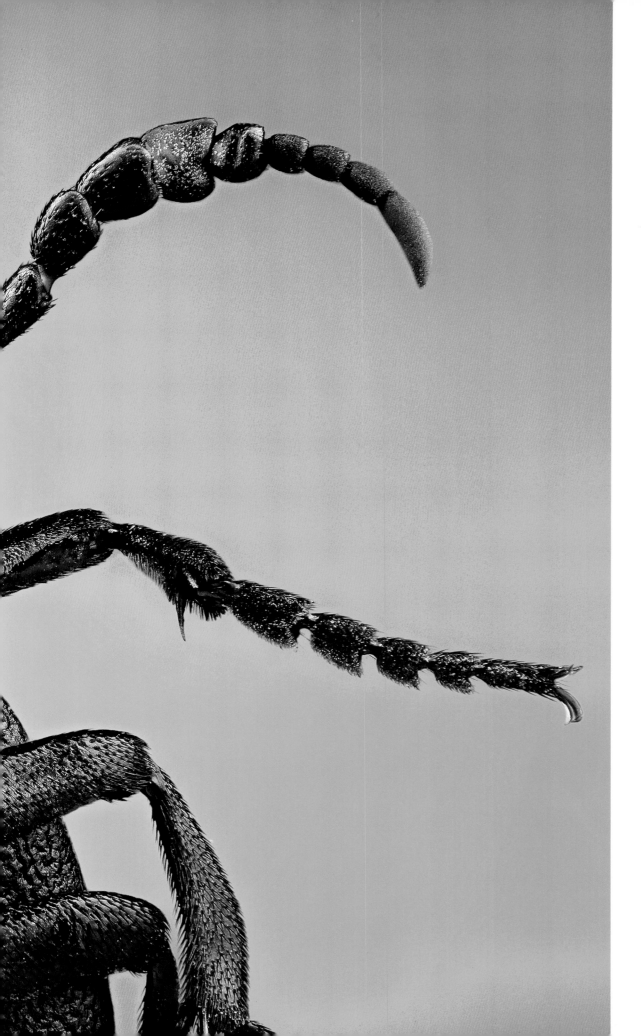

Black oil beetle *Meloe proscarabaeus*, ♂
Body length: 19 mm | Studio, 188 exposures

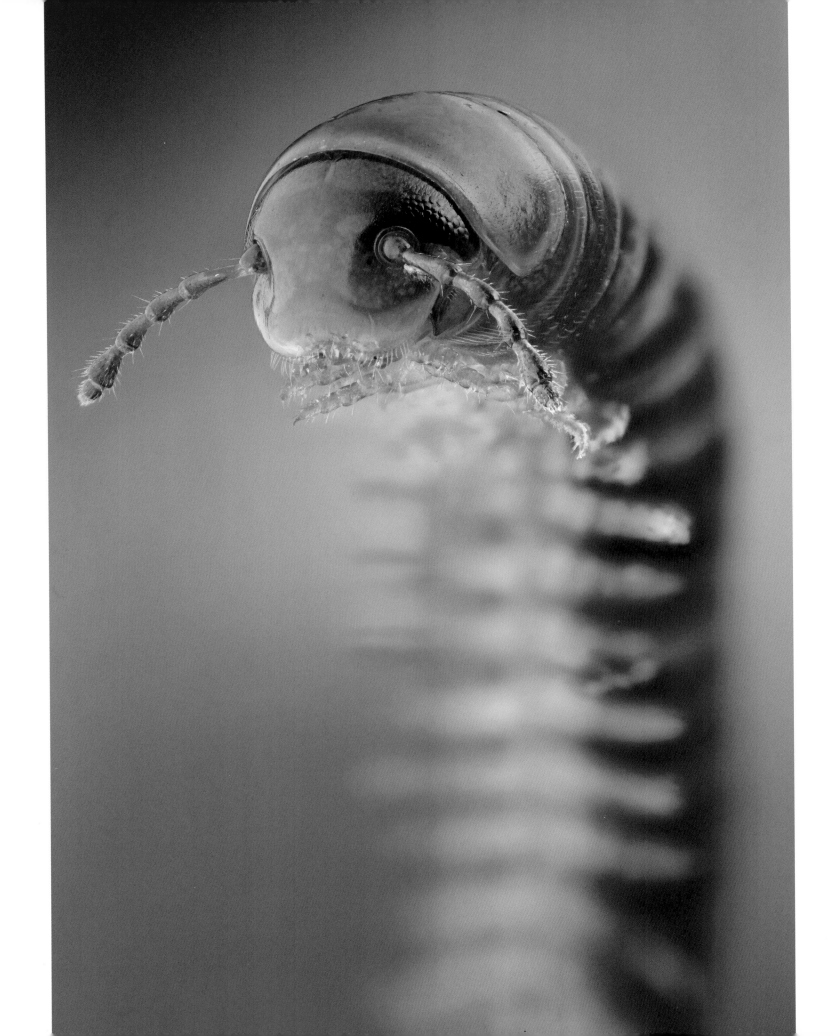

M

ANY SPECIES thrive in dark and damp places. Some are also nocturnal and spend their days underneath rocks, vegetation, loose bark, rotting wood, compost, or underground.

If you wish to study insects that live this way, a good strategy would be to find areas with varied fauna and flora. An overgrown garden, a park with a lot of shade, or the nearest grove can be good places to start. Such sites provide vital habitats for many species that want both moisture and darkness. The humidity of the area should also vary, as some species prefer more moisture in the soil than others. When you are familiar with the species in your immediate surroundings, you can then extend your search.

So as not to disturb the surveyed spot, you should always put the stones back in the exact same place as they were found.

Millipede *Julidae*
Body length: 20 mm | Studio, 80 exposures

The family *Julidae* are myriapodous arthropods (millipedes) of the *Diplopoda* class. Millipedes are uniformly built, with a head and a multi-segmented body and several body rings that bear their legs. At the rear, there are several body rings that are legless as well as the final tail ring. The side plates of each segment have melted together with the back plate, forming a unit known as the body rings. Starting with the fourth pair of legs, the body rings have two pairs of legs per body ring. The shape and type of a millipede's eyes vary from a row of simple eyes to a large, rounded area with simple eyes. Often the first and second pairs of legs of the males are hook shaped, used during courtship, when the male and female cling to each other. Millipedes play an important role in the ecosystem, as they are involved in breaking down the rotting leaves and other plant parts. There are twenty known species of *Julidae* in Sweden.

Black snail beetle *Phosphuga atrata*
Body length: 11 mm | Södermanland
(Nackareservatet Nature Reserve), 18
exposures

This black snail beetle belongs to the family of
carrion beetles. Their bodies are long and flat,
with a sharp-edged neck shield, club-shaped
antennae, five-membered tarsi, and protruding
cone-shaped front feet. Most species feed
on carrion and are known for their extreme
sense of smell that allows them to find dead
animals from faraway distances. But unlike
other carrion beetles, this species does not
feed on carrion, but rather on live snails. The
black snail beetle prefers the moist woodlands,
where it looks for snails during the night. It
has an elongated narrow head that it uses to
reach the snail even if it withdraws into its
shell. Their larvae are also predators.

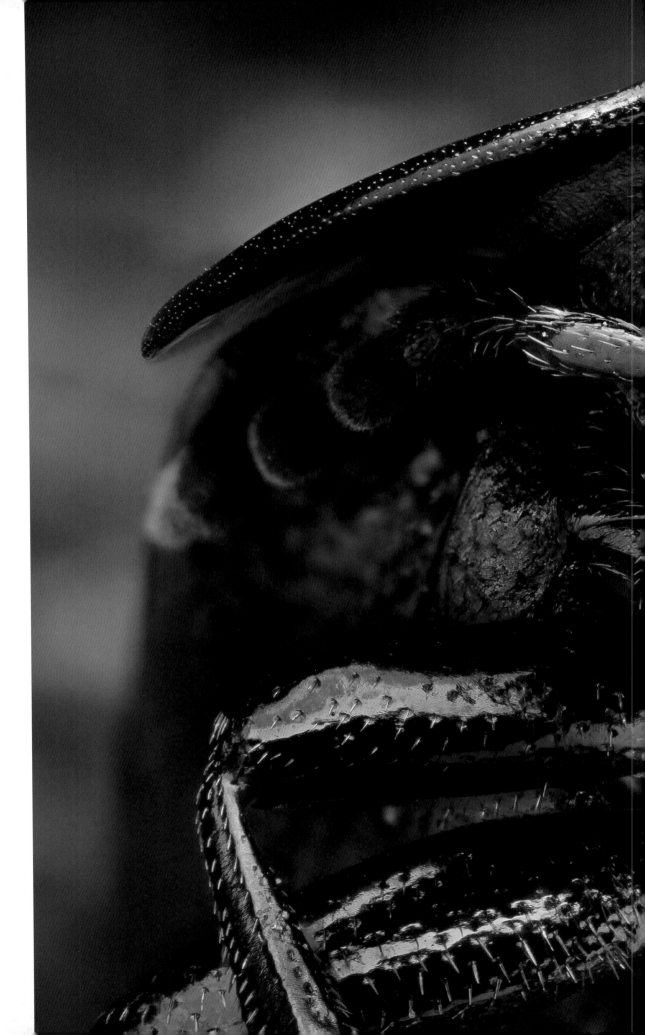

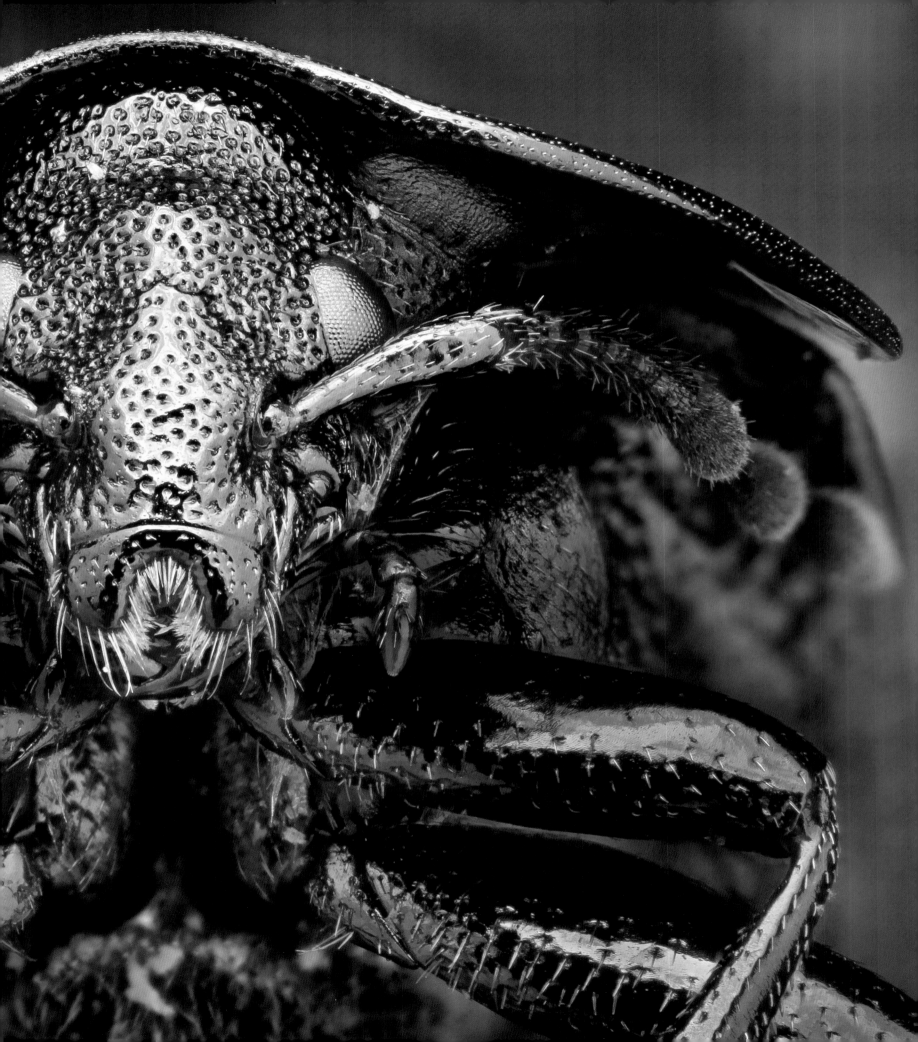

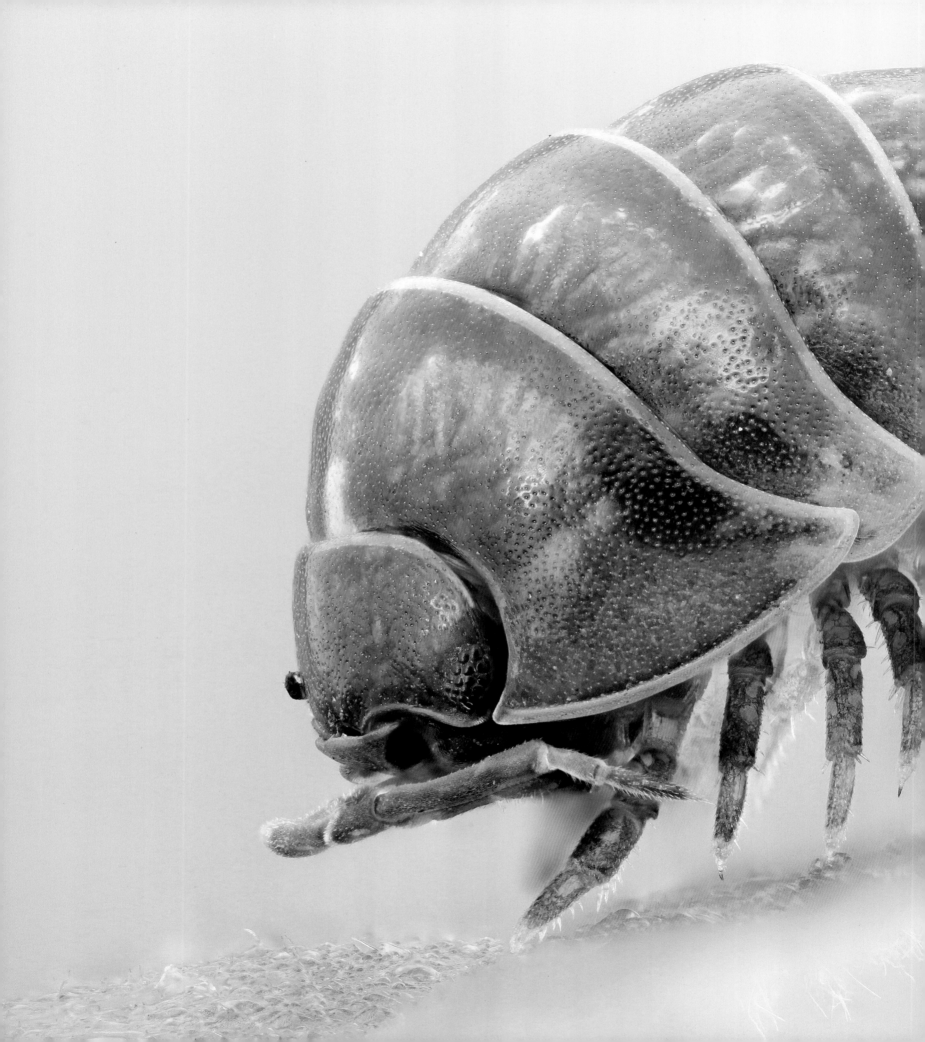

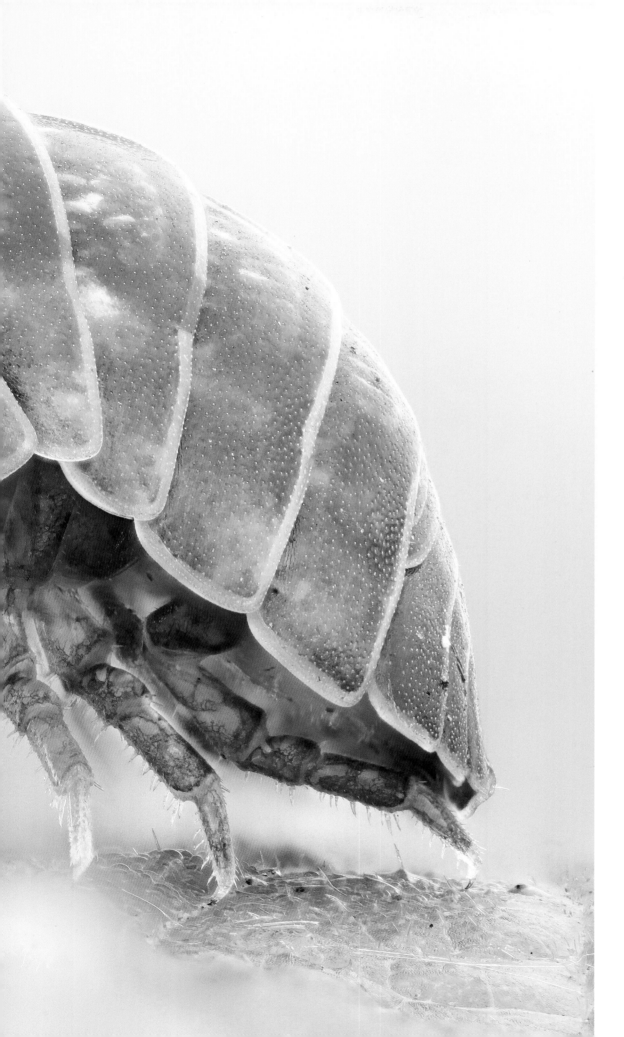

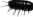

Pillbug *Armadillidiidae*
Body length: 7 mm | Öland, 96 exposures

The pillbug can roll up into a ball, hence its Swedish name, *klotgråsuggor* (roughly translated to "globe-shaped gray sowbugs"). Pillbugs belong to the crustaceans, and just like them, they breathe with gills located on their seven rear pairs of legs. These gills force the terrestrial species to reside in moist environments. Pillbugs also have lungs, but these account for only about 5 percent of their oxygen uptake. They presumably live off of a mixture of plant material and microorganisms. Pillbugs are of great significance to the comminution of dead leaves and are an important part of the soil ecosystem. There are several related species that occur in deciduous forests, particularly on calcareous soils. Its Swedish name—*gråsugga* ("gray sowbugs")—might be based on the fact that they resemble small gray pigs that eat things humans won't.

Springtail (no English name) *Allacma fusca*, ♂
Body length: 3 mm | Öland, 10 exposures

The springtail is almost circular in shape with a well-developed jumping fork, a kind of catapult that allows them to rapidly jump away from predators. This fairly common long, dark brown globular springtail can grow up to 3.5 mm, and their bodies have long and pointy bristles. You can find them in humid environments close to the ground, preferably on pieces of wood and plants.

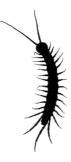

Stone centipede *Lithobius* sp.
Body length: 25 mm | Studio, 308 exposures

Stone centipedes belong to the class *Chilopoda*, which are characterized by their (when viewed from above) flat, segmented body. Each body segment has a single pair of legs. The top of the head is covered by a plate, the sides are covered by panels, and a shield lies underneath the jaw, which all together form a head case. The number of simple eyes varies, both between and within the species. The stone centipedes are predators that primarily feed on other invertebrates. Most species of *Chilopoda* run away when they are attacked, but some species curl up instead, making it difficult for the predator to reach them. In Sweden, the genus includes fourteen species.

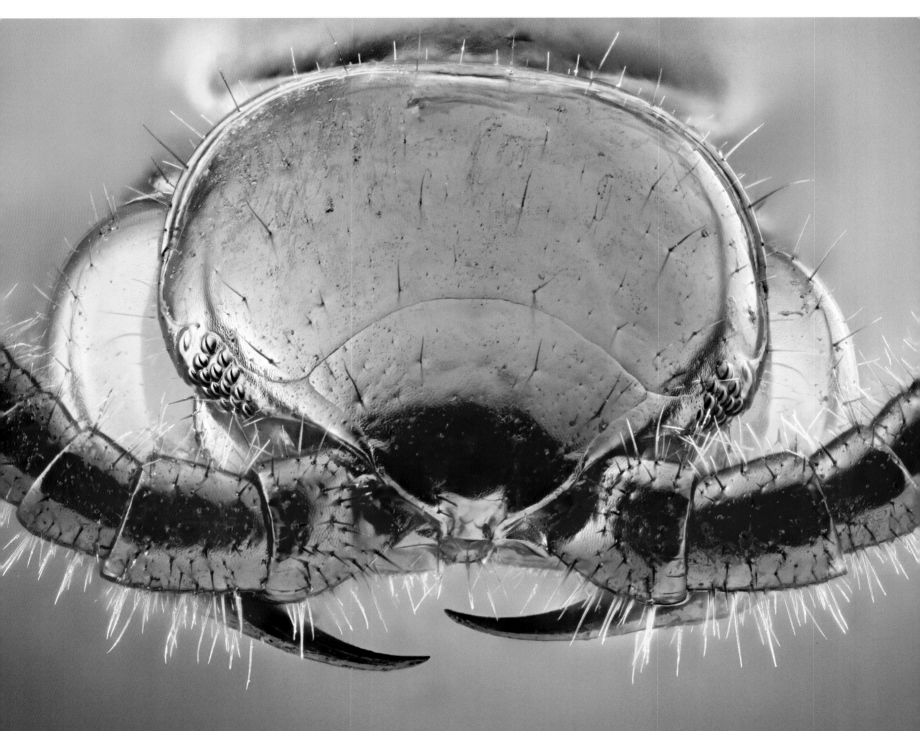

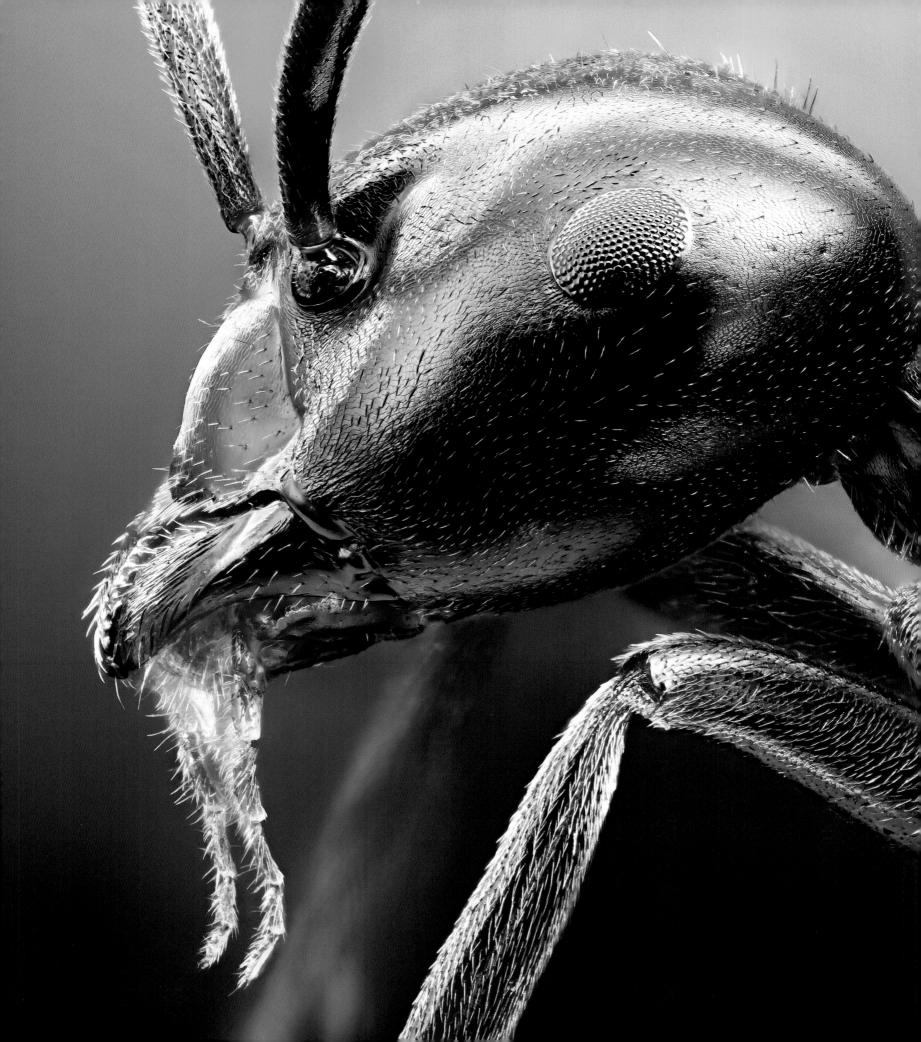

Jet ant *Lasius fuliginosus*
Body length: 4 mm | Studio, 241 exposures

In Sweden, this ant is also known as the glossy or shiny black wooden ant. This 4-to-6-mm-long ant is relatively easy to recognize thanks to its shiny black color and wide head. Another characteristic is the orange-like scent that the ant emits. Its jaws are relatively weak, but small insects like aphids can easy be taken as prey. You can find these ants walking in a narrow line up and down the stems of older trees, usually to milk the aphids of their honeydew. Their nests are mostly built in dead wood, such as the base of old trees and hedges, but they have also been known to nest in sand dunes and old walls. If another species of ant attacks their nest and its inhabitants, these ants produce an odor that repels the attackers.

These ants can also build their nests in fresh timber, including that used for building houses, which, in turn, leads to a conflict between them and humans.

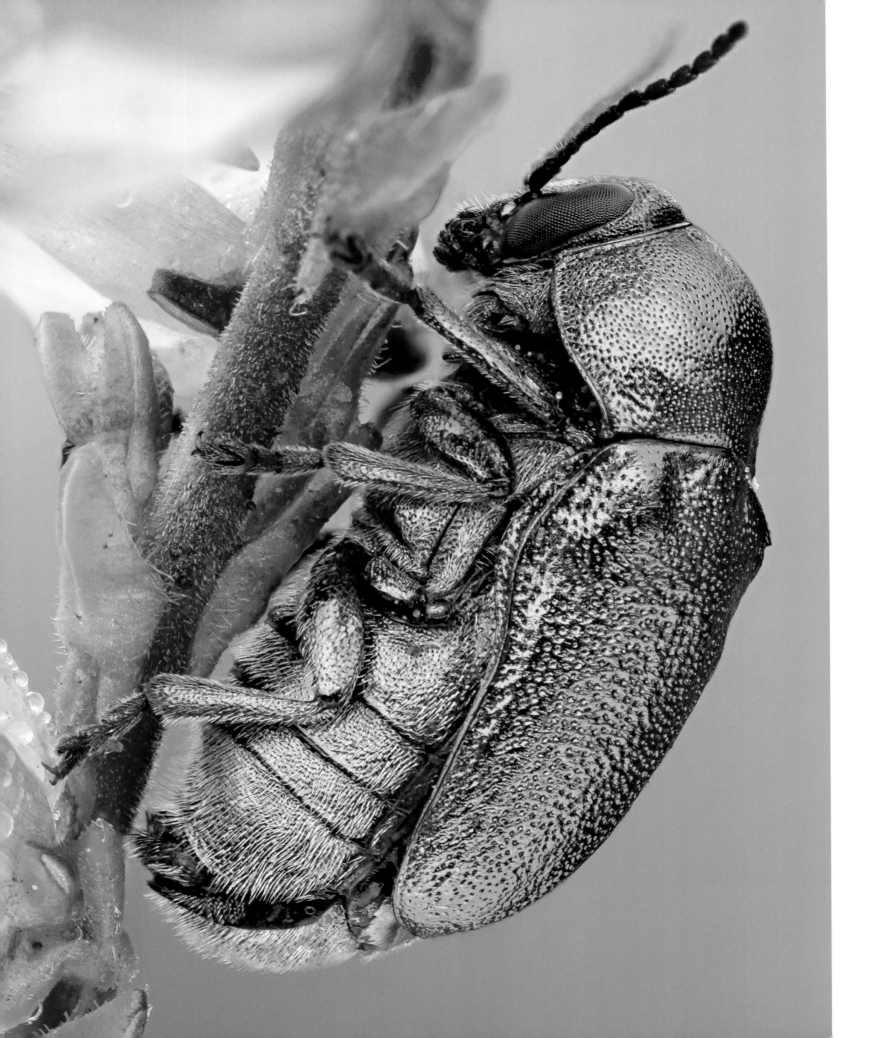

There are a large number of insects that can be found in meadows. That's thanks to the great diversity of plants and the grasslands that favor many weaker species rather than a few dominant ones. However, open fields are currently in short supply. Natural meadows can be found only along the shorelines, where the ice in winter cuts off all surrounding vegetation so that neither trees nor shrubs can grow. All other meadows are man-made, while the pastures are dependent on the working forces of livestock. The meadows are going extinct because we have changed the way we work the land, killing butterflies and other insects that live in these habitats. Many species that used to be called "common" not even fifty years ago are now endangered and may very well become extinct.

The remaining meadow flowers are pushed away, often by grass, leaving species like caterpillars nothing to live on. And without insects, birds can't survive; and when they die, we humans suffer as well.

Leaf beetle (no English name) *Cryptocephalus sericeus*
Body length: 6 mm | Öland, 13 exposures

This leaf beetle is a 6-to-7.5-mm-long leaf beetle with an elongated cylindrical, extremely arched body. Its base color is black with an intense green or blue-green metallic sheen. The head is extremely bent down and barely visible when seen from above. The fully formed beetle can be found in flowers, preferably composite flower types. Its Swedish name, *fallbagge* ("falling beetle"), is derived from its tendency of simply letting go and falling to the ground when threatened. The beetle can be found in dry and hot areas like sandy steppelands, dry grasslands, sandy soils, gravel pits, or south-facing road cuts. There is very little known about the beetles larval stage, but most likely it takes place on the ground. The beetle is categorized as *Near Threatened*.

 Eyed ladybug *Anatis ocellata*
Body length: 8 mm | Öland, 32 exposures

This ladybug is recognized by its reddish, orange, or almost auburn wing covers that are marked with spots that resemble eyes. The number of spots can vary from zero to twenty-two, and some of the spots can be partly fused. The neck shield is black with a lighter edge and lighter irregular patches on the sides. It's a common species associated with coniferous or mixed coniferous forests, but here it is seen sitting on a blade of grass. Usually it hunts aphids, the softwood lice that live on conifers, but can also eat pollen and nectar if aphids are scarce.

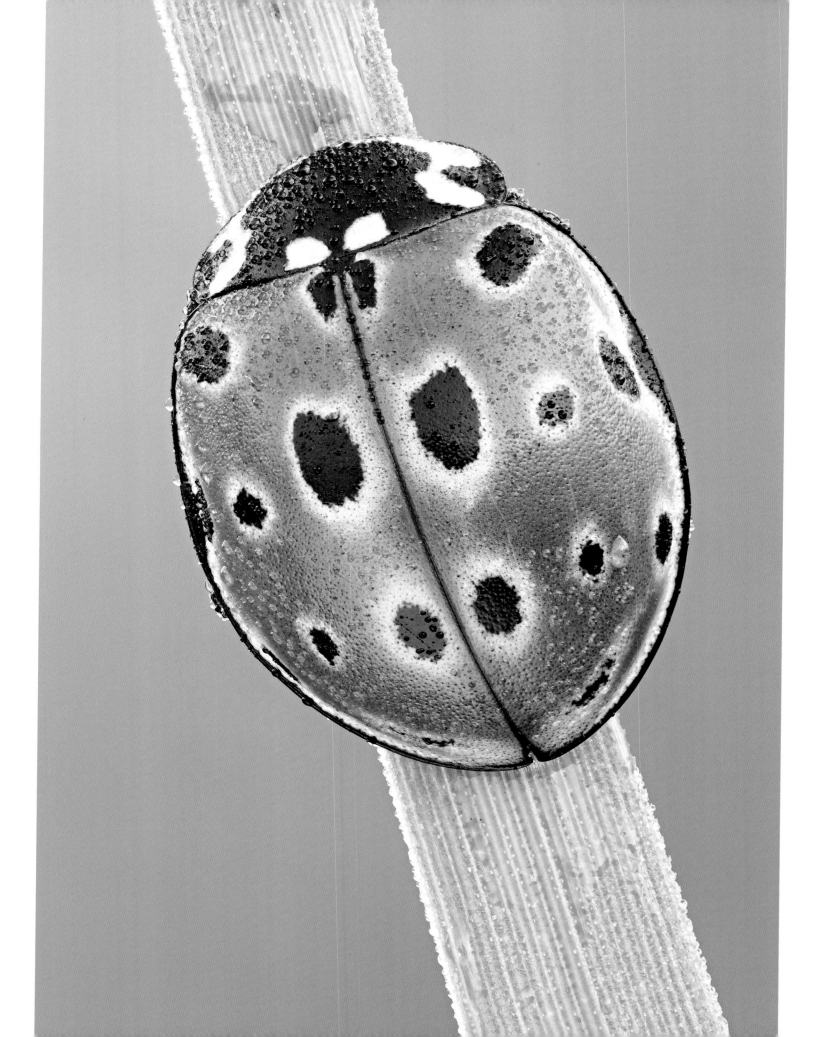

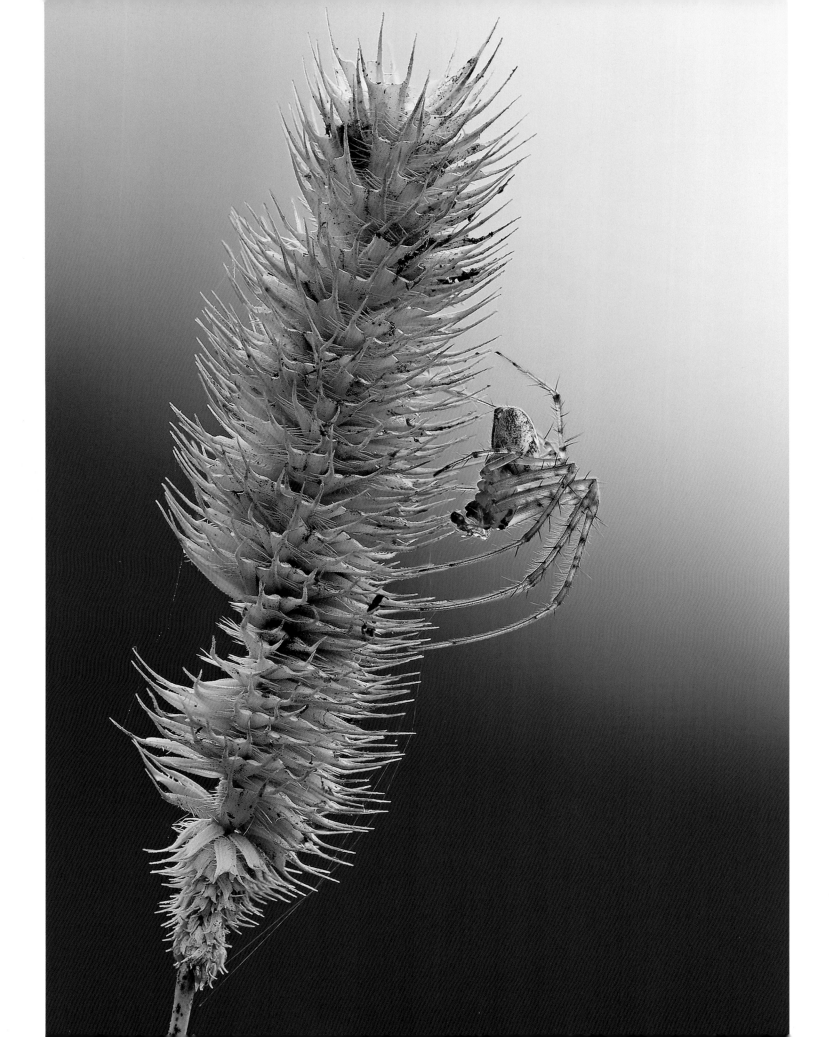

 Tetragnathid spider *Metellina mengei*
Body length: 5 mm | Södermanland (Nackareservatet Nature Reserve), 4 exposures

The tetragnathid spider is sometimes called *munkspindel* ("monk spider") in Swedish. They resemble the orb weaver spiders in appearance, and even weave wheel-shaped nets, but belong to the related family of long-jawed spiders, *Tetragnathidae*. This spider can be recognized by the wide band on its underside and by the small hole in the middle of its web. It is mainly located in grasslands, but can also be found in forested areas. It's easier to find this spider during the spring and summer (it's still active in the late summer and autumn, but much more difficult to find).

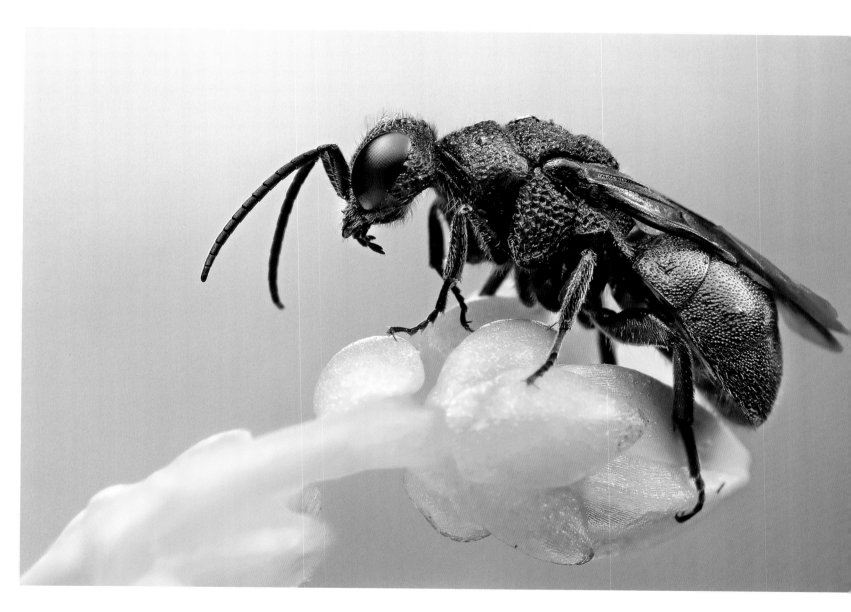

Cuckoo wasp *Holopyga generosa*
Body length: 6 mm | Södermanland (Nackareservatet Nature Reserve), 1 exposure

The cuckoo wasp is also known as *guldstekel* ("golden wasp") in Swedish. The sunlight enhances its metallic colors that shimmer in blue, green, purple, red, copper, brass, and gold—all in slightly different combinations. Their colors are generally iridescent, a phenomenon that occurs when light is reflected from more than one surface and the reflections overlap each other. Additionally, the entire body is often covered with small holes and bumps, which enhances and modifies the color reproduction.

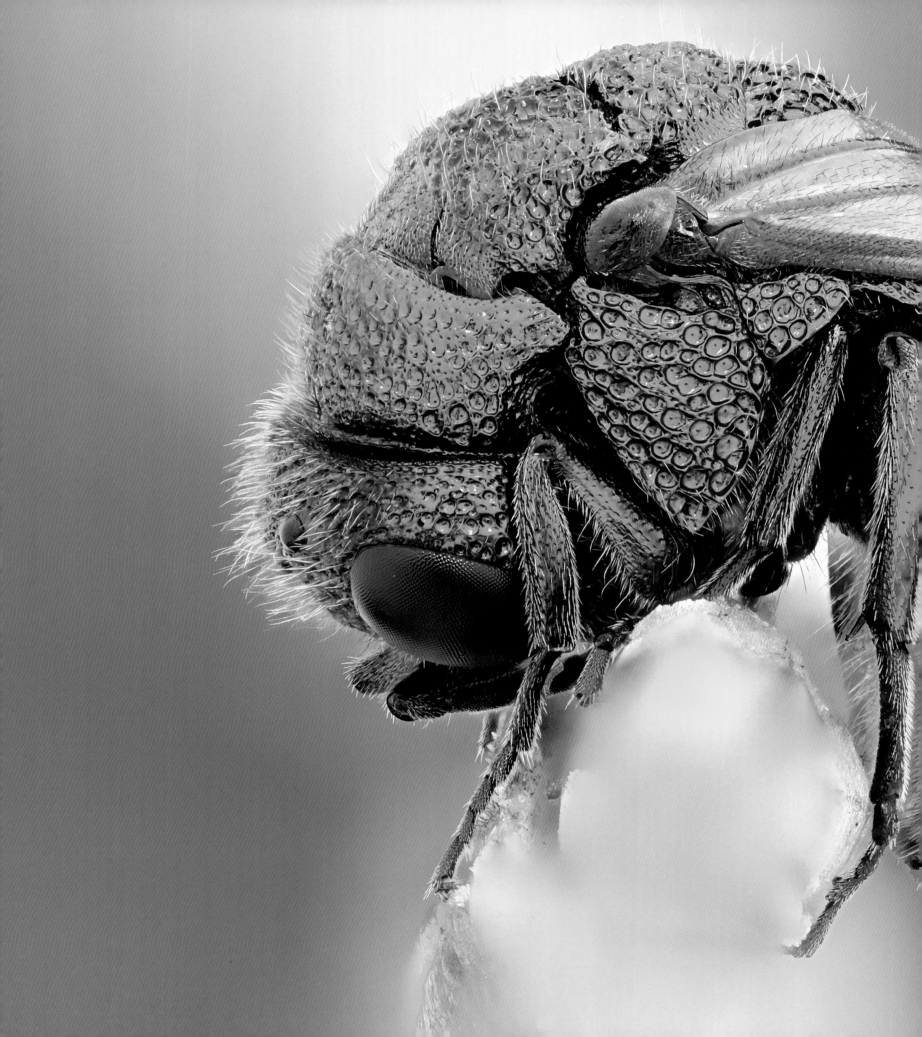

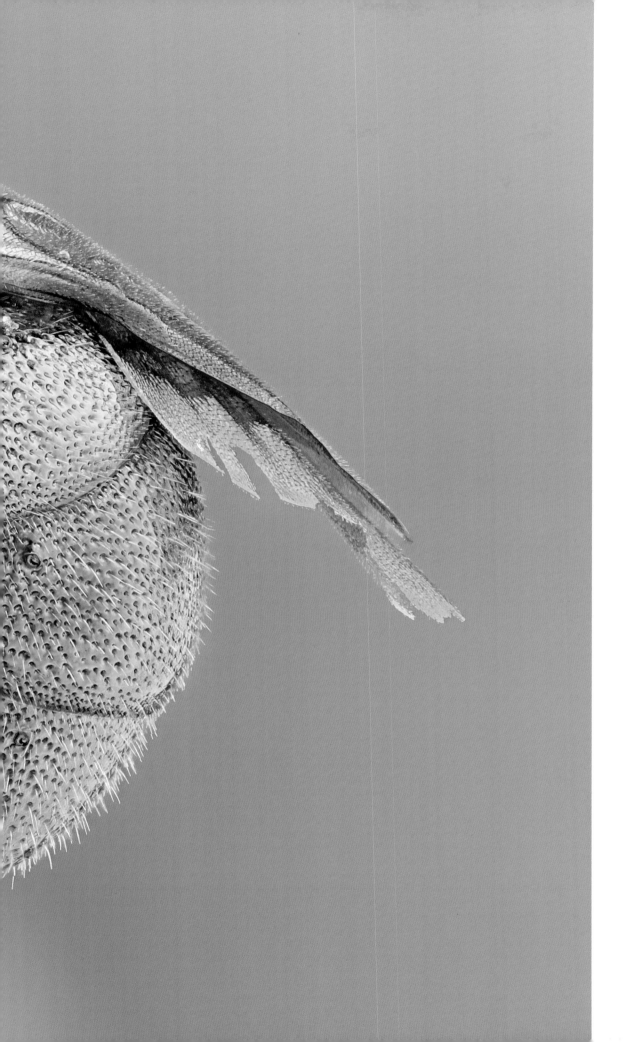

Cuckoo wasp *Holopyga generosa*
Body length: 7 mm | Södermanland (Nackareserva-tet Nature Reserve), 65 exposures

This U-shaped positioning of the body is typical for the cuckoo wasp when resting or dead. It is not unknown for the wasp to spend the night firmly sea-ted on blades of grass. The wasp in the image has locked its jaw onto a blade of grass, preventing it from falling down while asleep. *Holopyga* is a large genus, but we don't know much about it.

Click beetle (no English name)

Ctenicera pectinicornis, ♀

Body length: 11 mm | Södermanland (Nackareservatet Nature Reserve), 52 exposures

This click beetle has a metallic greenish-brown color and very distinct furrows on its wing covers. The males have distinct comb-toothed antennae, and the females (like the one in the image) have only smaller growths on each joint of the antennae. At the very tip of the male's antennae there are very sensitive receivers, chemoreceptors, which among other things capture the female's aroma. These beetles usually reside in meadows. They get their name, click beetle, from the catapult mechanism that is triggered when they find themselves upside down. By pushing the thorax against the abdomen, they "snap"—making a clicking sound—and flip right side up.

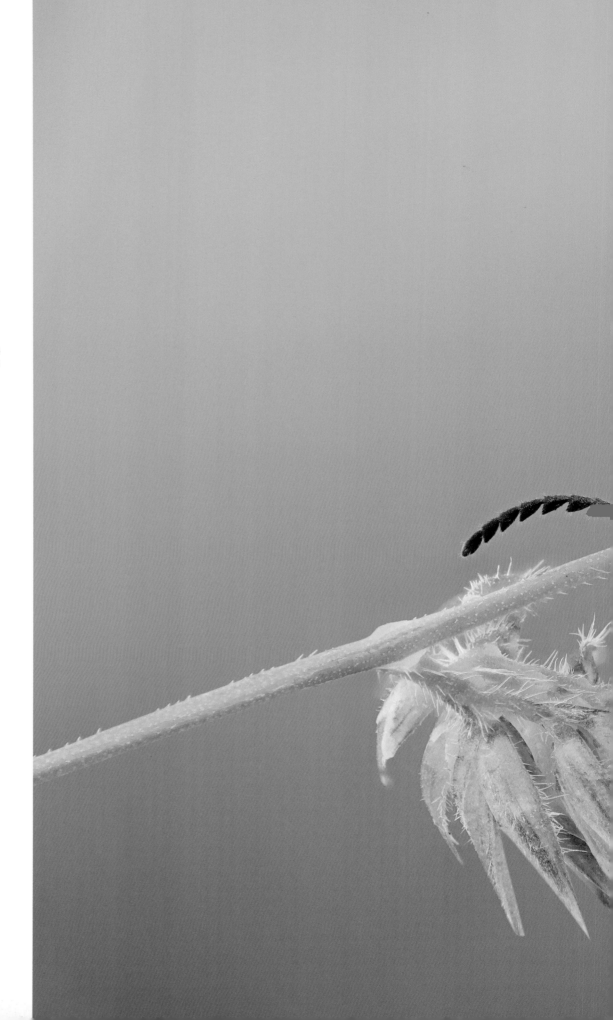

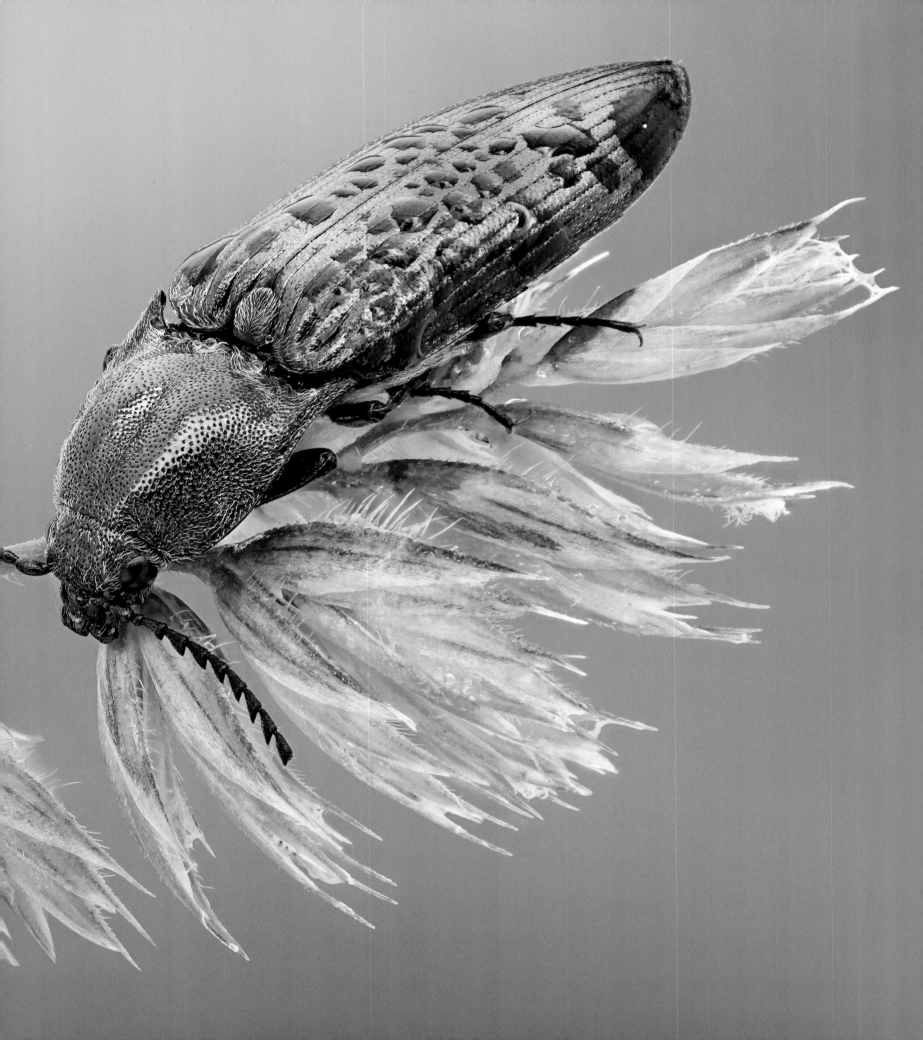

Mason bee *Anthidium punctatum*
Body length: 7 mm | Södermanland (Nackareservatet Nature Reserve), 59 exposures

The male mason bees claim their territory by flying in a certain pattern over an area where they have the best chance of meeting a female. It might be the place where the females hatch or close to protruding objects like blades of grass, rocks, shrubs, or trees. The males might defend their territory by attacking intruders of the same species, but most of the time they're quite peaceful. The mason bees build their cells in rows inside hollow plant stems, under rocks, or in cavities in walls and bricks.

They chew the hair of plants and use it as building material. These hairs might come from plants like mullein, coltsfoot, and lamb's ears.

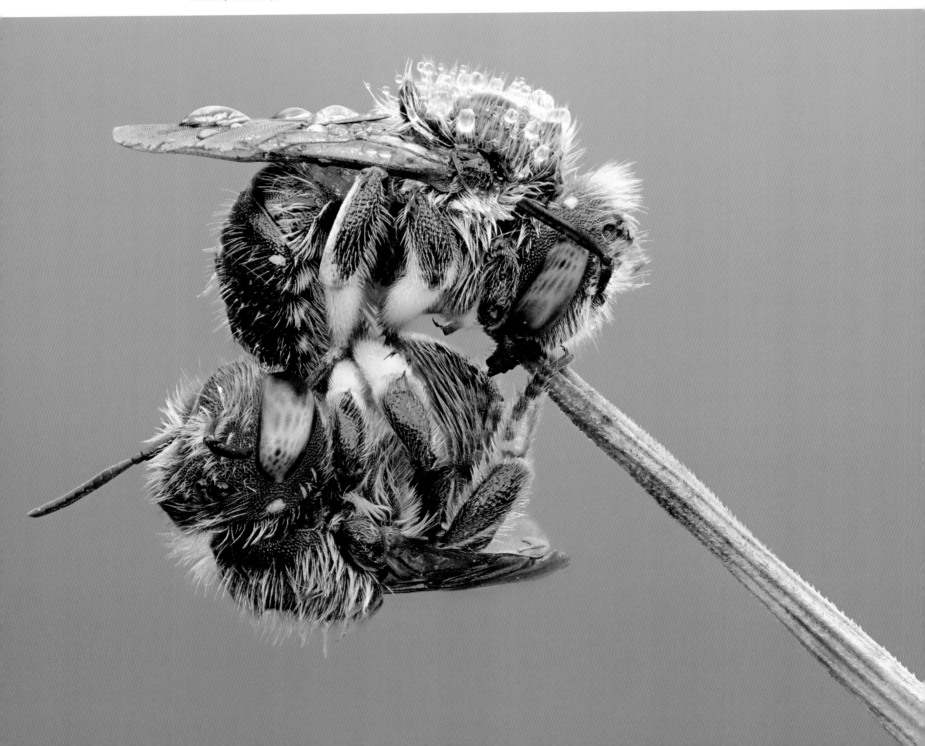

Flower longhorn *Stenurella melanura*
Body length: 8 mm | Södermanland (Nackareservatet Nature Reserve), 85 exposures

The flower longhorn is fairly small (6 to 10 mm) and belongs to the family of longhorn beetles. Apart from its red wing covers, the beetle is completely black. During the height of summer, this common species can be found sitting in various flowers, especially those with accessible nectar. Both females and males can mate several times, and the males often stay on top of the female to prevent her from mating with others. The beetle is a polyfag—that is, it attacks different types of wood (like oak, beech, spruce, and pine)—creating holes where its larvae can develop.

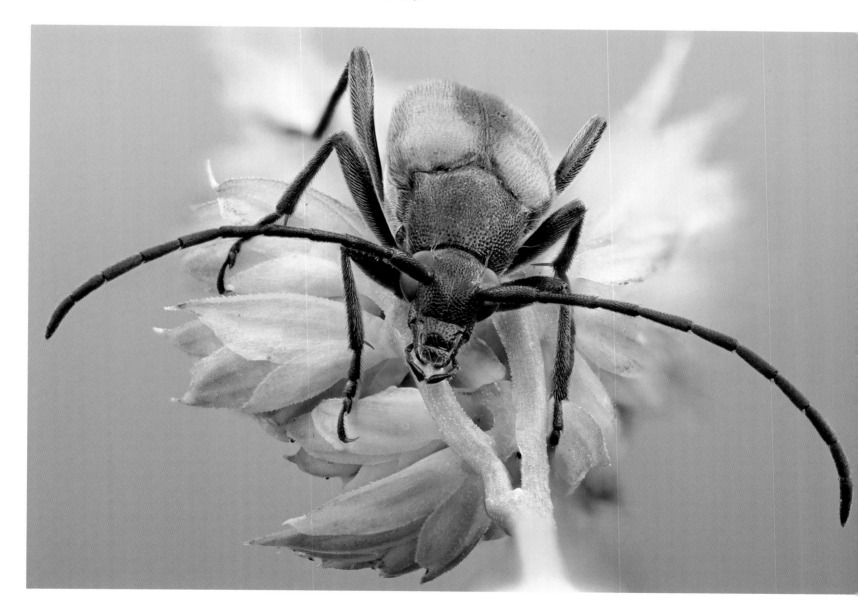

Leaf beetle (no English name) *Donacia crassipes*

Body length: 9 mm | Södermanland (Nackareservatet Nature Reserve), 23 exposures

This leaf beetle is commonly found on the leaves of water lilies close to the glittering waves of the water. Maybe to prevent detection from birds, the beetles' flat, shiny shell glistens like the water surface to prevent it from being seen. It's not only the top of the beetle that's metallic; on the underside of this beetle you will find thick, shiny silvery or golden hairs. The body is long and narrow, with no hairs on the top side. Both larvae and adults feed on the water lily. These beetles are particularly active during hours of sunshine.

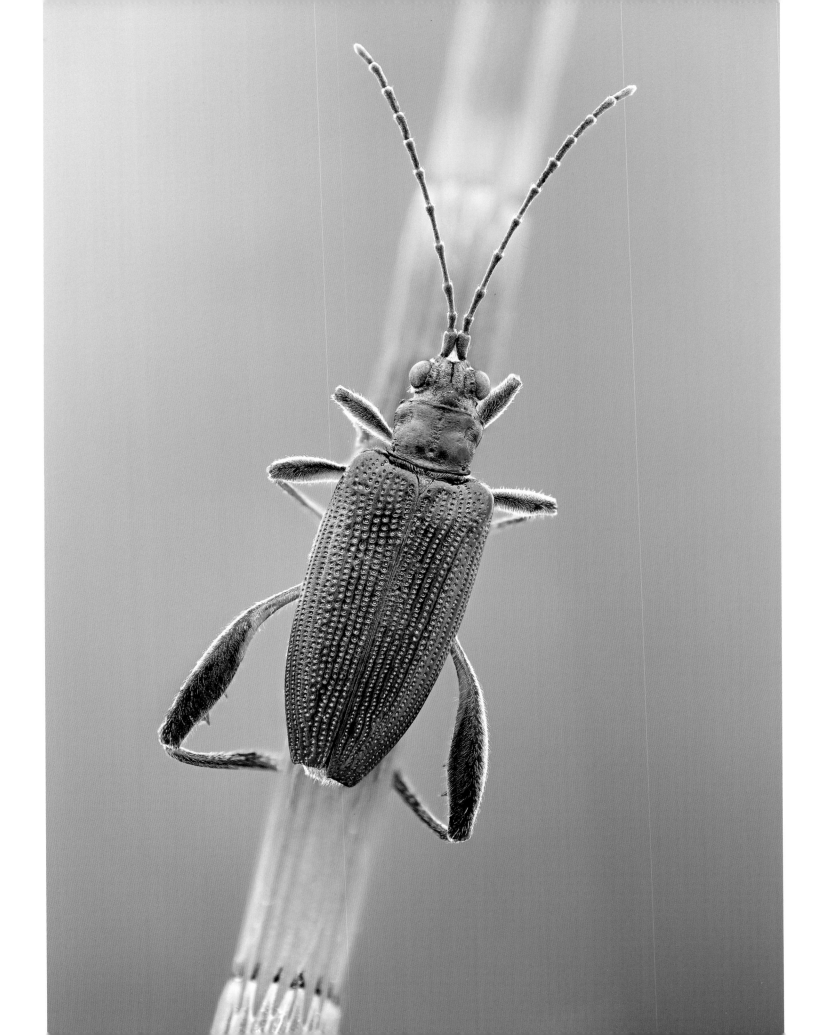

M

ANY BUGS, for various reasons, end up inside our houses. They can catch a free ride with us or our pets, sneak into our suitcases when we travel, or simply fly or crawl through a open window. The heat and low humidity in our modern houses and apartments often result in the swift deaths of these guests. Some of these bugs do, however, survive the indoor climate, making our homes a fully functioning habitat. They settle indoors, more or less permanently, against our will. They might come from warmer countries and multiply quickly, and as they can't survive the cold winters, we see them only indoors. These new housemates are typically omnivorous, like the beetle larvae, cockroaches, booklice, and mites. Flies and mosquitoes are hardly major annoyances. Fruit flies and dark-winged fungus gnats can be quite irritating in their short lifespans, though. Insects do stay away more often than not, and sometimes they can even be of assistance. Spiders, for example, capture all kinds of bugs.

There is a certain category of indoor creatures that live exclusively off of wood, at least as larvae. The most common wood eaters are various beetle larvae and wasps like the carpenter ant.

American cockroach *Periplaneta americana*
Body length: 35 mm | Studio, 168 exposures

The almost 3-cm-long American cockroach is a species that has cosmopolitan distribution and is one of the least-liked insects. The cockroach is generally photophobic and nocturnal, as they stay hidden during the day. They love heat and stay close to ovens, warm water pipes, or anything similar in a home or apartment. We find them only indoors in Sweden, as they can't survive our winters. Cockroaches spread a foul odor from glands situated on their backs. The female covers her eggs with small, gnawed fragments, making them difficult to find. One set of eggs (containing ten to twenty eggs) that's laid in a cargo container can easily spread from one location to another.

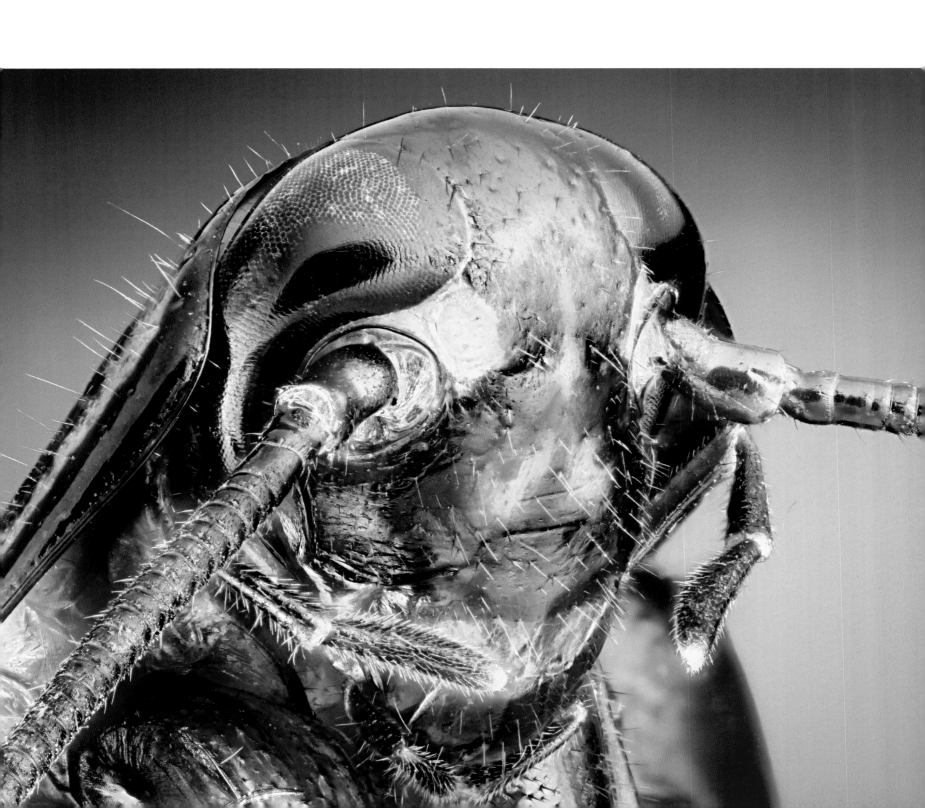

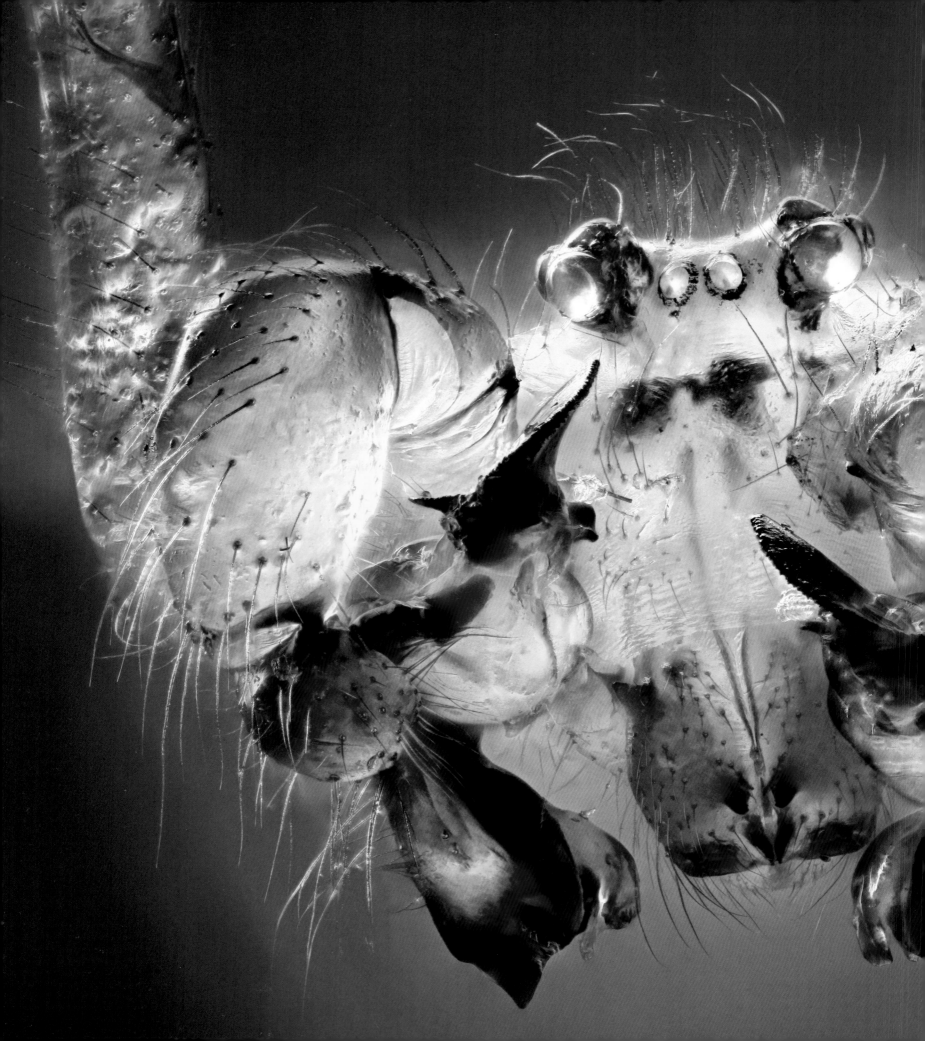

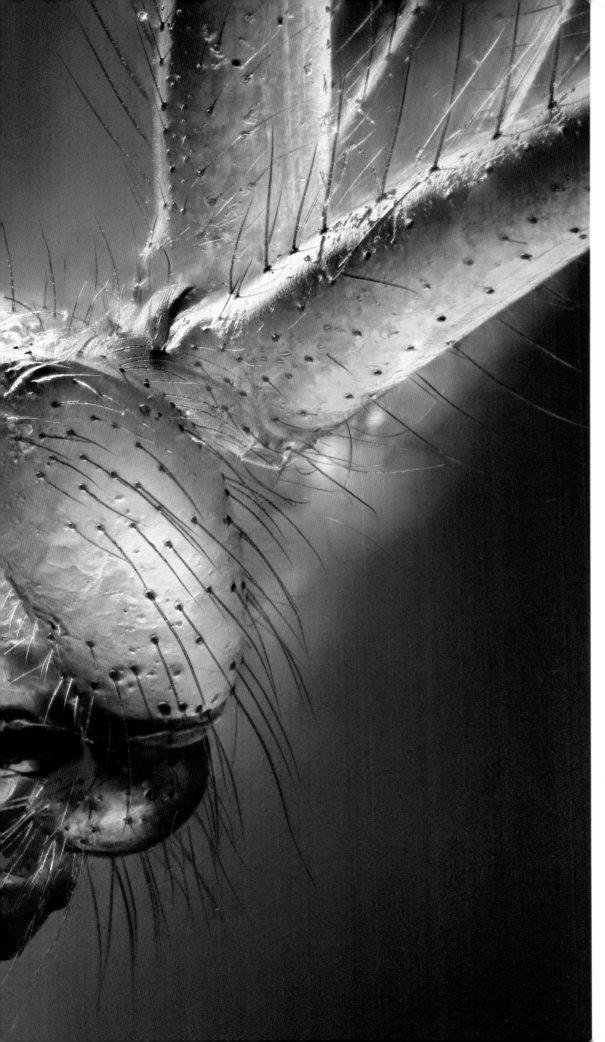

Cellar spider *Pholcus phalangioides,* ♂
Body length: 5 mm | Studio, 249 exposures

The cellar spider, which is grayish brown, can have legs that are up to 5 cm long. This species is a recent addition to our country, often found indoors in cellars and storages. Cellar spiders often live together with their own species, and other spiders in the area are usually killed. When a cellar spider is threatened, it shakes its web. This moving web works as a camouflage, as the almost transparent spider more or less disappears. This spider is harmless to humans and even helps us by lowering the number of insects and spiders in our homes.

SOMETIMES WE ALSO GET the bugs that bite or sting—fleas and lice, such as bedbugs, are some of the insects we definitely don't want indoors. Fleas are blood-sucking parasites that are usually found feeding on mammals. Fleas normally live on mammals and can sometimes transfer an infection from one species to another.

Lice are also blood-sucking parasites that feed on mammals. There are two species that can also be found on humans: the body and head lice (*Pediculus humanus*) and the crab lice (*Pthirus pubis*). Unlike fleas, lice stay on the same host animal and adapt to its body temperature.

Bedbugs (*Cimex lectularius*) are not lice, but belong to the suborder *Heteroptera*. All bedbugs live exclusively off blood. They are mainly active during the night and can suck blood every night. They do not, however, spread infectious diseases. After being virtually eradicated in northern and western Europe, they've become more common in recent years. Bedbugs can be found in cracks in walls and floors, and behind loose wallpaper, paintings, and furniture. And, of course, in beds.

Bedbug *Cimex lectularius*
Body length: 5 mm | Studio, 175 exposures

The bedbug has a cosmopolitan distribution and is considered to originate from the Mediterranean countries. Bedbugs are not lice,* but more closely related to the stink bug. It's wingless, 4 to 5 mm long, and has a wide, flat body that allows it to hide in small confined spaces during the day. The most common hiding places are the seams of a mattress, cracks in the bed frame, and other little nooks close to our beds. It is in these places you often find indications of bedbugs—their excrement leaves dark-colored stains. The bugs come out at night and are drawn to our body, head, and the carbon dioxide we breathe out. Bedbugs are one of the most difficult pest problems to eradicate quickly. High levels of hygiene and meticulous cleaning might help in controlling them, but there's usually a need for professional treatment to make them disappear for good.

*The bedbug's Swedish name roughly translates to "wall lice," hence the need to point out the fact that this is not a louse.

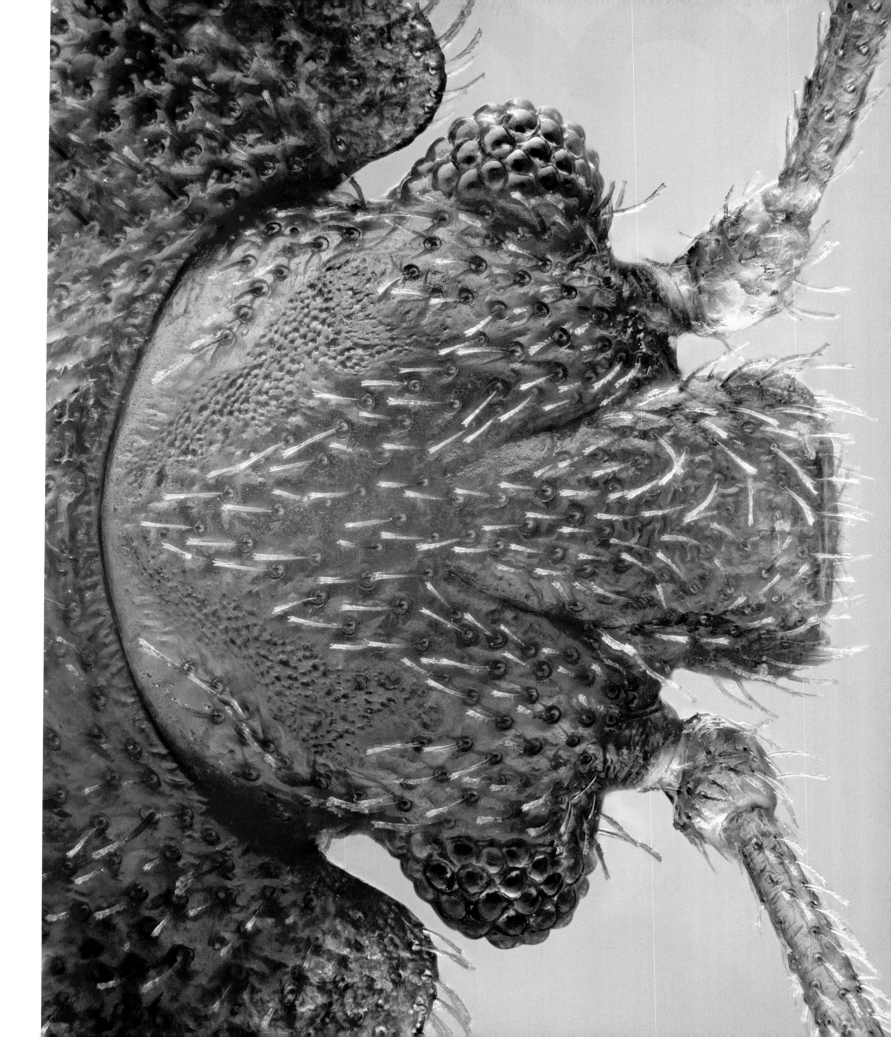

Carpenter ant *Camponotus* sp.,
worker
Body length: 9 mm | Studio, 89
exposures

The carpenter ant is one of the largest
native ants in Sweden, and can be 6
to 18 mm long. They build their nests
in wood—stumps, logs, and roots of
damaged trees. Carpenter ants are a large
problem when they build their nests in
our wooden houses, gnawing out passages
and holes. Like many other ants, the
carpenter ant lives almost exclusively
off the sugary excrements from aphids
and scale insects. When the carpenter
ants swarm in early summer, you can
occasionally find single ants or winged
individuals—this does not, however,
mean that their nest is nearby. The
carpenter ant is one of the most common
insects you can find in the Swedish
forests.

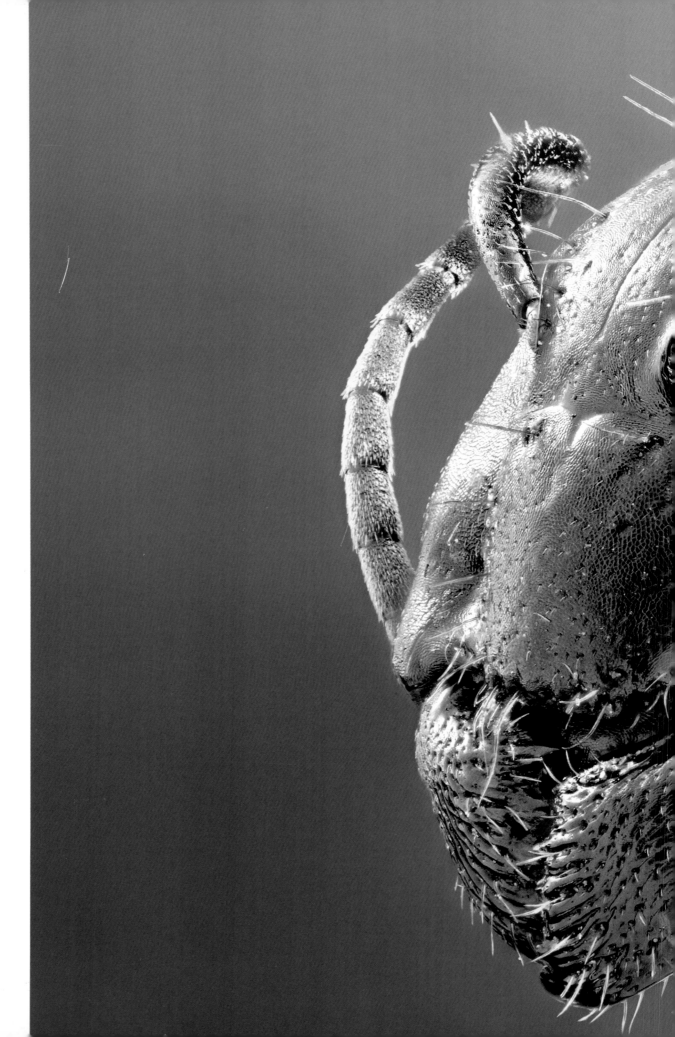

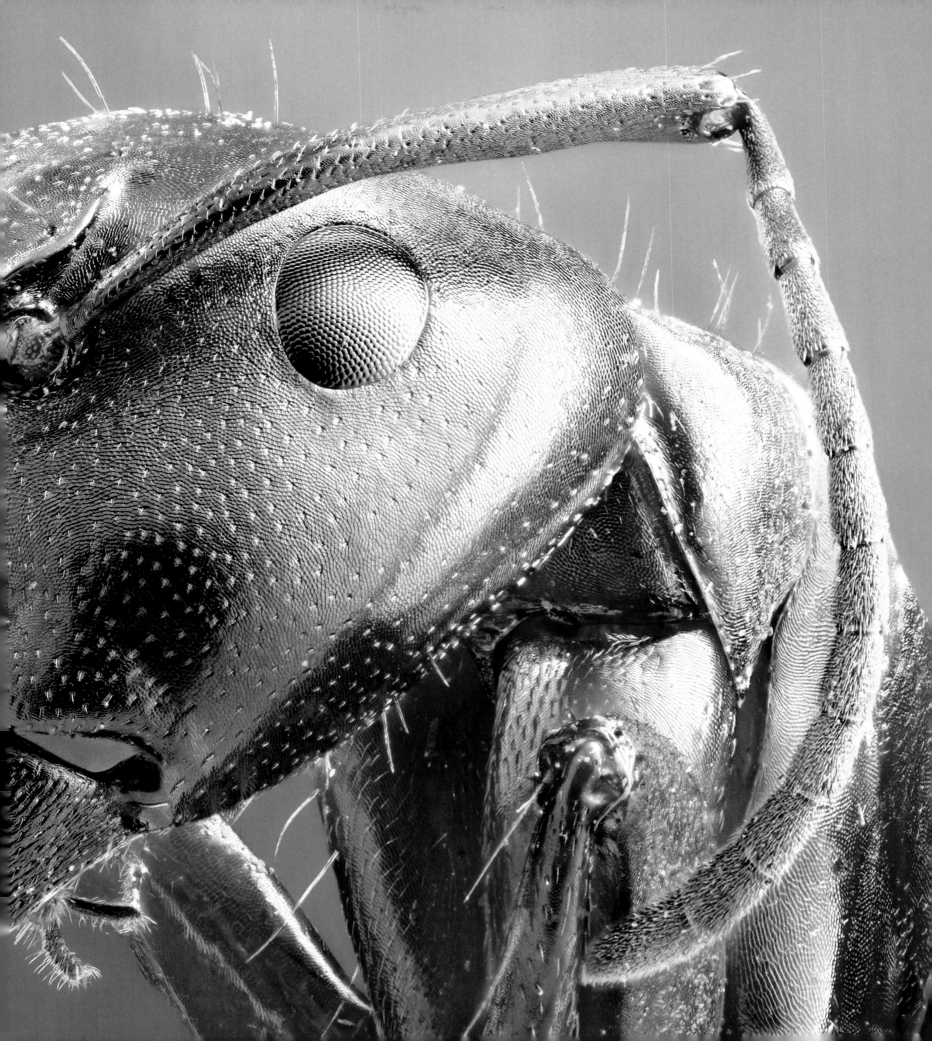

Fruit fly *Drosophila melanogaster*
Body length: 3 to 4 mm | Sörmland (on the kitchen tap), 1 exposure

With the exception of Antarctica, fruit flies can be found all over the world. In summer they come into our homes, often when we bring damaged or overripe fruit home. Sometimes you can see swarms of fruit flies over the spoiled fruit in supermarkets.

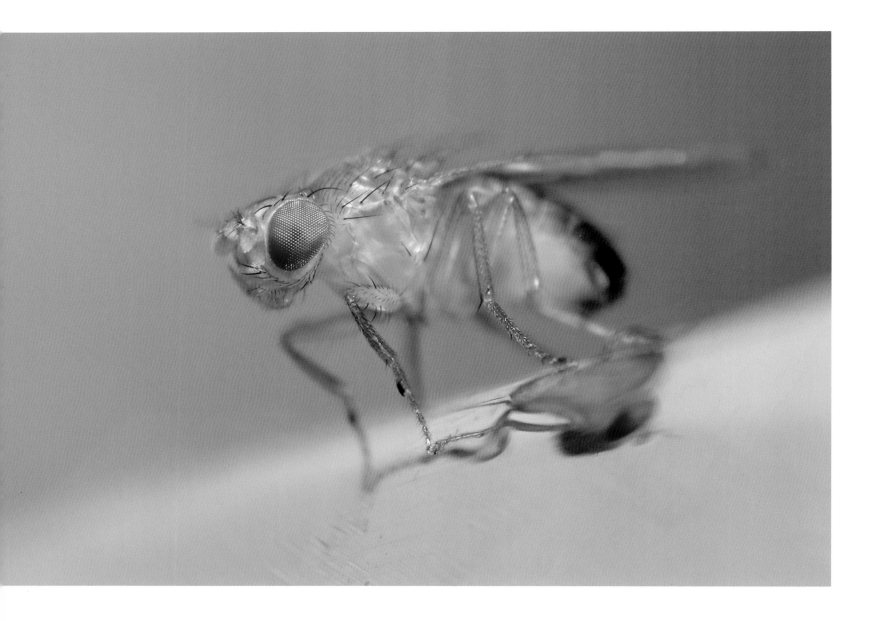

Red-legged ham beetle *Necrobia rufipes*
Body length: 5 mm | Studio, 281 exposures

The red-legged ham beetle also goes by another name, the copra beetle, because of the incredible amounts of this species found in all copra cargo. Red-legged ham beetles are one of our most difficult pests that feed on stored grain and other starchy products. Beside the copra, this beetle also attacks very diverse types of food like dry dog food, dried fish, lard, cocoa, powdered eggs, and nuts. Its larvae are pure carnivores that won't even spare the larvae and pupae of their own species. The red-legged ham beetle is very sensitive to temperature; the eggs can't survive below 15°C (59°F), the larvae need around 20°C (68°F), and the pupae just over 18°C (64.4°F). This means that they have a very small chance of becoming permanent pests in Swedish homes.

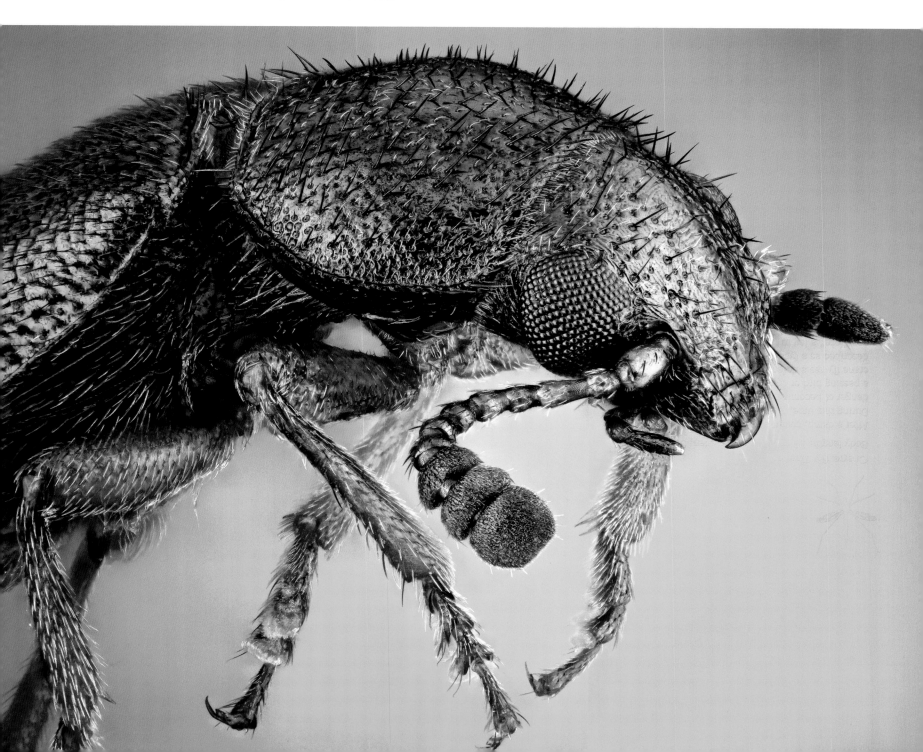

 White-marked spider beetle *Ptinus fur* ►
Body length: 3 mm | Studio, 292 exposures

The appearance of this beetle actually resembles that of spiders more than beetles. Its neck shield is short, arched, and gathered in the back, connected to the wider, egg-shaped abdomen. It can be found indoors as well as outdoors all over Sweden, usually in cool and damp places like warehouses for grain and fodder. The white-marked spider beetle is omnivorous and nocturnal. The process from egg to fully grown beetle takes at least a year, and this poor reproduction rate means they are considered only minor pests.

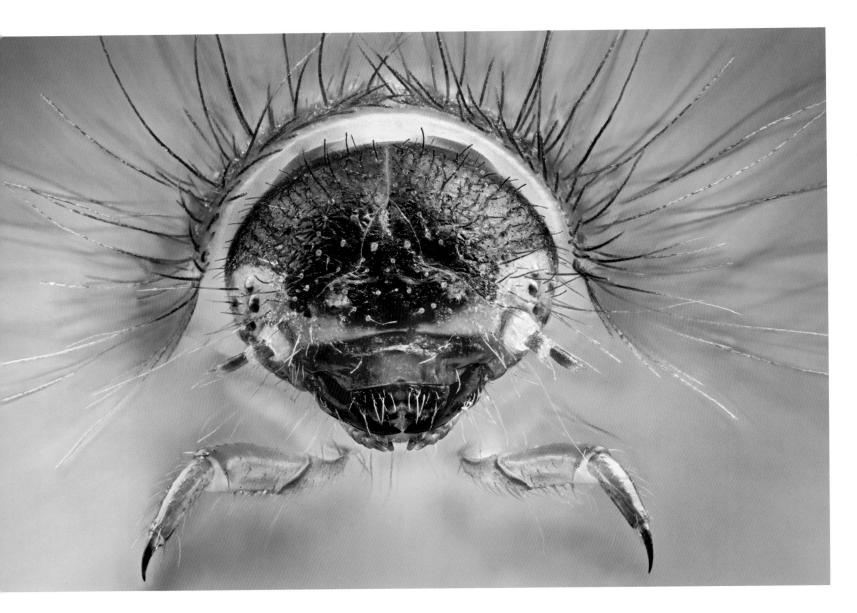

 Hide beetle *Dermestes maculatus*, larva
Body length: 8 mm | Studio, 264 exposures

This family of beetle, commonly referred to as skin beetles, can cause severe damage indoors. Some of the species that belong to this family are the fur beetle, wardrobe beetle, museum beetle, larder beetle, and hide beetle. The natural food for the larvae is dry animal products, while the adults eat only nectar and pollen. When the females are fertilized, they become photophobic and seek out dark and hidden places. Suitable hiding spots in nature are, for example, the nests of birds, wasps, and bumble-bees. This is where the eggs are laid, and after they've hatched the larvae quickly find the food they desire. Unfortunately we have a rich assortment of materials that the larvae can eat inside our homes.

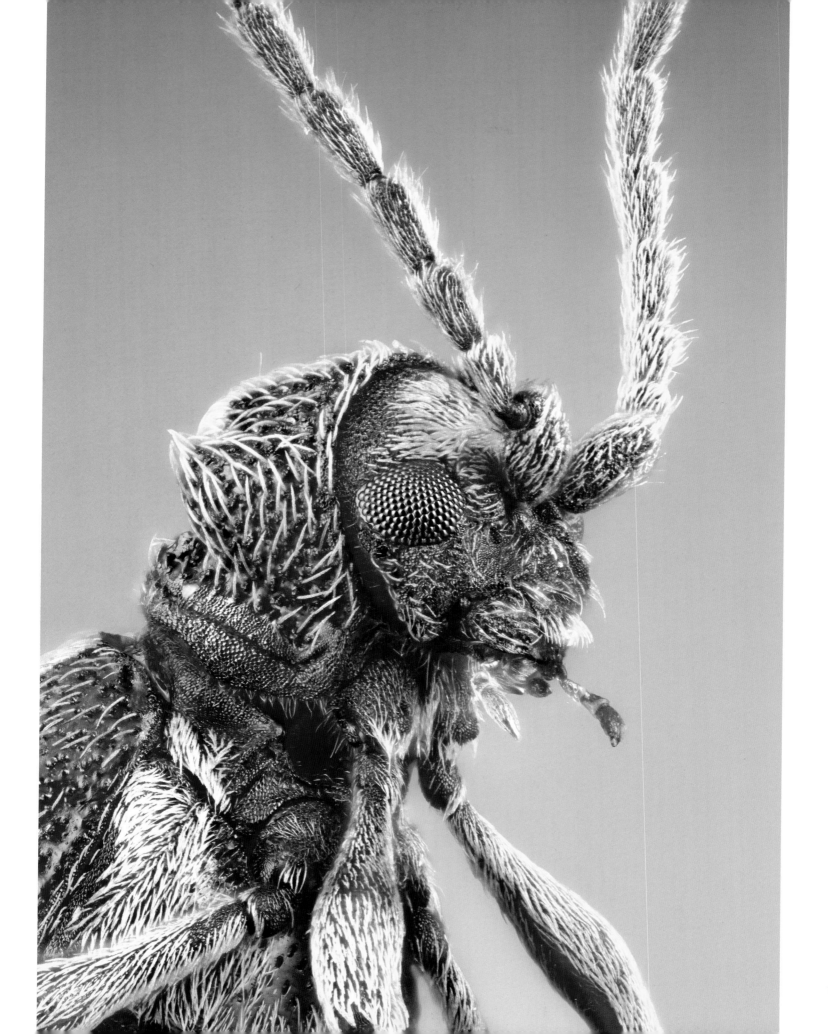

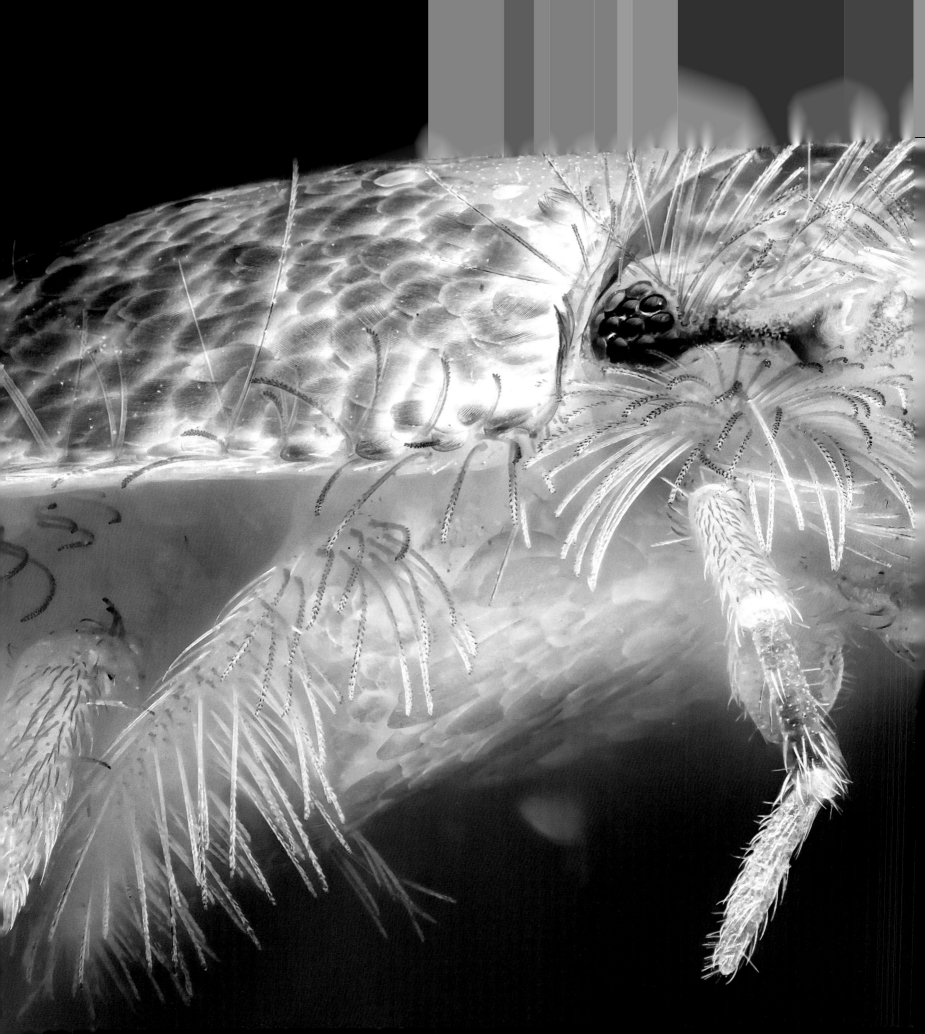

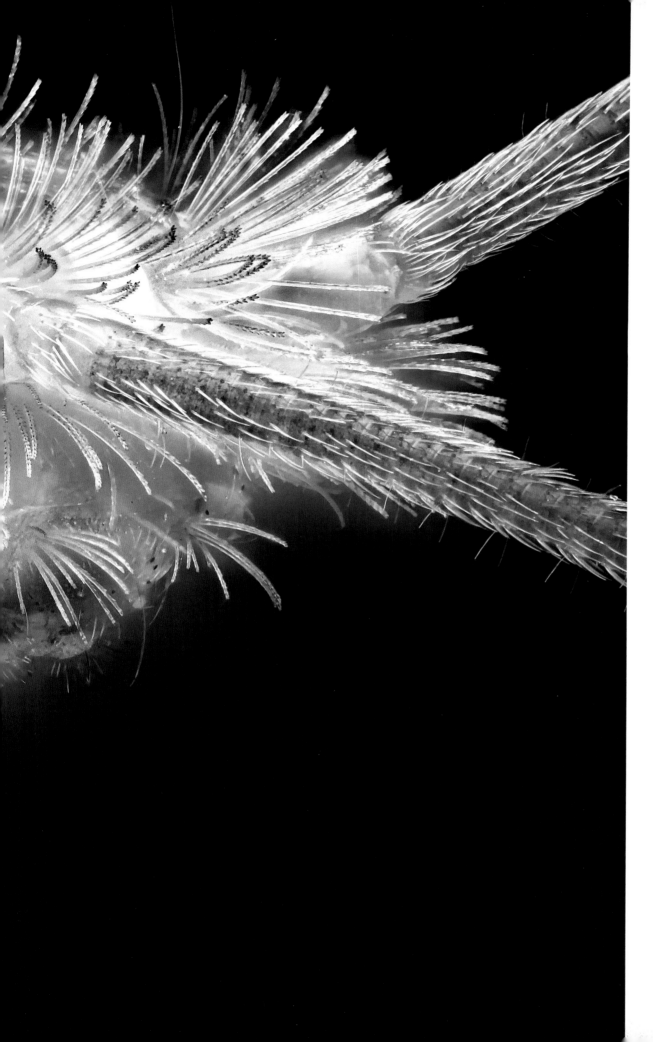

Silverfish *Lepisma saccharina*
Body length: 8 mm | Studio, 258 exposures

The silverfish's name is derived from the insect's color and the fish-like appearance of its movements, which make it look like it's swimming across floors and walls. It's a fast, photophobic, and wingless insect with three separated cersi (tail bristles). Silverfish can be found in all kinds of environments, preferably where it's a little damp. It is located throughout the world. The silverfish eats mainly starchy and sugary substances, and they are common in bakeries and mills. They can cause damage to wallpaper when they use their sharp mouthparts to gnaw for the starch. Book spines, glued paper, and starchy textiles can also be subject to attacks.

The impact that humans have on nature affects the number of insects in the world. Our modern agriculture and forestry puts the insects on a collision course with us, as we are competing over the same materials. One of the factors contributing to the success of insects is the development of wings. Wings help them increase their distribution and make it possible for them to move away from hostile environments. Having wings makes it easier to find food, find mates, escape from danger, or find the right place to lay their eggs. The insect's exoskeleton is like an adapted armor around its body and protects its internal organs from mechanical injury. Softer parts in the joints and between the parts of the body allow for great mobility. The entire surface of an insect's body is covered with water-repellent substances, which means that some small insects never get wet. The combination of a small size, an external skeleton, and wings is unique to bugs, and these qualities have greatly contributed to their success.

European pine sawfly *Neodiprion sertifer*
Body length: 7 mm | Studio, 70 exposures

Males of the European pine sawfly have greatly enhanced antennae made to detect the female's scent from far away. This sawfly is regarded as a pest because it attacks pines in forest plantations. The larvae, which only feed on pine needles, primarily eat the needles from the previous year but can also eat the fresher ones when food is scarce. Sometimes the branches are left completely bare, but it is unusual for the trees to die from being infested by the European pine sawfly. The attacks begin in late May or early June, and last until the beginning of July. The larvae then leave the trees and spin a cocoon on the ground, where they pupate. In early September, they hatch and swarm almost immediately. After mating, eggs are laid in pine needles and the life cycle of the European pine sawfly begins again.

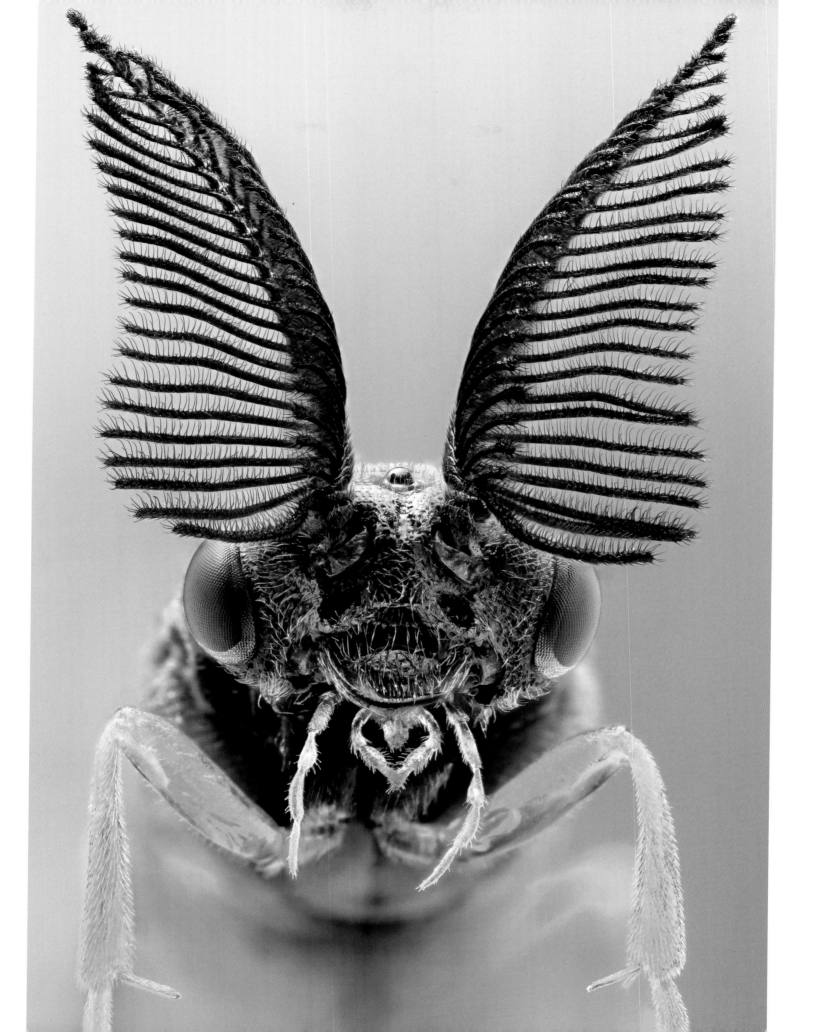

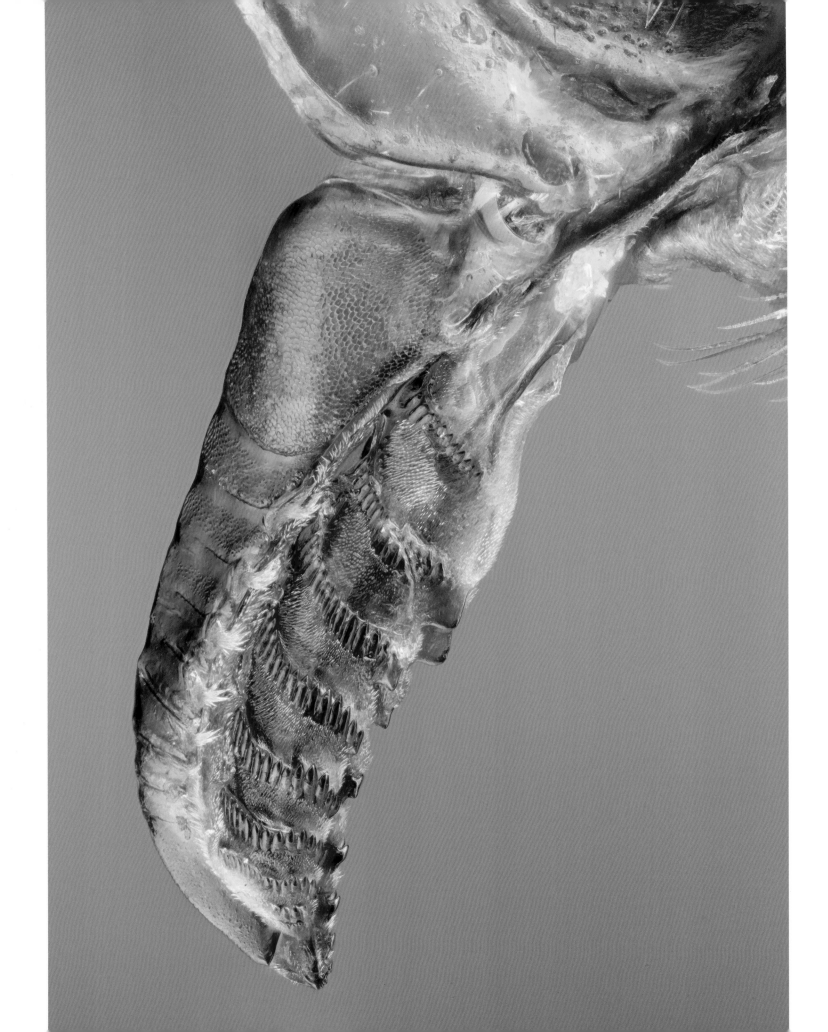

◄ **European pine sawfly** *Neodiprion sertifer*, ♀ ovipositor
Body length: 9 mm | Studio, 192 exposures

Females of the European pine sawfly have an ovipositor that resembles a
saw. It is used to cut small incisions into the pine needles where they lay
their eggs.

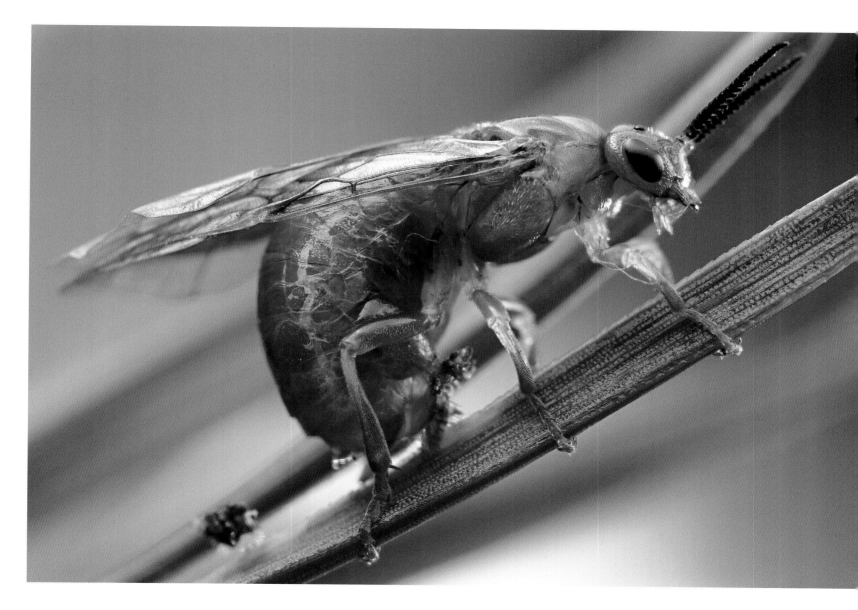

 European pine sawfly *Neodiprion sertifer*, ♀
Body length: 9 mm | Studio, 1 exposure

The newly hatched and mated females lay their eggs on fresh pine needles from September to the end
of October. The eggs are laid in pockets the females have cut into the edges of the needles, using their
ovipositor. These damages often occur in the same area for several years in a row. If the trees are simul-
taneously attacked by, for example, the pine shoot beetle, this damages the trees seriously, as all of their
needles may be lost.

 Bark beetle *Scolytus triarmatus*
Body length: 6 mm | Studio, 192 exposures

The Red List from 2010 names all of Sweden's three elms (the wych elm, the field elm, and the European white elm). They have been affected by fungal diseases that kill the trees. The Dutch-elm disease can be found all the way up to the provinces of Mälarna. The fungi were discovered in Sweden in the 1950s, and were brought in with infected timber. The green leaves of the elm hang and shrivel up in the early summer, turning yellow and brown after only a few days. It's the elm bark beetles that spread the fungus when they gnaw the bark of living branches in the top layers of the elm. The spores germinate and create mycelium that grows into the vascular tissue of the tree. The disease is spread rapidly on the outer growth rings. If the tree has been contaminated with the disease, fungal spores can stick to newly hatched beetles and with their help spread to other locations.

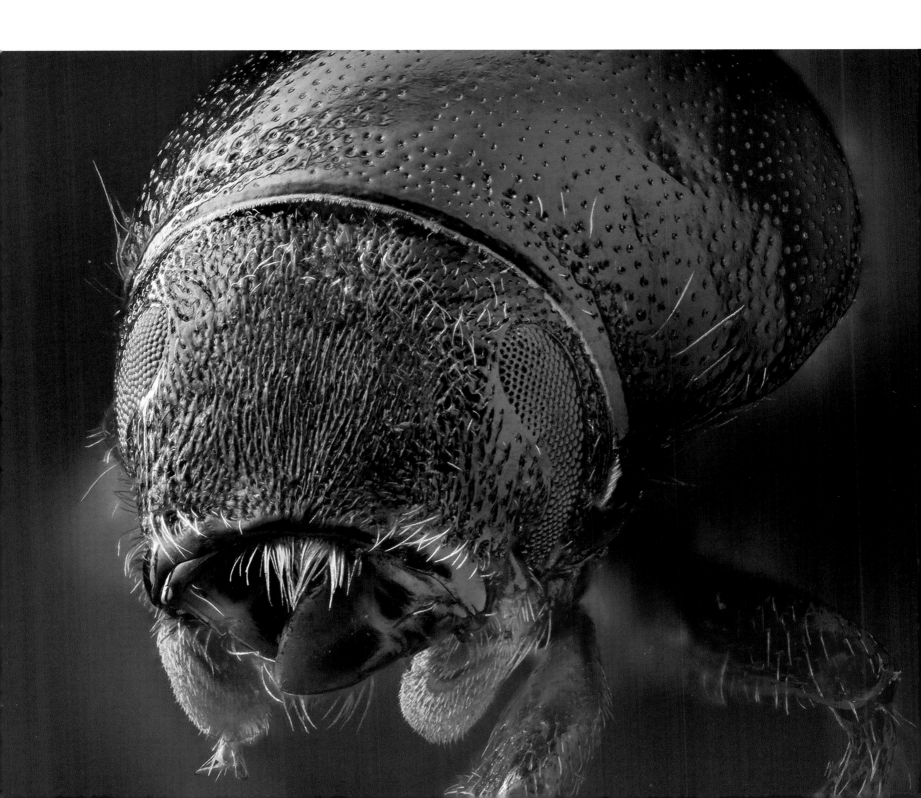

Body length: 3 mm | Studio, 132 exposures

Mouthparts of the tick have sharp hooks that allow them to drill into the skin and then hold on while they suck blood. Females insert a mildly numbing poison that also works as an anticoagulant. The male uses his mouthpart to transfer sperm from his own genitals into the females. The female tick stays with her host until she is full of blood. When the female is fertilized and has eaten her last big meal of blood, she lets go, falls to the ground, and lays her eggs.

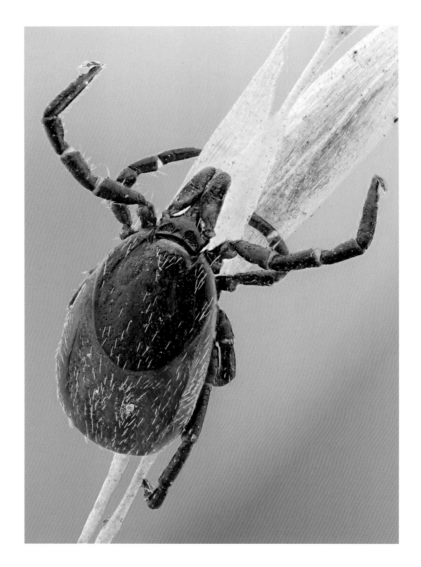

Tick *Ixodes ricinus*, ♀
Body length: 3 mm | Södermanland (Nackareservatet Nature Reserve), 102 exposures

Ticks are likely the animal that spreads the most diseases in Sweden. Most known are TBE (Tick-borne encephalitis) and Lyme disease. The life cycle of the tick has four stages: egg, larva, nymph, and adult. To complete the larva–nymph and nymph–adult steps, the tick needs to ingest blood. For the eggs to develop within the female, she needs to suck even more blood, while the male dies after mating.

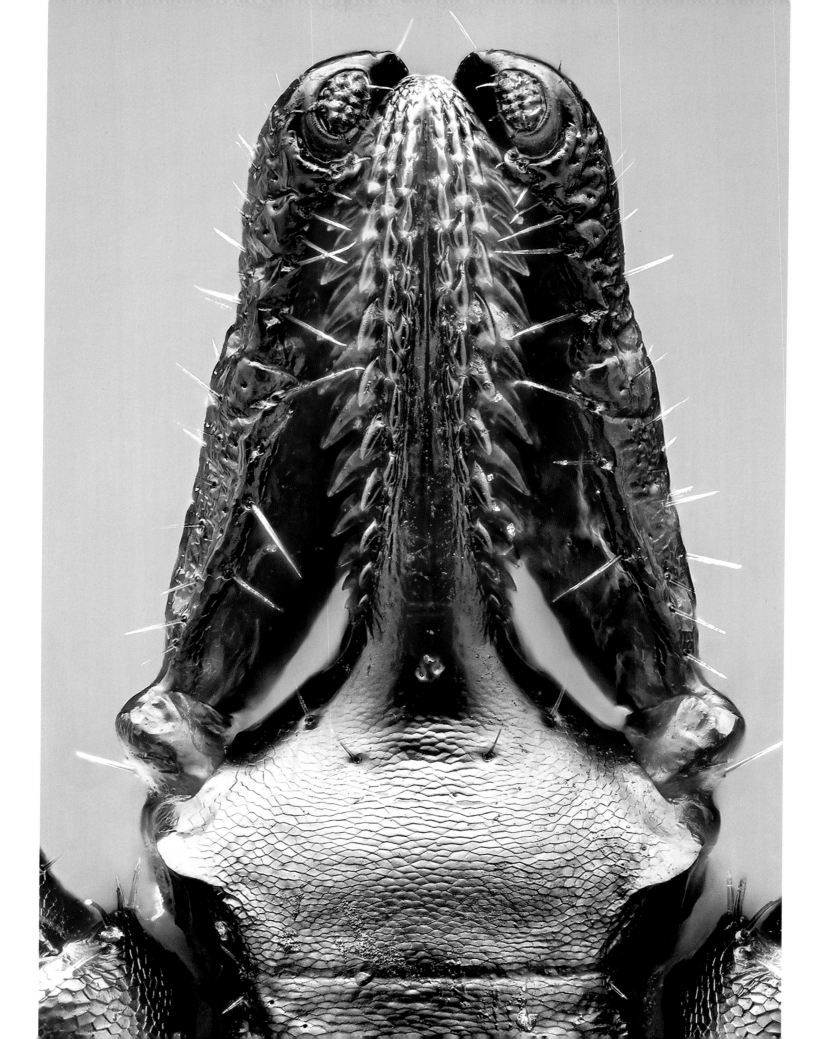

Common horsefly *Haematopota pluvialis*
Body length: 10 mm | Ångermanland, 1 exposure

In Sweden, you can find three different types of horsefly. The largest and loudest are called the pale giant horsefly. They mainly attack humans, cattle, and larger wild mammals. Then there's the splayed deerfly, which is yellow and black with dark mottled wings and looks like a small delta plane when sitting. Lastly we have the common horsefly, which is grayish black with gray mottled wings that are folded along the body when resting. In Sweden there are over forty species of horsefly. The females are always bloodsuckers, and their mouthparts are leaf-like stilettos that are used for biting into the skin of mammals. Males only suck nectar and other plant juices.

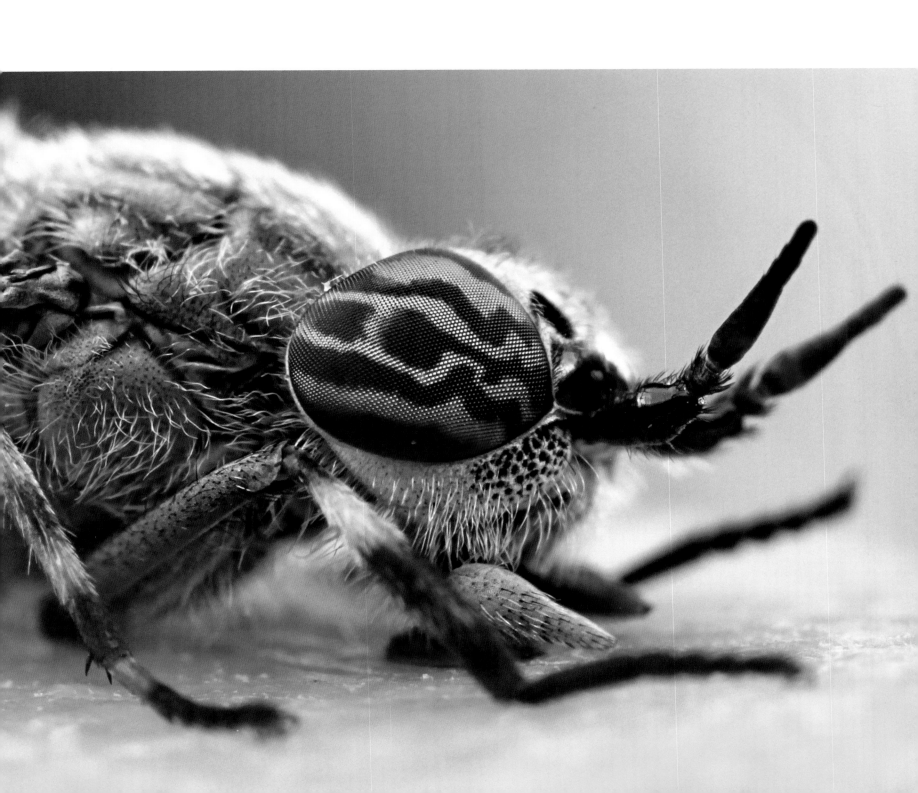

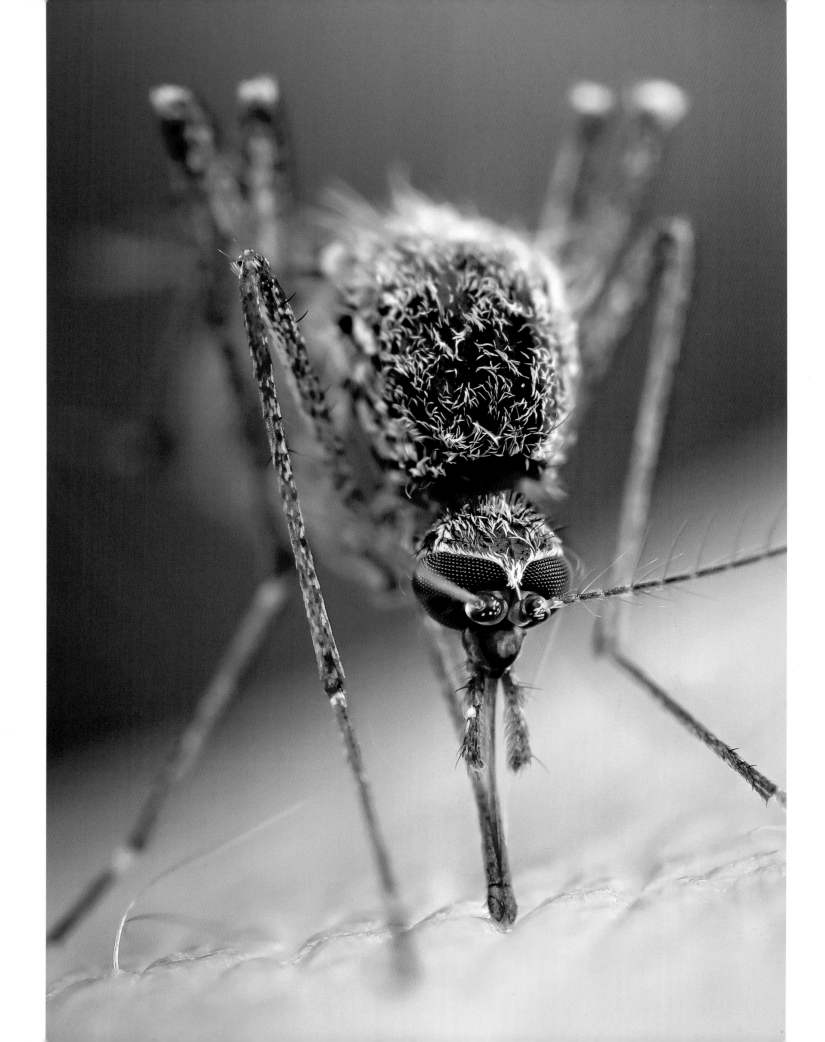

Common house mosquito *Culex pipiens*
Body length: 6 mm | Öland, 1 exposure

The mosquito in the photo belongs to perhaps the most-common species of blood-feeding mosquito in Sweden. It goes through four stages during its life cycle: egg, larva, pupa, and adult. Eggs are laid in connected packages and placed in or near water. The larvae are purely aquatic but breathe air using a breathing tube that goes above the water's surface. Pupae are usually found by the water's surface. They breathe through two curved tubes situated on the thorax. Mosquitoes are able to fly one hour after hatching from the pupa. After the females have been fertilized, they need proteins to produce eggs. It is therefore necessary for the female mosquito to suck blood from other animals.

W

WATCHING A CATERPILLAR become a pupa and then witnessing the adult butterfly crawling out of the cocoon is a sight you will never forget. Especially not the moment when they slowly unfold their small, rough, and colorful wings to their full size.

The eggs of an insect are themselves not very big, but compared to the ones that lay them, they are surprisingly large. The eggs are usually round, oval, oblong, or somewhat bent. For some insects, the step from egg to larva takes only a couple of days. For others it may take much longer. When the larva is fully grown, it bites or gnaws its way out of the egg.

The larva grows fast and needs to repeatedly replace its skin with a larger one. The appearance of some insects changes drastically when changing from larva to adult inside the almost immobile pupa. In the pupal case, most of the larva's body breaks down and is then reconstructed into the adult insect. When hatching, a butterfly breaks free through the back seam of the cocoon. It slowly crawls out from the cocoon, gently pulling its antennae and legs out. The wings are still small, but after a while the insect starts to pump out blood into the wing veins. The expanded wings slowly harden and gain strength. A butterfly often spends its first day sitting still before making its first flight. Many butterflies consume nothing in their adult stage; instead they live off stored nutrients from their larval stage.

Hatched eggs of a moth *Dicranurini*
Body length: 2 mm | Södermanland (Nackareservatet Nature Reserve), 30 exposures

The eggshell has many features. Among other things, it needs to protect itself against dehydration but at the same time let air in so that the larva can breathe. Air enters the egg through small pores in the shell. There's also a mesh of air ducts in the shell itself. The female usually lays her eggs close to the host plant of the species, preferably on the underside of a leaf so that they're not easily detected.

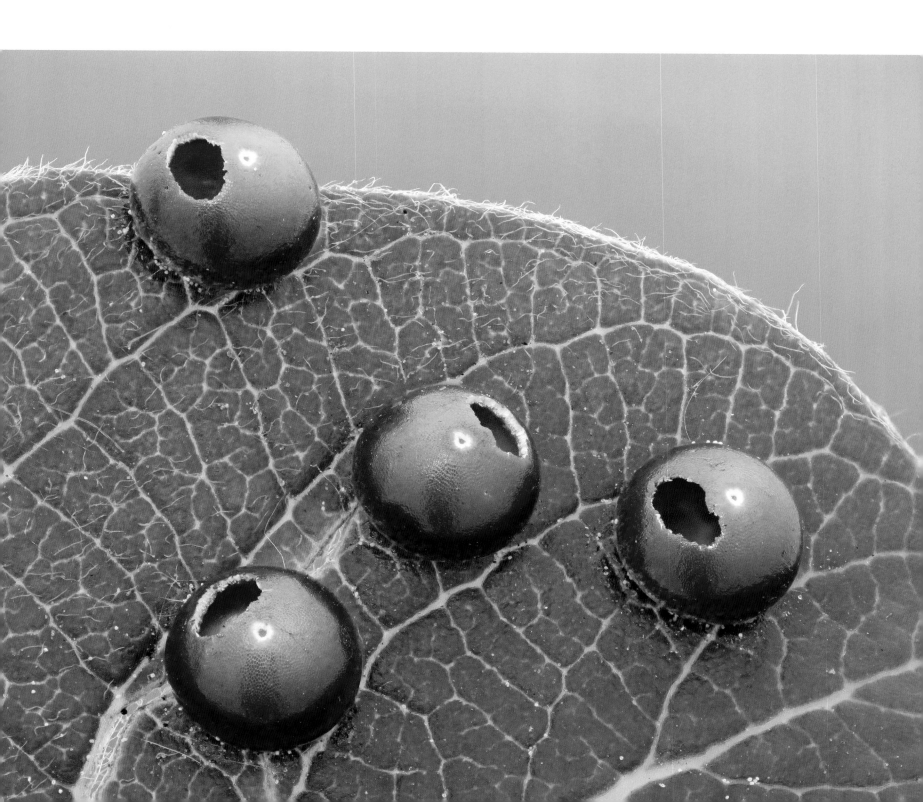

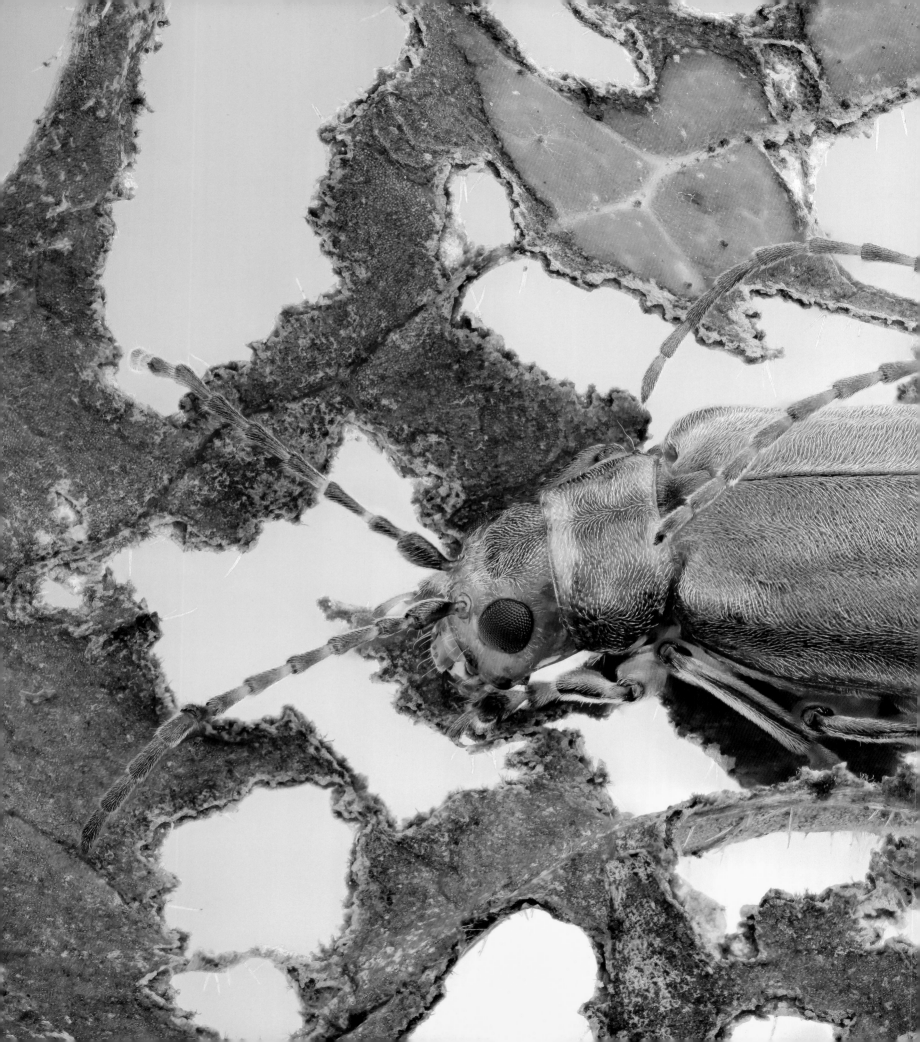

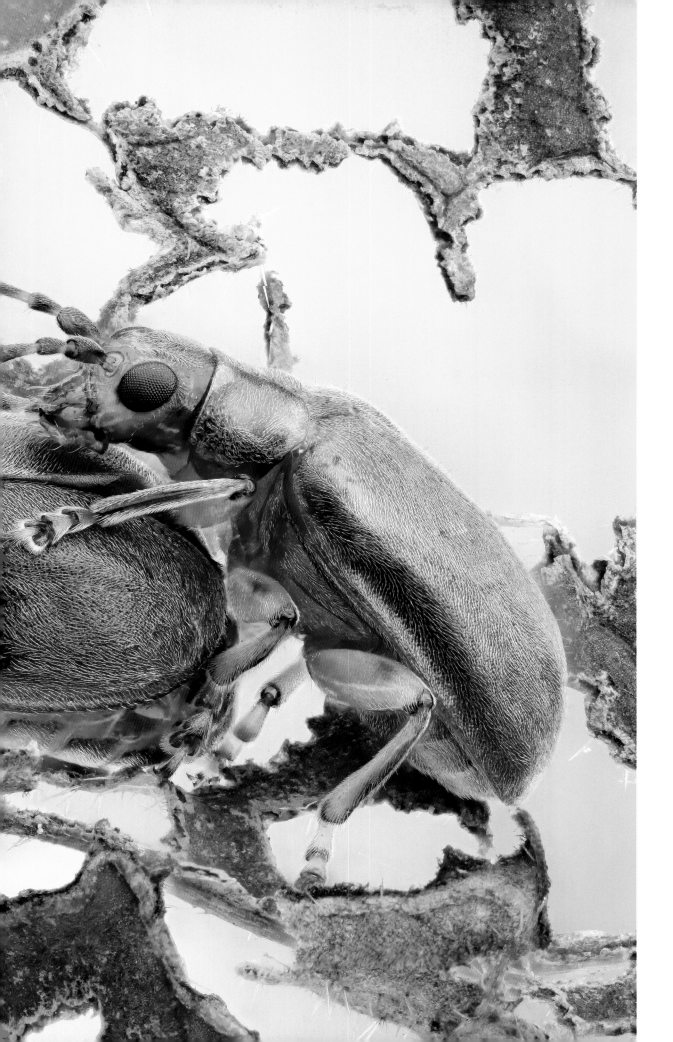

Viburnum leaf beetle *Pyrrhalta viburni*, ♀ ♂
Body length: 5 mm | Öland, 89 exposures

This beetle is quite common, and both adult and larva feed voraciously on leaves. Its host plant is normally the guelder rose, but it has been known to feed on other plants as well. The larvae often hatch in large numbers between May and June, and cause great damage to the guelder rose shrubs that sometimes are eaten bare, mainly in central Sweden. The adult beetles often nibble on the plant during the late summer. After mating in the late summer, the female nibbles small holes in the new sprouts. In each pit she lays several eggs and covers them with secretions and shavings. In mid-May, the eggs hatch and the larvae spend about a month eating the new foliage. When they're finished eating, they move down to the soil to pupate, and a few weeks later the adults emerge.

WITH ITS GREAT reproductive capacity, one single species of insect could cover the entire surface of the earth if nothing stood in its way. Someone is said to have calculated that a common housefly with a partner could, in optimal circumstances, be the source of numerous generations and 325,000,000,000,000 individuals in only one summer! Most female insects have a special container, semen theca, to preserve sperm. One single mating can give the female sufficient sperm to last throughout her entire life. For mating on land to be successive, the sperm is transferred through a penis directly into the female. Thus the insects have completely freed themselves from a life in the water, in the same way that reptiles, birds, and mammals have.

 Snail-killing fly *Pherbellia annulipes*
Body length: 5 mm | Öland, 10 exposures

Many of the species in the genus of fly that is seen in this photo (with twenty-three species in Sweden) have very similar appearances. Determining species is therefore quite a difficult task and often requires genital examinations. Flies keep on the edges of beaches and marshes. The larvae are predators that eat snails, but which snails constitute their prey is unknown. This fly's biology is otherwise also unknown, but the larval stage of the related species is short (one to two weeks), which means that several generations of flies can hatch during one season. The two flies in the photo are most likely mating.

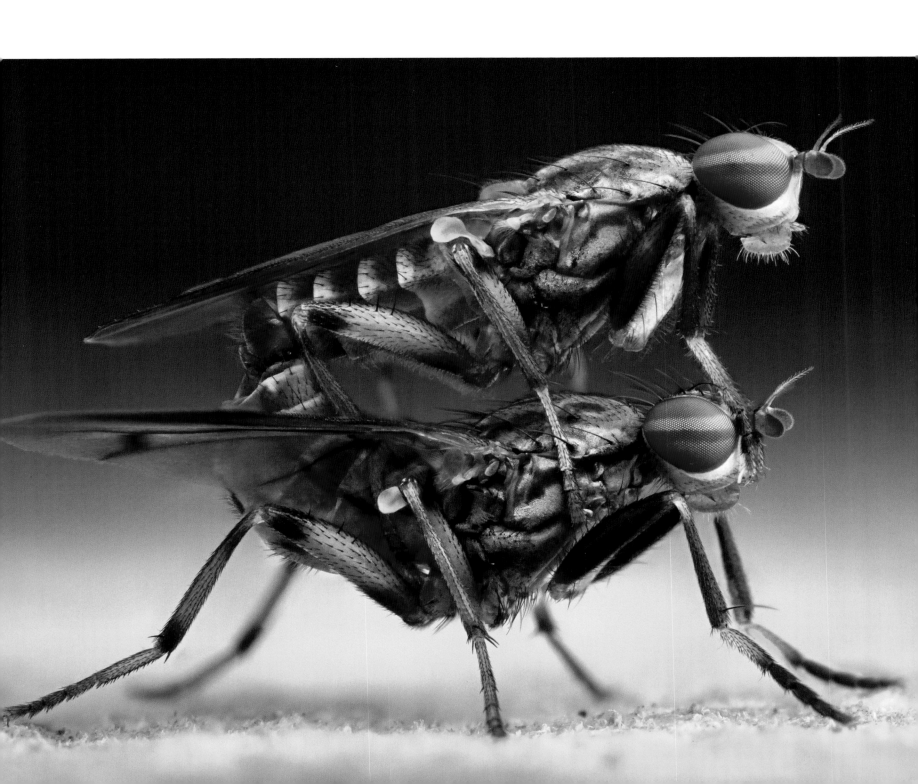

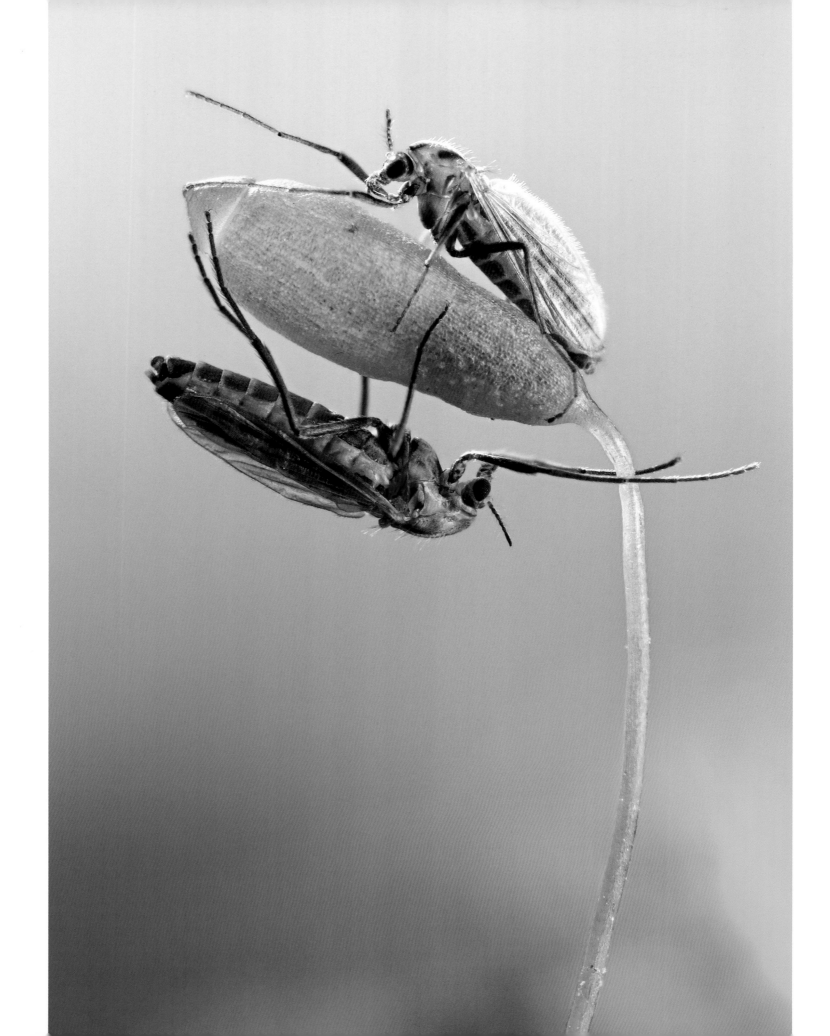

◄ **Non-biting midge** *Chironomidae*
Body length: 3 mm | Södermanland (Nackareservatet Nature Reserve), 3 exposures

The non-biting midge gets its Swedish name, *fjädermyggor* (which roughly translates to "feather mosquito"), from the males' feather-like antennae. Female antennae are more coiled or thread-like. Chironomids have no sharp haustellum, so they cannot suck blood. During mating season, the males can be seen in dense swarms, waiting for females to fly by. The antennae are very important organs for the chironomids, as they are used for both smelling and hearing. Males know if a female is of the same species by simply listening to the flapping of her wings.

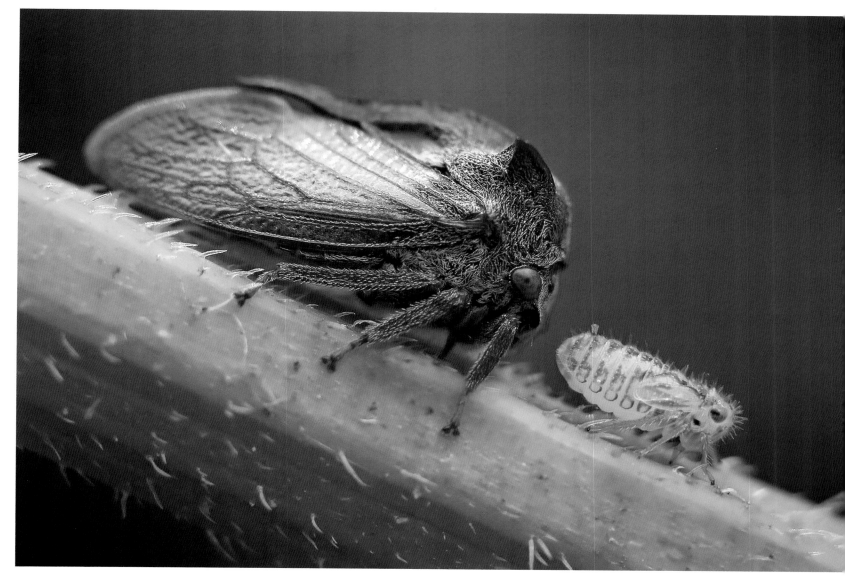

 Treehoppers *Centrotus cornutus*, adult and nymph
Body length: 8 mm | Öland, 2 exposures

This treehopper can be up to 7 to 8 mm long. It has dark colors and almost crystal-clear wings. The neck shield has two short, pointy horns on the sides and one long horn that continues over the abdomen. The appearance of the larva gets closer to that of the adult after each molt. They typically go through five larval or nymphal stages before becoming adults.

Bagworm moth *Psyche casta*, rival males
Body length: 5 mm | Södermanland (Nackareservatet Nature Reserve), 15 exposures

There are about twenty specialized species of bagworm moths in Sweden. The adult females are wingless in all but two Swedish species. They live their lives in bag-like houses made of sticks, pieces of pine needles, grains of sand, and grass blades that are woven together with silk. The larvae feed on green or decaying plants like grass, mosses, lichens, or algae. When the larva is fully grown, it attaches the bag to a surface and then pupates. In the larger species, the female usually stays within the bag, but females of smaller species cling to the bag's exterior.

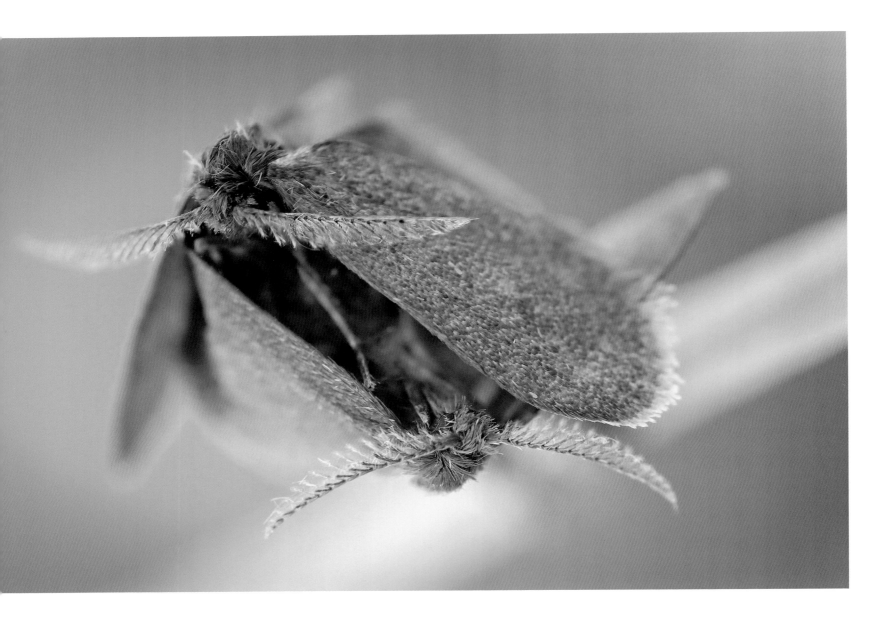

Bagworm moth *Psyche casta*, mating couple ▶
Body length: 5 mm | Södermanland (Nackareservatet Nature Reserve), 9 exposures

The wingless females attract males using their scent. After mating, the female lays her eggs in the bag she created as a larva and then dies.

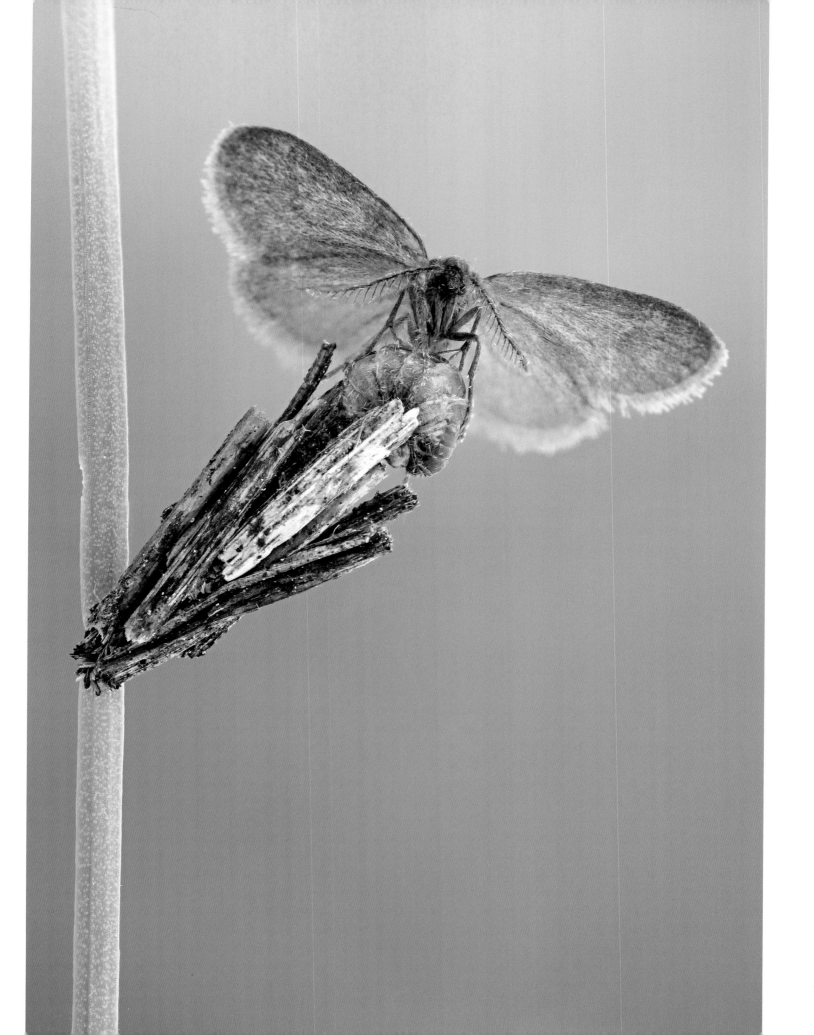

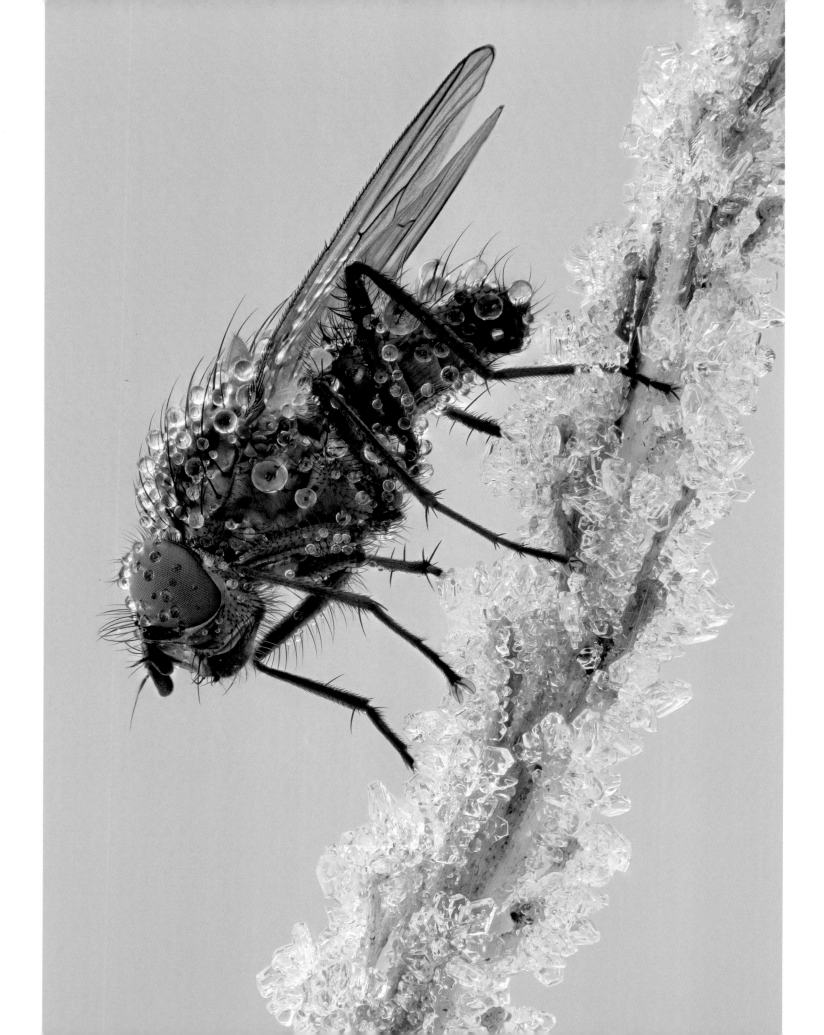

Anthomyiidae fly *Anthomyiidae*

Body length: 6 mm | Södermanland (Nackareservatet Nature Reserve), 60 exposures

The fly in this photo has barely survived the freezing night; its metabolism has generated enough heat to keep ice crystals from forming in its cells.

In Sweden alone, there are almost 300 different species of *Anthomyiidae*. They got their Swedish family name, *blomsterfluga* ("flower fly"), because many of the adult flies visit plants to drink nectar and eat pollen. However, some species are predators that suck from other insects. *Anthomyiidae* are closely related to houseflies and have a similar appearance. As larvae, the species of *Anthomyiidae* live very differently compared to each other. Some species live inside plants, others feed on decaying substances, and others feed as parasites. Some are seen as pests on cultivated plants like vegetables and root vegetables.

Eggs of aphid *Cinara*

Body length: 1 mm | Södermanland (Nackareservatet Nature Reserve), 15 exposures

The aphids of the genus *Cinara* often lay their eggs on pine needles. The eggs are attached to the needles thanks to the sticky secretion that's on each egg. The aphids are examples of insects that hibernate as eggs. It is likely that this is the easiest way to survive the winter, as eggs contain less water than larvae, pupae, and adult insects. When winter comes, the eggs have the best chance of avoiding ice crystals destroying the cell walls of the insect.

Shadowspider *Nuctenea* sp.
Body length: 4 mm | Södermanland
(Nackareservatet Nature Reserve), 48
exposures

The spider in the photo resembles the smaller *Nuctenea silvicultrix*, but could very well be the larger species of the same genus, *N. umbratica*. The smaller spider is commonly found in bogs in southern and central Sweden. The larger species are rarely seen in vegetation, but are common in buildings and other man-made constructions. The webs of the *Nuctenea* are more or less rounded with radial threads that, like the spokes of a wheel, connect in the middle of the web. The web is made to capture smaller flying insects; the sticky threads cross and spiral over the radial wires from the center and outward. The web's center tends to be displaced in the direction of where the spider is hiding, giving it quick access to whatever prey gets caught.

These spiders are also active during the winter, making them an important food source for birds.

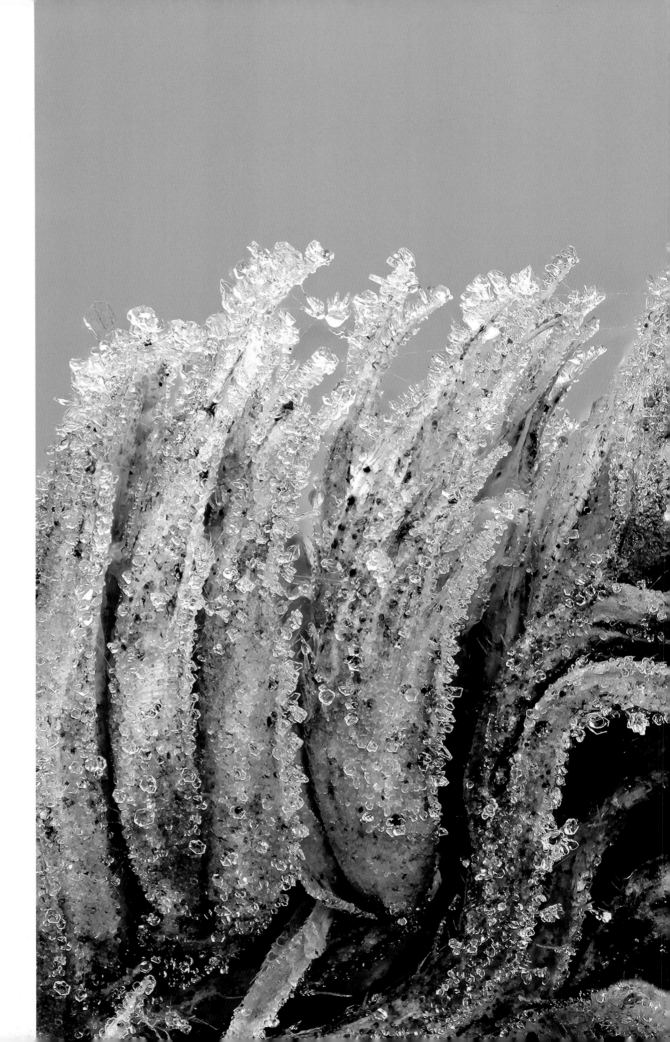

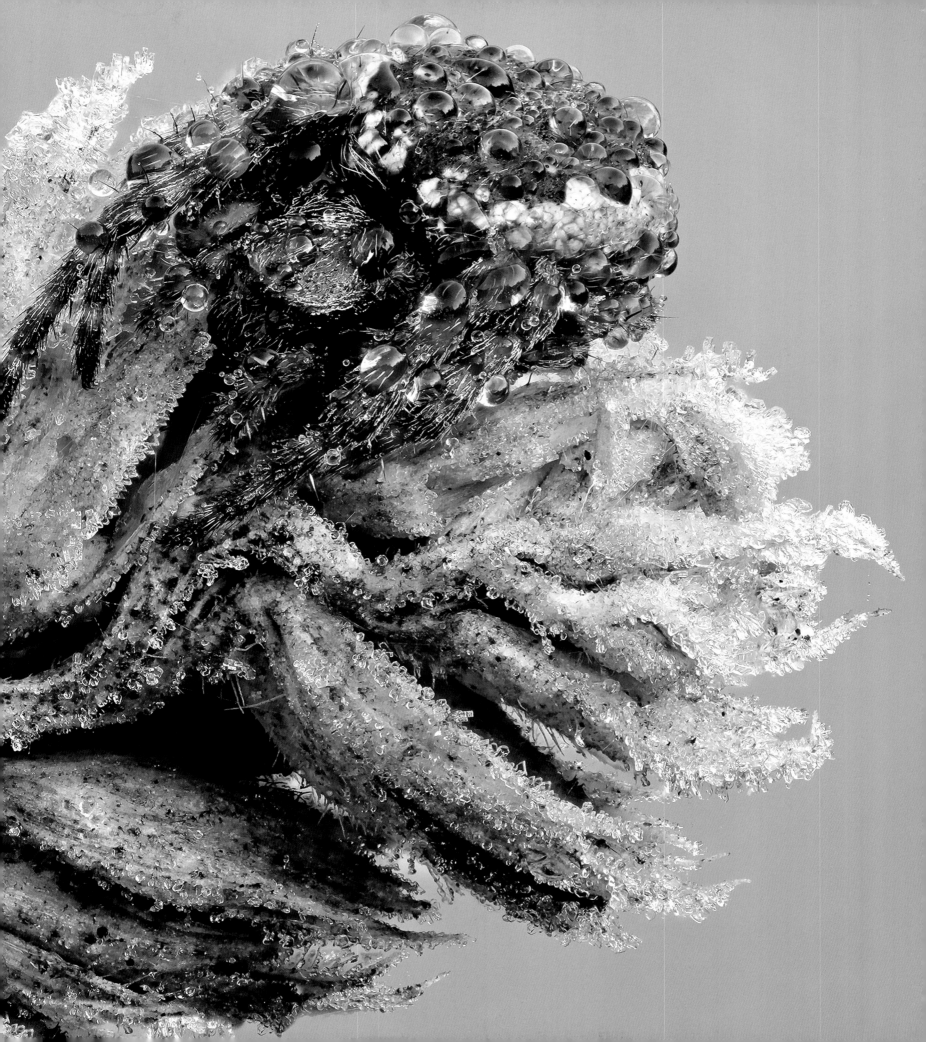

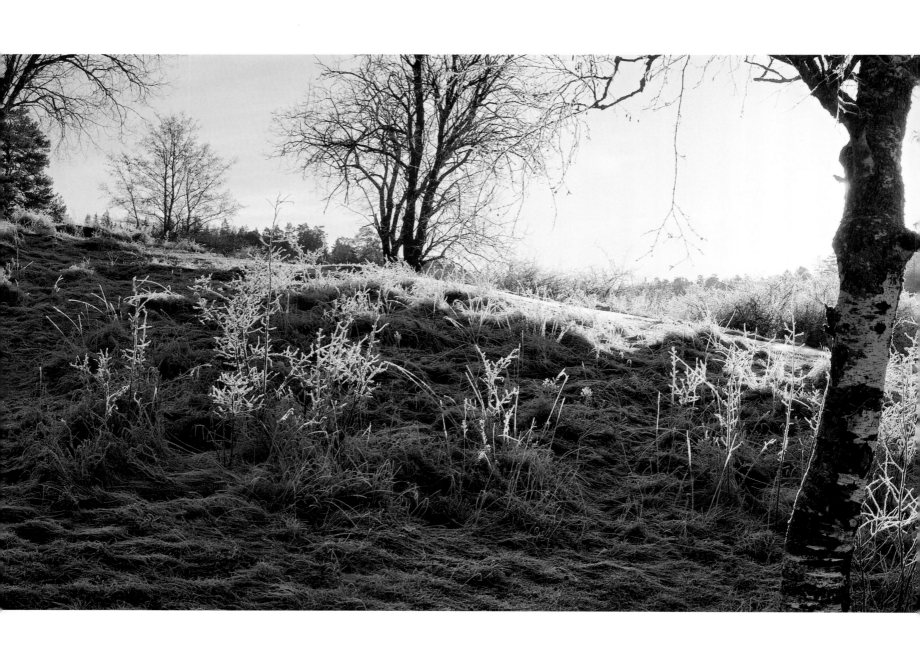

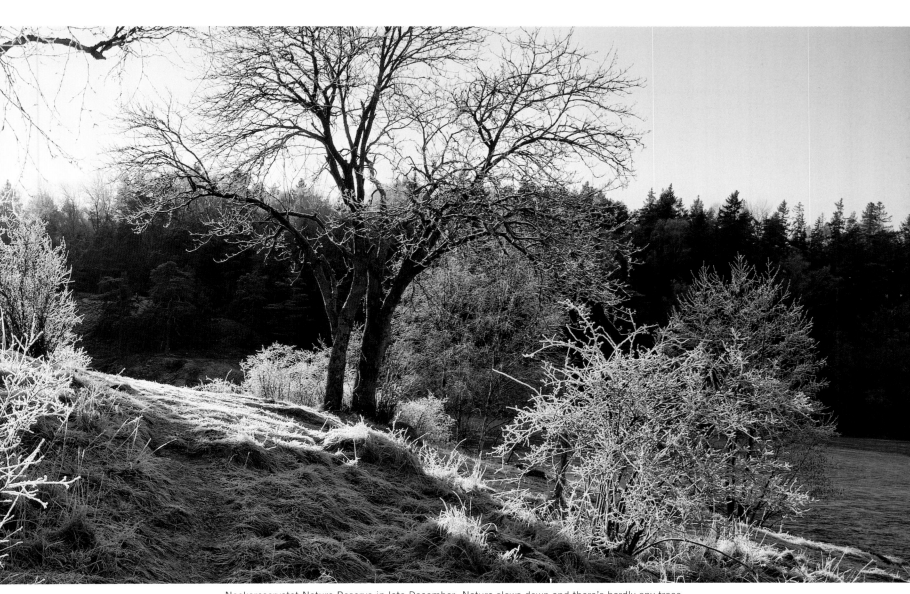

Nackareservatet Nature Reserve in late December. Nature slows down and there's hardly any trace of insects and other bugs.

PHOTOGRAPHING BUGS

As a bug photographer, I need not worry about the lack of subjects. On the contrary, handling the diversity of insects has proved to be a challenge. It might become necessary to have some sort of limitation, like focusing only on a certain species or, like me, choosing a certain area that you can return to time and time again.

Returning is not only a useful limitation. In an area of 20 x 20 meters, you soon

learn where and how the light falls and shifts as the sun finds its way up over the tree line. As it happens, the conditions are best during dawn and sunrise. The bugs are still cold and therefore stay relatively calm. Also, the light is soft, which makes image exposure much easier.

Getting up when the alarm clock rings at three o'clock in the morning might be a pain, but it's worth it half an hour later. That's when I jump off the bike in my favorite glade and unpack my coffee thermos and camera. The equipment is a mixture of old and new: a modern system camera with a macro bellow equipped with a close-up lens from the sixties. Encouraged by a nightingale, I begin my search for dormant insects in the dewy grass (p. 187). Despite visiting this site many times before, and even if I've looked at bugs

my whole life, there's still a great chance of me seeing something I've never encountered before.

I could count the perfect mornings on one hand—it's always either too cold, hot, windy, or rainy. Herein lies the challenge that made field photography one of my favorite activities and that also motivated me to devote myself to another form of photography. In my studio that's large enough to fit onto the windowsill in my living room, I can continue to study the insects even during winter. I have to settle for dead and preserved subjects that have been stored in the freezer. With microscope optics in front of the camera and the subject enclosed in a modified Ping-Pong ball (to spread and soften the light), I can take an even closer look. The most inconspicuous insects suddenly reveal themselves as the intricate and imaginative creatures they really are. /JH

More information about the technology and equipment can be found at johnhallmen.se.

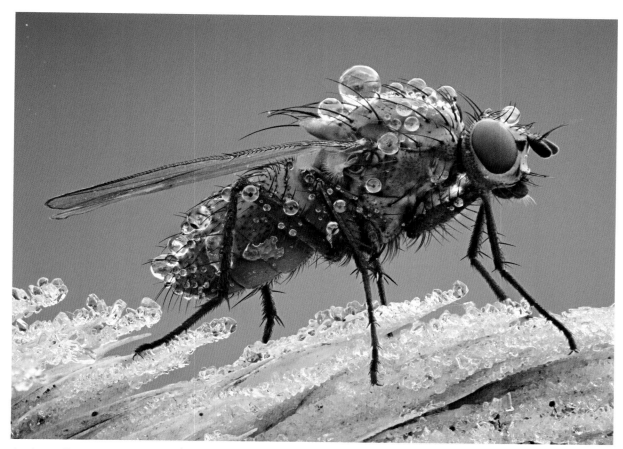

Anthomyiidae fly *Anthomyiidae* | Body length: 7 mm | Södermanland (Nackareservatet Nature Reserve), 30 exposures

FOCUS STACKING (OR FOCAL-PLANE MERGING)

By taking multiple images and combining them you get an image with a greater depth of field. The technique is called *focus stacking* and helps the photographer to overcome the greatest obstacle when shooting bugs: the shallow depth of field of the macro lens. As the subjects get smaller, the limitations become more noticeable and you realize how much there is to gain by using focus stacking.

For this technique to work, you need a series of images in which different parts of the subject are in focus, shifting gradually from the parts closest to the camera to those farthest away. The software that takes care of the focus stacking identifies the sharp parts of each image and combines them into one single image. The amount of photos needed varies depending on factors like magnification, aperture, and the size and shape of the subject. Therefore the number may vary, ranging from only a handful to a few hundred. Also, the length of the gradual shifts can vary. When I photograph sequences in the field, the lengths of steps are often between a few hundredths of a millimeter and a whole millimeter. In the studio I can reach magnifications so high that the lengths of the steps are only a thousandth of a millimeter. If the steps are too long you get gaps that appear as blurred bands in the image. If they're too short, you end up with a rather unnecessary amount of images.

I would like to thank the following people for their help in the identification and/or verification of certain species:

Johan Abenius, Nynäshamn (*Hymenoptera*)
Reinoud van den Broek, Netherlands (flies)
Björn Cederberg, Uppsala (*Hymenoptera*)
Bengt Ehnström, Nås (beetles)
Håkan Elmquist, Mariefred (butterflies)
Mattias Forshage, Stockholm (*Hymenoptera*)
Bert Gustafsson, Stockholm (butterflies)
Lars Imby, Stockholm (butterflies)
Frans Janssens, Belgium (springtails)
Lars Jonsson, Kristianstad (spiders)
Torbjörn Kronestedt, Stockholm (spiders)
Staffan Kyrk, Stockholm (spiders)
Åke Lindelöw, Uppsala (beetles)
Lars Lundqvist, Lund (mites)
Kajsa Mellbrand, Finland (spiders)
Nikola Rahmé, Hungary (beetles)
Stanislav Snäll, Stockholm (beetles)
Nikita Vikhrev, Russia (flies)

Copyright © 2012 by John Hallmén (photographs) and Lars-Åke Janzon (text)
Originally published by Norstedts, Sweden in 2012, under the title *Kryp*
Published by agreement with Norstedts Agency

First Skyhorse paperback edition 2019

Skyhorse Publishing books may be purchased in bulk at special discounts for sales promotion, corporate gifts, fund-raising, or educational purposes. Special editions can also be created to specifications. For details, contact the Special Sales Department, Skyhorse Publishing, 307 West 36th Street, 11th Floor, New York, NY 10018 or info@skyhorsepublishing.com.

Skyhorse® and Skyhorse Publishing® are registered trademarks of Skyhorse Publishing, Inc.®, a Delaware corporation.

Visit our website at www.skyhorsepublishing.com.

10 9 8 7 6 5 4 3 2

Library of Congress Cataloging-in-Publication Data is available on file.

Cover design by Carl Åkesson
Cover photograph by John Hallmén

Print ISBN: 978-1-5107-5050-0
Ebook ISBN: 978-1-5107-5055-5

Printed in China